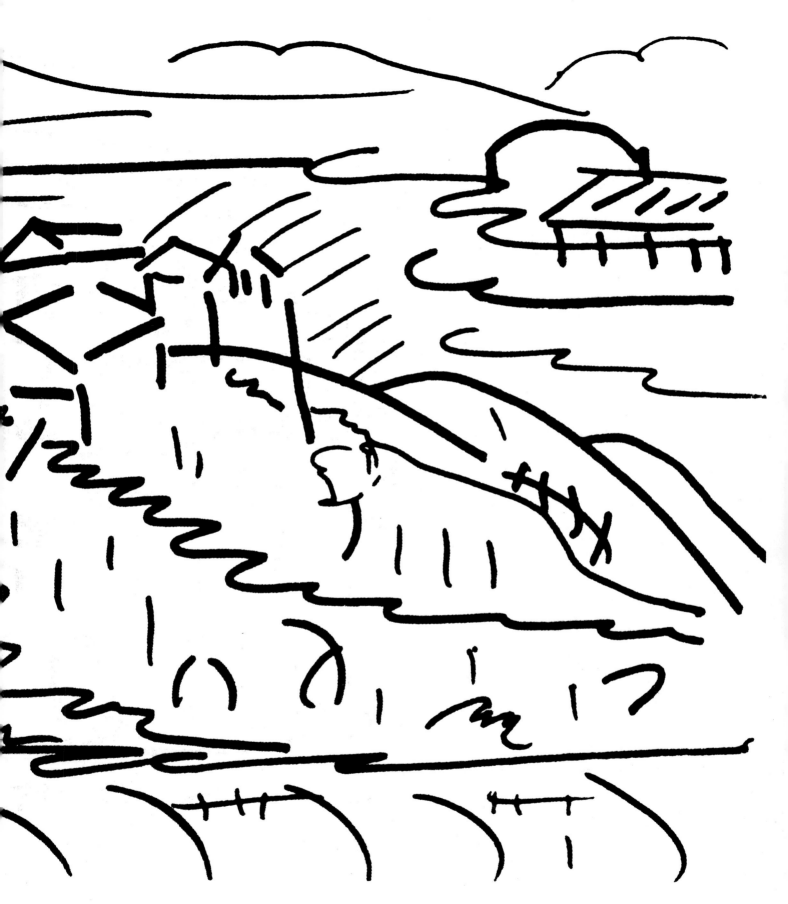

DRAWING
MASTERCLASS

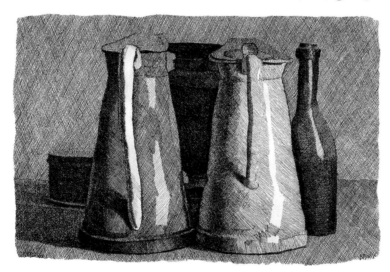

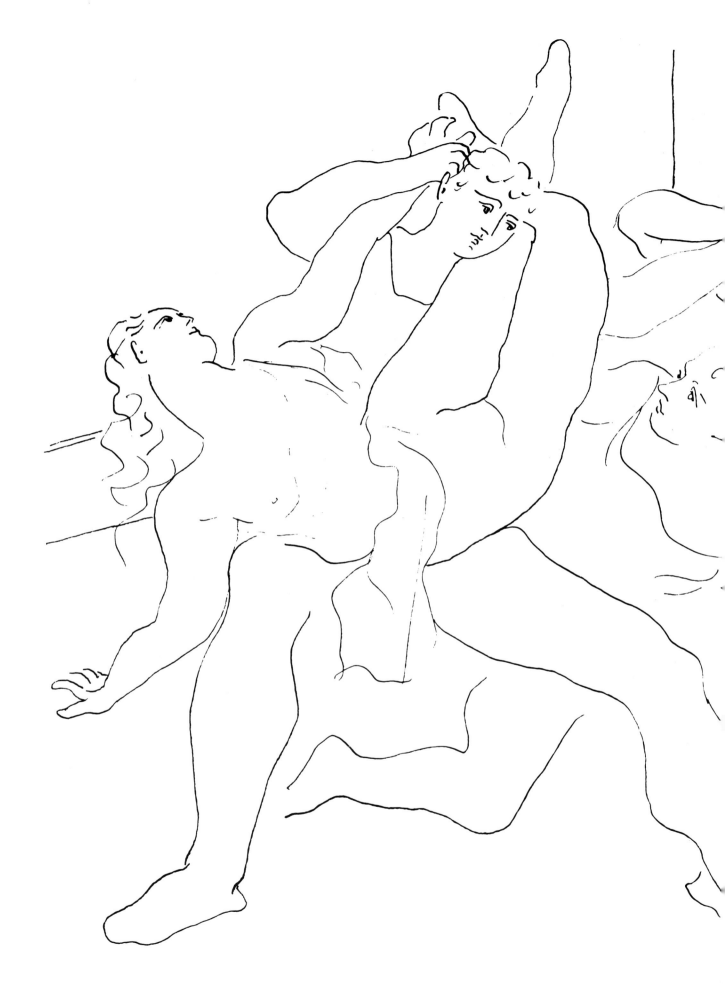

DRAWING
MASTERCLASS

RON BOWEN
THE SLADE SCHOOL OF FINE ART

A BULFINCH PRESS BOOK
LITTLE, BROWN AND COMPANY
BOSTON · TORONTO · LONDON

First North American Edition

Library of Congress Cataloging-in-
Publication Data

Bowen, Ron.
 Drawing masterclass: lessons
 from the Slade/Ron Bowen. – 1st
 North American ed.
 p. cm.
 "A Bulfinch Press book."
 ISBN 0-8212-1985-5
 1. Drawing – Technique.
 2. Drawing – Study and teaching.
 3. Slade School of Fine Art. I. Title.
 NC735.B56 1992
 741.2 – dc20 92-53194

Bulfinch Press is an imprint and
trademark of
Little, Brown and Company (Inc.)
Published simultaneously in Canada by
Little, Brown & Company (Canada)
Limited

ART EDITOR KAREN BOWEN

PRINTED IN ITALY

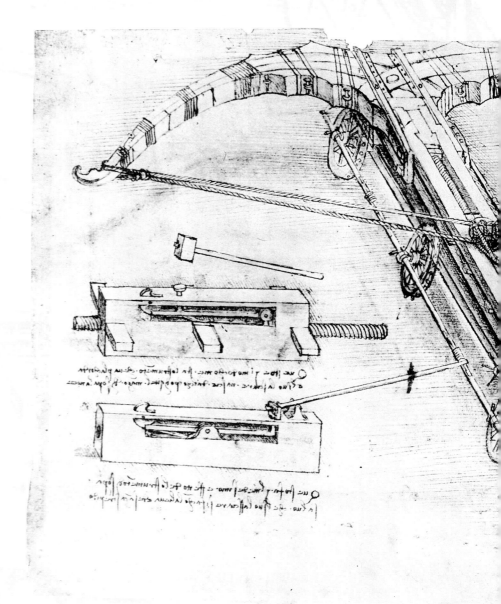

p. 1 Georgio Morandi
STILL LIFE WITH FIVE OBJECTS 1956

pp. 2-3 Pablo Picasso
FOUR DANCERS 1925

contents Leonardo Da Vinci
THE GREAT CROSS-BOW from Codex Atlanticus

CONTENTS

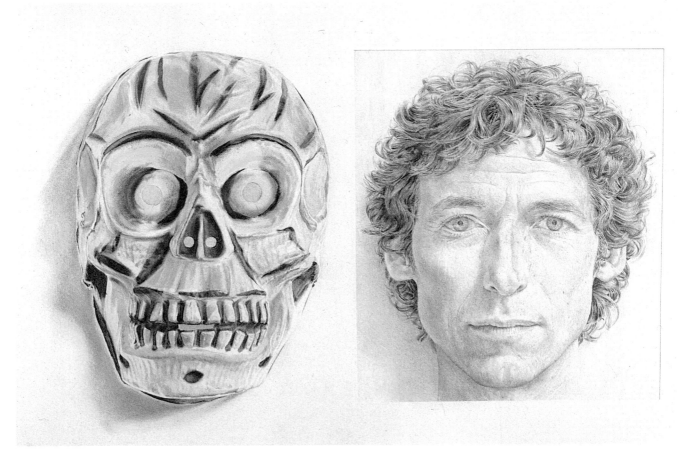

above **Ron Bowen**
ME AND MY SHADOW 1980

*This drawing is intended as a
momento mori. It juxtaposes a
careful self-portait with one of
the familiar masks that we
use to approach, or flirt with,
the idea of death.*

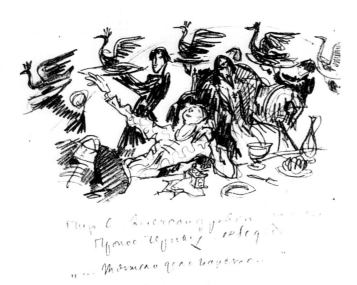

left **Sergei Eisenstein**
Sketch for scene from **IVAN THE
TERRIBLE**

*This working drawing for a
film was made by the director
to visualise the look or feel of
the scene for himself and those
who would have to carry out
his directions.*

FOREWORD

I have spent most of my life trying to understand the world through 'picturing' it. My experience as a professional artist has led me into a variety of situations that have required that this picturing take many different forms. In common with many artists, I have used drawing to organise the shifts in visual approach that are required in moving to new subjects or ways of looking at things and to serve the variety of practical purposes that follow from them – to figure out how to build theatre pieces, to make plans for paintings, to reconstruct figures from scientific information, and, throughout, to observe, visualise and analyse. This book is based on that variety of professional experience, and reflects my belief in the advantages gained by considering the many drawing systems that have developed around different ways of visualising the world.

It also reflects my experience as a teacher of drawing to young artists, and others such as architects or medical students, who are building quite divergent pictures of the world. It is unfortunately too common to find that even advanced students in these disciplines passively accept the visual conventions that they find laid out for them. They have found 'a way to draw', and cannot find ways to interpret their surroundings outside of it. Less experienced students are likely to describe themselves as 'not being able to draw' and identify the problem physically, as one of the hand not being able to follow the eye, while their drawings suggest that their problems lie in their lack of understanding of how marks placed on a surface can relate to our experience of our surroundings.

In their own ways, both groups are either using or looking for predetermined solutions or rules. But drawing is, above all, a means by which to challenge visual assumptions. It is developed by careful investigation of the way we see and experience our surroundings, and the consideration of the many ways in which to put this down on paper.

Drawing is the most universal human activity for organising what we see. I believe that almost anybody can do it reasonably well. The hand-eye coordination is no more complicated than that used in writing. The visual grammar that allows simple marks to stand for complex visual information is already in our brain.

There are no rules that govern the inquiry, but there is a wealth of past experience of it in examples from every field of human experience, and there are ways of looking methodically at how it has and can be used to raise the level at which we can see, and transcribe that experience.

ORGANISATION OF THE BOOK

This book is based on the notes and occasional lectures I have developed over the years. I have tried to make it comprehensive, but it is a personal viewpoint; I have not put anything in it that I have not used or considered myself.

It is divided into an introduction and five chapters. There is some degree of overlap between them, but each describes drawing from one of its essential aspects. A technical directory at the back of the book includes notes about those drawing methods and materials that are of general use. I have broken each chapter of the book into short separate sections to allow easy reference. Each section suggests a possible starting point for investigating the activity of drawing.

The images that accompany the points made in the text include drawings from the popular and high arts. Since drawing underlies so many different kinds of work, I have included printed, engraved and painted works if the drawing element in the image justified its inclusion.

I have credited the works in the book as carefully as possible, though the informal nature of many drawn works can make precise details difficult to determine. Some are untitled, or without dates, which can only be determined approximately – sometimes not at all. In some cases, it would be impossible or misleading to credit a single artist, and in others a description of the nature of the image has replaced a title. More complete information concerning image, artist and context for each image appears on pages 159-160.

The book is meant to be drawn as it is read, and includes suggestions and games for doing so. If followed in this way, the book will literally draw you through my description of what drawing is, the way in which it relates to the way we see, what its essential strategies are, and what sorts of purposes it has been put to historically.

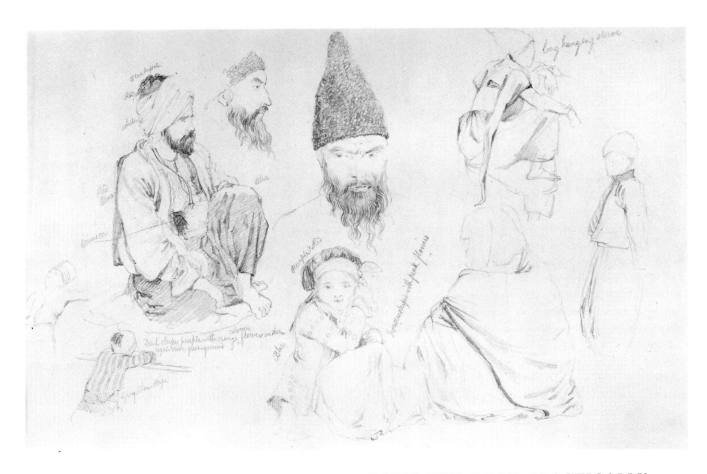

above **Richard Dadd**
FIGURE STUDIES IN TURKEY
AND SYRIA 1842

The sketchbook has become the constant companion of many artists, and in the sketchbooks of past travellers, like the Victorian painter Dadd, we can see their first impressions of the often exotic locations they visited.

opposite **Fernand Léger**
FRAGMENT OF FACE 1933

Drawing is based on the use of the simplest materials in the making of complex images. This pen drawing of Léger suggests the possibilities for building form using such simple means.

USING THE BOOK PRACTICALLY

Start by choosing a room and some objects that you would like to draw. You will be drawing the same space and familiar objects throughout the book, as well as executing a series of self-portraits and drawings of parts of your body, combining the space, objects and self-image in increasingly complex ways. The process of analysis will be focused around ten 'games', through which you will be encouraged to look at these subjects in many different, sometimes contradictory, ways. The games are accompanied by drawings by students and young artists who have used them as the starting points for works. These are meant solely to indicate possible interpretations – there is no correct way to approach the games.

In addition to these games, the book is meant to be followed in sketchbook drawings. Some pages of text have suggestions for how the ideas introduced can be followed. But even when no specific information is given, try to visualise what is being said by drawing it, using what is at hand and familiar, or making up forms in your head. The most important thing is that you become used to manipulating ideas through drawing, and moving and shifting things around while you draw.

I have related the book to reassessing the familiar through drawing, but I also think that moving outwards to the unfamiliar is valuable. Get in the habit of taking a sketchbook with you, using it as a companion to help you see and understand things better. The goal is not to make finished drawings. It does not make any difference if the drawings are very accomplished or not; we learn as much from our mistakes as we do when we get things right.

MATERIALS

You will not need expensive or complicated materials. Most of the book can be followed with a pencil and a pad of paper. However, you should give yourself some scope for experimentation with different sorts of mark-making instruments and various sizes of paper. Since you will be doing some drawing on a mirror, you will also need a relatively fine felt-tip marker that will mark on glass, and a medium-sized mirror, as well as a fine pen (fibre tipped are most suitable), some pencils in the mid-range of softness, a kneadable rubber (eraser), a pad or some largish sheets of paper, an easily carried sketchbook, a piece of cardboard, a ruler, a small Stanley knife or cutting blade, a piece of thread, and some tape. Consult the materials section at the back of the book for more information about materials you might use.

Make a viewer by cutting a rectangle out of the middle of a sheet of card, as shown.

A GAME FOR BEGINNING TO DRAW

Start by making a drawing of yourself, the room you have chosen, and some objects on a surface, such as a table.

Next look at your image in the mirror. In order to draw onto it you will have to look through only one eye. One of your eyes is stronger than the other; you can find out which it is simply by marking the tip of your nose on the mirror with both eyes open, then shutting each eye in turn. Seen through the stronger eye, the mark will hardly move; through the weaker one, it will shift considerably. Sighting through the stronger eye, mark the top and bottom of your head and its widest point at the ears. Measure it vertically and horizontally. It will be surprisingly small, only about 11.5 cm (4½ inches) high, half the size of your head. Even more surprisingly, your mirror image will always be the same size. If you draw a simple line around your head and move back from and closer to the mirror, it will always just fit into this outline – just the first of many surprises in store when we start to investigate how we see.

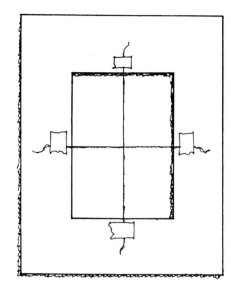

MAKING A VIEWER

Viewers are helpful in assessing the angles of what we want to draw. It is important that the rectangular cut-out has true 90° corners. I suggest a card size of 15 x 20 cm (6 x 8 inches), a cut-out area of 7.5 x 11.5 cm (3 x 4½ inches), bisected by string in both directions, secured by tape as shown.

above **Georges Seurat**
PORTRAIT OF AMAN-JEAN 1883

In this portrait of his friend and fellow artist, Seurat carefully establishes the individual likeness, as well as the social status and profession, of the sitter.

PICTOGRAM Lascaux, France c. 13,500 B.C.

This cave drawing represents a man in the simplest possible terms.

top **Hendrick Hondius**
WORLD MAP from Jan Jansson's Novus Atlas
1647-62

A classic solution to the problem of how to depict the entire globe on a flat surface.

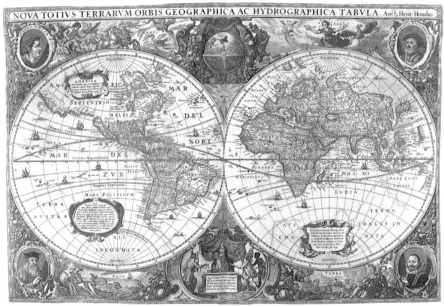

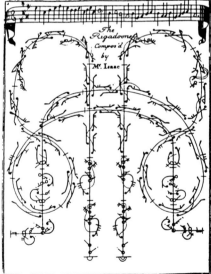

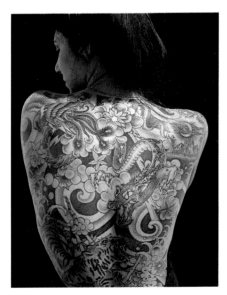

above **Raoul-Auger Feuillet**
FEUILLET DANCE NOTATION
late 17th century

The diagram describes both the path of the dance and the steps of each of the partners.

above **Jim Watson**
TATTOOED WOMAN/CHERYL

opposite **Andreas Vesalius**
ANATOMICAL FIGURE from the De Humani Corporis Fabrica **1555**

Knowledge gained from dissection of the body is applied here to a classical figure.

WHAT IS DRAWING?

Drawings form the basis of humankind's earliest record of itself. Cave images were developed over many thousands of years, and perhaps date from as early as 25,000 B.C. From the gracefully moving and empathic pictures of hunted animals to the pictograms of their pursuers and the stencils of the hands of the artists themselves, they range in form from the surprisingly naturalistic to the entirely schematic. Drawings pre-date written language and were the foundations for hieroglyphic picture symbols; the Egyptian hieroglyphs for ox, 𐎛, and house, ⊐, slowly evolved into the 'A's and 'B's of this page. Maps, which picture the world from positions we cannot physically occupy, are known to have existed in Babylonia as early as 4,500 years ago. Construction plans, which project into the future, were in use in the Old Kingdom in Egypt, and what could be considered the first naturalistic portrait – of the pharaoh Ahkenaten – was made at the capital he founded at Amarna in the following millennium. Classical vases and reliefs were essentially drawn, and provided Greece with visual interpretations of its narrative histories and myths. In the Renaissance, drawing became the meeting place of the scientist and the artist, both using it to determine the underlying nature of reality. Today we use drawings to direct the most ordinary activities – crossing the road, giving first aid, changing the film in our camera. Our technology relies on drawings to construct microchips as well as sky-scrapers, and, from wallpaper to clothing and tattoos, we decorate our living spaces, objects and ourselves with drawn forms.

Drawing, in its many forms, is the principal means by which we organise the world visually. We use it to work out ideas of all sorts, collect information and analyse the way we see things in order to plan, instruct or speculate. Through drawing, we are led to 'see' and to understand.

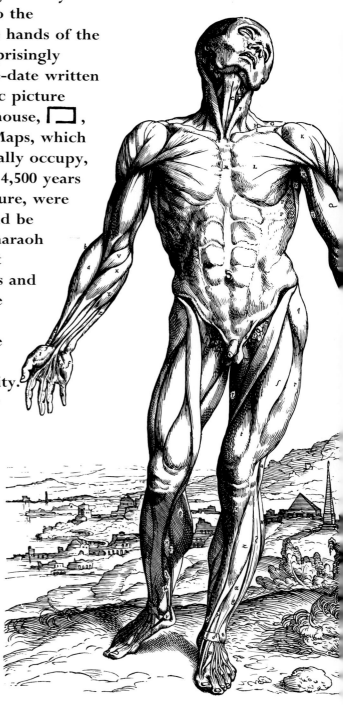

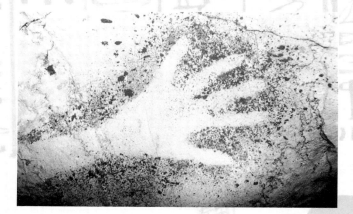

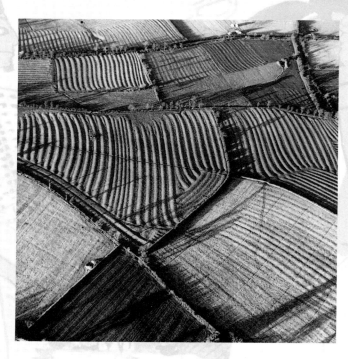

top **STENCILLED HAND**
Cassis, France

One of the many stencilled hands that appears in cave art; it has been dated variously at 18,000 B.C. and 12,000-11,000 B.C. (as has the horse's head on p. 15). The appearance of children's as well as adults' hands, in positions suggesting the child had been lifted, implies that these images had a ritualistic function, rather than simply being records of the artists.

above **FURROWS AT BYFIELD HILL, NORTHANTS 1951**

The cultivation of fields inevitably leads to the marking out of ownership boundaries. In early Egypt, for example, maps were developed to define the permanent boundaries of land that changed yearly as it was flooded by the Nile.

In order to investigate the relationship that drawing has to the development of understanding, we should start with some questions about the activity itself. What actually is drawing, and what unifying attributes underlie its many forms?

The term is most often applied to works made with implement, such as pens or pencils, or to works made on paper. Although descriptions in terms of materials may be useful, they do not seem adequate when we talk about the drawing element in paintings, carvings and prints. To look for a description we must first look for the essential qualities of drawing as an activity, and it may be useful to initiate any description of this kind with the derivations of the word itself.

English words for drawing come from both the German and Latin origins of the language. The verb 'to draw' is derived from the Old English *dragan*, meaning 'to drag', and suggests the physicality of the activity. The word 'design' is currently applied to planning and decoration, but until the last century was used more comprehensively to describe drawing. It comes from the Latin *designare*, meaning to designate, or mark out, and suggests the component of identification in describing or designating. The Indo-European roots *(dhragh, sekw)*, which underlie both German and Latin, contain a host of references relating the act of pulling or following to marks, signs, sight and seeing.

The image of dragging a mark-making implement across a surface conjures up the antiquity of an act that is little changed. Tool-using was one of the first distinguishing features of human beings, and among the first tools were those employed to score or mark. The earliest drawings are outlined with scored or incised lines, and were seen to be magical re-creations. Our simple drawing tools connect us directly with our forebears – we draw with charcoal now just as they did then – and magic is still not all that far from the simplest drawn image.

Marking is a tactile activity – touch is involved – and describing the thing we see with marks is powerfully related to touching it. Touching something from afar by drawing it is an act of empathic projection, and, if the projective nature of drawing is one of its most powerful attributes, it also has some dangers built into it for both the seer and the seen. The myth of the death of Actaeon, killed for catching sight of the Goddess Artemis, is a reminder of the punishments meted out to those who touch by sight that which is proscribed. Within the magical sphere, the image is an appropriation of what is depicted, a

control over it. There is also the opposite, 'Pygmalion' fear, that the realised image can take on a life of its own, and be beyond control. The many taboos and pictorial constraints that surround images of the powerful or sacred are acknowledgement of both of these beliefs, but are present in all image-making.

Early drawings involved not only the making of marks, but also a concern with the confirmation of the existence of the mark-maker. The images on cave walls include simple stencils of hands. Some have fingers missing, or the fingers are deliberately bent into some sort of code. Of all the hand images, these have aroused the most conjecture for the obvious reason that while the image of a whole hand needs almost no explanation, a partial one, since it deviates from the norm, suggests an event or story. There is some indication here of the difference between our automatic acceptance of depictions of whole things and the sort of conjectural process that is triggered when parts are missing, not shown.

The Magdalenian hunting culture, from which our first images sprang, gave way to an agrarian society in which the conditions for the making of many other drawn forms began to appear. Dragging, in this context, is related to activities that leave marks on the earth, such as the ploughing of fields, and the more complex activities that follow from this rudimentary parcelling up of the world, like the making of maps. Questions of what forms such depictions will take become more complex as they take in more of the earth's surface, and the solutions are necessarily extreme. The world is, after all, spherical or 'rounded' and any attempt to put it on a flat surface will involve a radical transcription. The same can be said for any object 'in the round' or any of the spaces around us.

Maps designate or 'name' territory. They reintroduce the connection of marking out to the naming of things, and to language, and balance the connection of drawing and empathic projection with its potential for analytical distancing, or overview.

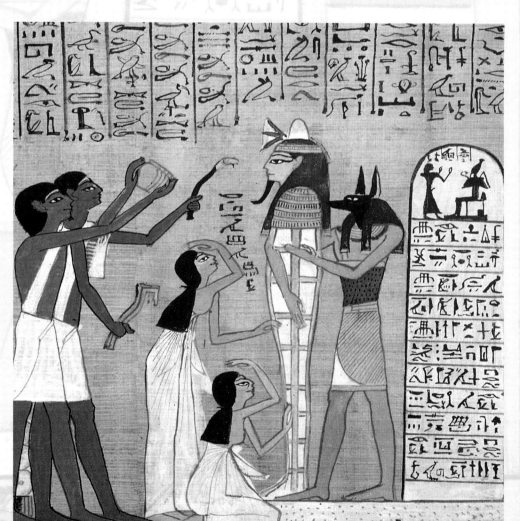

THE OPENING OF THE MOUTH CEREMONY from the Book of the Dead of Hunefer, Nineteenth Dynasty **c. 1310 B.C.**

This picture is, first of all, a magical re-creation, which preserves a significant event for an afterlife. It is part of a ritual. The central panel depicts the mummification of the pharaoh, attended by Anubis, god of mummification and protector of tombs; the tablet at the right describes his power and position in hieroglyphics. By the time of this depiction, the two languages of pictures and picture/writing had developed separate identities as magical tools. Both were sacred, and were used to confer power and permanent existence through images.

Trace around your hand – first laid out flat, then with one finger bent under then in a fist, etc.

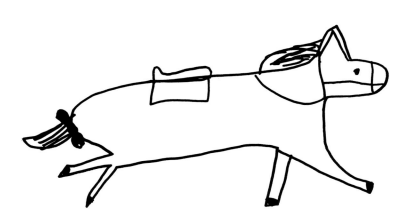

This drawing by Fay, aged six, is representative of the drawings of young children, who depict the most typical, known features of their subject in simple, clear forms. The side view allows us to read the horse image easily; the running legs are an interesting attempt at describing its action. It is a highly conceptualised drawing, in sharp contrast to the one on the facing page, by a child of almost the same age.

The sophistication of this drawing by an autistic child of five-and-a-half, poses questions about our language and image-making abilities. The foreshortened image and dynamic space depicted are features of experience that children – and adults – conceptually pull towards the known, constant features of what is seen. The drawing seems only to have been made possible by the absence of this need to conceptualise.

The word 'seeing' is often used to mean understanding. We say 'I saw the light', or 'I see what you mean'. Our sense of the way we understand is that a kind of form shapes itself around our experience within which our observations make sense. In the dialogue between this schema and our developing perceptions lies what we call thought, which at its deepest level is conjecture about constancy and change.

This starts in infancy. The perceptual system we have inherited for survival is a highly visual one, but it is what we experience through all our senses that informs how we see. Infants develop awareness through other senses before seeing becomes a discrete activity, and so bring already accumulated experience, or schema, to it. A relationship between touch and sight is established at this stage. The investigation by touch of an object sets up a memory of its permanent shape, while sight delivers a different image of the object for each separate position it is in. The interconnection between the memory images we have in our head and our experience of their possible variations in appearance is essential to our survival, as well as our ability to picture things and our active thought process itself.

Subjects of a perceptual experiment in which the appearance of objects was reversed through special lenses could suddenly see the objects the right way round when they were allowed to touch them. Such sudden shifts suggest that there is a lot more to seeing than sight.

Nevertheless, it is sight, with its ability to take in the changing situation quickly, that becomes the organising sense early on in this process. Our first experience of learning to balance, walk and pick up things involves our sight-coordinated senses in actions that leave us with deep visual associations that pre-date language. When language develops, it too begins by being centred on what doesn't change – concepts such as 'mother' or 'chair', for example, imply constancy. Since children learn to identify a chair within many different types of form, conceptual categories are identified that are altogether separate from form. Only later are descriptions of actions or change such as 'fall down' or 'all gone' added to them. And then, these descriptions of actions are, in themselves, constant. Informed by continually changing images from our eyes, language feeds these identities and categories back to them to create a powerful dynamic that allows us to make increasingly complex distinctions between the many forms that come into our vision, to identify the constants within transience. The delight children take in naming things is indicative of this close interconnection and its place in our development.

When children begin to draw they start by matching simple shapes to these concepts – a cup is drawn by adding up all the features that it is known to have, rather than how it looks in any single position. Those who continue to draw are likely to consider the situation as well as the constant features of the cup, integrating the perceptual and conceptual thought processes.

This enlarged cognitive process is the one through which we experience and understand the world. It depends on our constantly making assumptions about and ordering the situations we encounter. The fact that so much of this information persists when our eyes are closed, in daydream and dream, suggests that the visual perceptual system continues to organise and connect up experience outside conscious thought.

above **HORSE'S HEAD**
Cassis, France

This cave image bears an interesting resemblance to the child's drawing opposite, relying, as it does, on the most typical aspect of the image. But the artist has combined acute observational abilities with his knowledge in creating the beautifully realised image.

Ellsworth Kelly
BRIAR 1963

Kelly, a minimalist artist, made many drawings in which he analysed living form in terms of simple linear shapes, which convey both the fluidity with which they were made, and his intense response to natural growth. The simplicity of the drawing amplifies the sense of incisiveness.

Draw both natural and manmade objects at various speeds – as simply as possible.

More than anything else, understanding involves both collecting and selecting from vast amounts of information. Drawing combines both of these activities in a direct visual-making process. It has been called the art of the conjurer; a few strokes make us 'see'. As with writing, the procedure for drawing is a highly integrated one. When we draw from our head or make a plan, our eye, our hand and the paper form a unified system. Even when we draw from observation, the action of eye from object to page is extremely rapid, so much so that the processes of observation and notation seem almost simultaneous. Drawing tools are generally simple scoring or marking implements. Some, such as pencils or pens, have the potential for mark in them; brushes or quill pens used with ink and water are primed or charged easily. The image can be made quickly and appears as we make it.

All our other image-making processes are indirect by comparison. Although photography is initially quicker, the results cannot be seen during the event. All of us who have taken photographs know how many times we have missed 'it' – that element that summed up the event – and the hundreds of photographs taken by professionals in order to come up with the one expressive shot are proof of photography's problems as a recording device. Painting, too, is comparatively indirect because of the amount of time spent making complex visual decisions on the surface of the palette, which directly involves neither subject nor image.

The possibility of getting something down quickly through drawing has determined its uses as a recording device, but I think also confers on drawings their sense of fact. At the centre of the need to describe in such a direct manner lies a necessary open-mindedness. Drawings lack guile, if you will, and are, accordingly, generally believable. For this reason, they are not only an essential recording tool, but drawing is one of the most personal and private of visual activities – one in which we can be honest with ourselves.

If the directness of drawings provides us with an ideal means for gathering information, their innate simplicity forces us drastically to reduce what we see to its essentials, selecting carefully from it in order to make some kind of equivalent. This simplicity is important. The early splitting off of drawn forms from all but the most schematic colour arrangements suggests that assessments of placement and form are disturbed, and are even disrupted, by complex colour associations.

Since drawings are made up of only line, mark and tone, they are unable to suggest the possibility of mimicry in the same way as photographs or paintings can. This gulf between physical fact and descriptive means forces both artist and viewer to engage imaginatively with what are obvious pictorial codes.

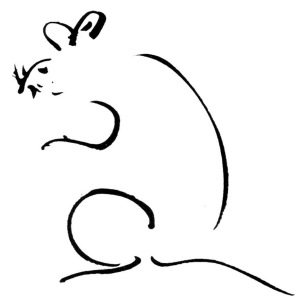

above **Sochu Suzuki**
MOUSE c. 1980

This quick brush drawing by a Zen monk and calligrapher is a classic example of the use of the brush in Japanese art to suggest form with minimal means. It also illustrates the human and humorous approach that Japanese artists have to animals and nature.

below **Philip Guston**
TWO HEADS 1968

In the 1960s, Guston used drawing as a means for making a radical change in his work. The drawings were simple and cartoon-like, owing much to the comic strips of the time. In them, he depicted the ordinary stuff of his everyday life along with politically related images, and combined them in a vast, desert-like American landscape. In this drawing, two Klu Klux Klansmen have taken on a mountainous solidity.

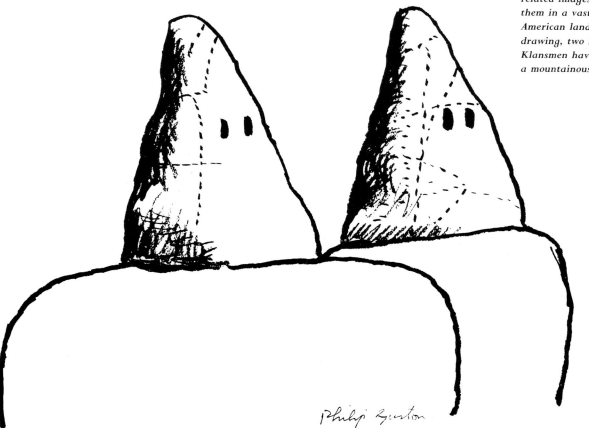

The ways in which we use drawing have altered completely with the availability of materials that are easy to use, starting with the invention of the pencil in the seventeenth century. Following such advances, drawing changed from a very specialised activity to one that has come to be used both for defined professional reasons and as a 'companion' activity available to everyone as an aid to observation and thought. Today, anyone who draws is likely to do so for a variety of specific reasons, as well as for some fairly undefined ones – to look, to store information or just to arrange things. The many forms that drawings take follow from these various intentions, and range from highly developed 'presentation' drawings and works of art in themselves, through compositional or construction plans, to studies, sketchbook drawings, jottings of odd observations and automatic drawings or doodles.

The intention within the work determines not only its surface form – its size, materials and pictorial conventions – but also its reference points for depiction – the degree to which our purposes prompt us to focus on our experience of the world outside, or our knowledge of it inside the mind.

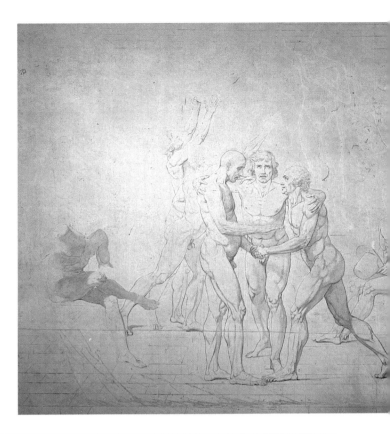

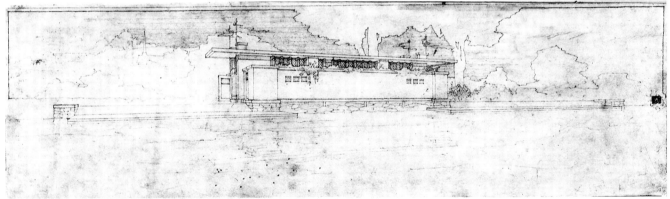

left **Karen Bowen**
AUTOMATIC DRAWING 1992

The sort of complicated pattern, built up with no set plan or purpose, that many of us start to make while we are only half involved in what we are doing, and which becomes a consuming visual game.

above **Frank Lloyd Wright**
Design for the **YAHARA BOAT CLUB 1905**

This is a presentation drawing – the architect's means of convincing his client that this is the way the as yet unbuilt house will look in its environment.

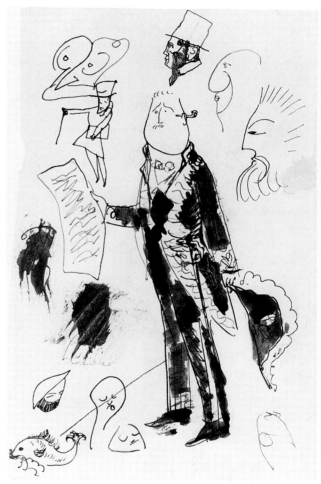

'Perceptual drawing' is directed outwards. It informs our response to new experience. But we also investigate the essential relationships that underlie experience through 'conceptual drawing'. In order to project forwards we can reconstruct and visualise the world from past experience. A further concern, with memory, fantasy, or with archetypal form, may lead us to make internally directed drawings, deliberately divorced from direct outside information.

Any of the above activities involves an act of radical transformation, or to put it another way, we could say that every drawing contains a strategy for seeing, as well as a 'grammar'. One of the most important features of drawing as an activity is the freedom with which one can move from one strategy to another in attempting to make sense of what is being described. We can easily see in the sketchbooks of artists and others the turning around and development of central ideas and images through series of drawn variations.

Some drawings mask the active processes of change by which they are made; others, such as studies and plans, make them obvious. But the invention and speculation within all of these processes are aimed at establishing the essentials of what is drawn. It is this definition of essentials that is the basic characteristic of drawing, and that forms the drawing skeleton that exists within other kinds of work.

above left **Jacques Louis David**
THE OATH OF THE TENNIS
COURT, 20 JUNE 1789
1791-1792

This drawing was made to give a classical understructure to the painting of an historical event. The final figures were to be clothed portraits.

above **Pablo Picasso**
CARICATURE OF GUILLAUME
APOLLINAIRE AS
ACADEMICIAN 1905

A sketchbook page in which Picasso amuses himself with one of his favourite games, making fun of his friends.

GAMES FOR
DETERMINING SIZE

GAME ONE
• Measure the room you have chosen as accurately as you can, either by truly measuring it, or by pacing it, working out the relation of heights to widths of walls and the sizes of the things in it.
• Make a floor plan and 'elevation' drawings of the walls, and place the furniture in the room wherever it best fits. Note your eye height in the room. As you pace the room, look at it from the positions in it that you do not usually occupy.
• Handle the objects you have chosen and measure them. Make some notational drawings on which you can clearly indicate their dimensions.

GAME TWO
• Sit in front of a mirror and measure your head in it by drawing a vertical ruled line down the middle of the reflected image of your face, and a horizontal one across it at the height of your eyes.
• Close one eye and mark the positions of all your features – the top of your head and your chin, and the outer edges of your cheeks and ears – in relation to these lines.

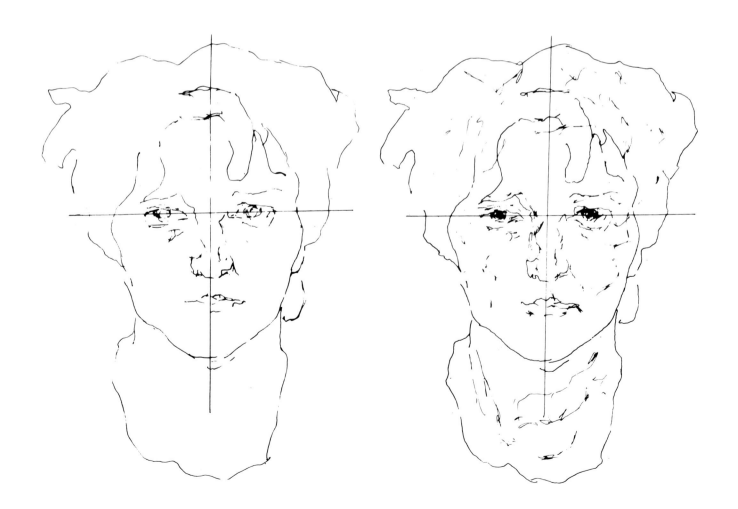

• Transfer these marks from the mirror onto a piece of tracing paper, but complete your drawing on the mirror. In order to keep yourself and your image in place, draw one ear, the opposite eye, and the bottom of your nose. Then draw in all your features.

• When you finish, re-draw this whole drawing onto a second piece of tracing paper. Now return to the first tracing, and use the marks on the first piece of paper as the basis for another drawing. Do this on the paper, while looking in the mirror. Compare the two drawings.

Sadie Tomlinson
MIRROR SELF-PORTRAITS
1992

The various versions of a portrait made from a mirror image are shown.
Far left: The tracing of the original image made in the mirror, showing the head held in place by the vertical and horizontal guidelines. The artist chose to draw a complete outline at this stage, though some single features would have sufficed.
Centre left: A tracing of the drawing as it was developed on the mirror. The drawing makes clear how little can be understood from facial features on their own, and how important the underlying structure of the form is to any description.
Left: The drawing is shown full size, after it has been developed on paper from the first traced mirror image. The eyes have been developed more structurally, the hair and supporting forms of neck and shoulders have become more definite. The shape of the chin has been clarified, and the description of the facial structure has shifted to the other side of the face, and is now described as a continual change in plane from chin to forehead.

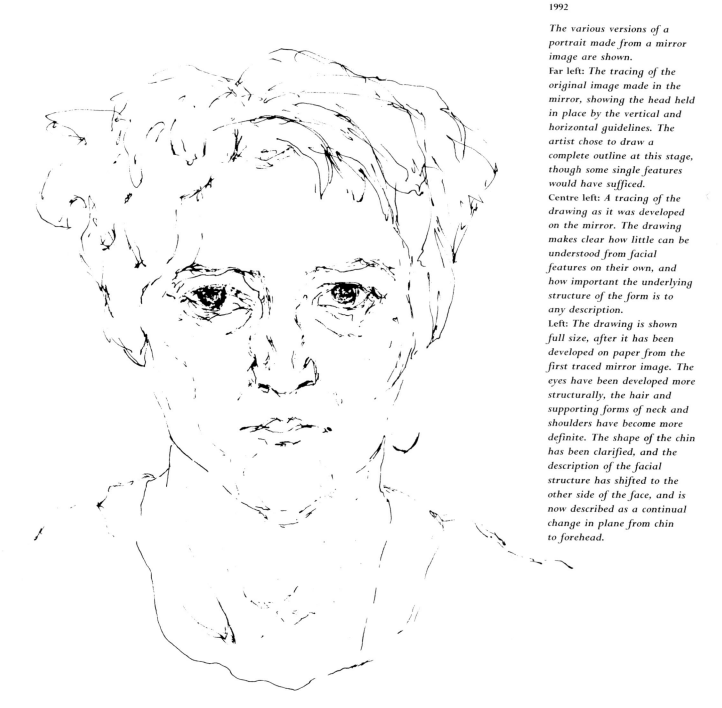

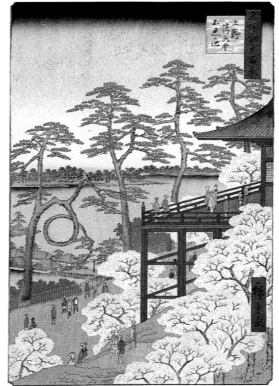

left **Hiroshige**
KIYOMIZU HALL AND SHINOBAZO POND AT UENO from One Hundred Famous Views of Edo **1856**

The scene is organised spatially around a single diagonal corridor that recedes into the picture from the lower left. This is reinforced in the alternating planes of natural and geometric form along it.

below **Pablo Picasso**
FOUR DANCERS 1925

This drawing hovers between two readings, as a volume of a group of bodies, and as a two-dimensional linear description on its own. The two dancers in front are drawn in a way that encourages us to follow the description back and forth from one body to the other. The other dancers are set away from them by virtue of their linear disconnection.

above **TWO OPTICAL PUZZLES**

Simple configurations can help us identify the clues we use when we see. In the top one, we extract possible objects from patterns of light and dark. The lower one relies on our identification of objects from their individual features. The discrepancies within this impossible form cannot be resolved – first we see one form, and then the other, depending on where we look.

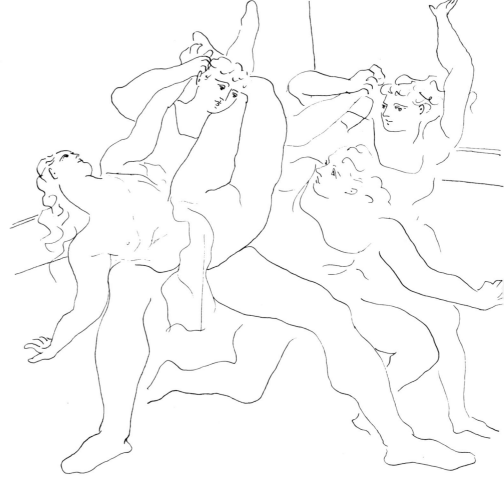

CHAPTER 1
ACTIVE SEEING

We do not see only with our eyes. Seeing is a highly active process that takes up a large portion of our brain. The retina at the back of the eye is an integral part of the brain. The image that we see is not the two-dimensional light image received upside-down and backwards on it, but the one that our brain has turned back into a three-dimensional model of our surroundings. We cannot separate the light image received on the eye from the way we enhance some of its features to make it clearer, or what we know from experience, or even emotional involvement, from the seeing process itself. We arrive at the image we see by entertaining many possibilities for what we are confronted with, and choosing the most probable. These decisions are unconscious, and really only rise to the conscious level in situations when it is difficult to see and we are obviously speculating, such as during poor visibility, or when we are confused.

The fertility of imagination with which we arrive at our seen images is exemplified in the strange images experienced when the 'normal' perceptual combination is upset. Stroke victims sometimes see confused images such as whole clock faces with all the numbers crowded onto one side. Russian psychologist A.R. Luria recounts the case of a soldier who, having lost the parietal lobe on the left side of his brain, could not see the right half of his body in a mirror, although his eyesight was unimpaired.

When we draw what we see, we are drawing our three-dimensional model of our surroundings. We turn this back again into a two-dimensional form that includes the clues to solidity and space that we use when we see. In the seeing process, we speculate in order to survive; in the drawing process, we speculate in order to understand. By bringing the dynamics of sight into the realm of the conscious, drawings help us to understand not only what we see, but how we see. That understanding, in turn, helps us to draw.

André Hermond
PIN-UP 1943-44

The classic pin-up pose combines different views of the figure to emphasise its most potent features: the seated/kneeling silhouette is arched back and turned so that shoulders and breasts can be clearly seen, and the face is turned to look towards us.

EYE AND BRAIN

A simplified description of the integrated system of the eye and brain may suggest the complexity of the seeing process. The light receptors on the retinal surface of the eye number many millions, each responsive to different qualities of the light transmitted through the lens. They consist of cone and rod cells, named for their shapes. The cones are responsive to colour, the rods to tonal value and low levels of light. These cells are distributed unevenly across the retina, packed more densely in a middle area of high focus called the fovea. They are connected through intermediary cells in the retina to the ends of long cells (ganglions) that are extensions of the brain itself, attached by fibres (axons) that run in the optic nerve to carry impulses from the eye to the visual cortex at the back of the brain.

The impulses from each eye divide on the way: those from the right-hand side of the visual field going to the left cerebral hemisphere, those from the left of the field, to the right. Messages from the central area of focus appear in both hemispheres. At this stage there are about a million ganglions from each eye connecting to around one hundred million

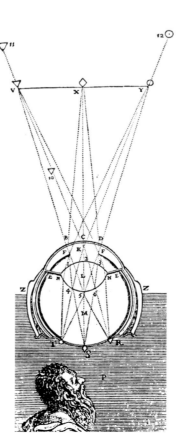

THE OPTICAL SYSTEM OF THE EYE 1637

This illustration, from René Descartes's treatise on vision, of an experiment by Christopher Schiner in 1625, demonstrates the way in which the lens of the eye throws an inverted image onto the retina. Natural scientists and philosophers, such as Descartes, investigated vision as the central feature of the New World view of the sciences. Descartes's many writings on the subject remain relevant to the theories that surround the investigation of the nature of perception today.

cells in the cortex. Each ganglion cell delivers its message to a particular part of the surface of the cortex, so that responses that originated in adjacent areas of the retina are delivered close to each other on the cortex surface. Though this spatial arrangement bears some relation to the original retinal image, it is neither a likeness of it, nor a 'picture' of it in the brain. This topographic arrangement is a kind of image map, made up of the million neural particles whose characteristics and patterns are to be analysed and restructured.

Science seems to be at a threshold of knowledge about what happens in the cortex. The image messages delivered across its surface map are analysed not only spatially, but in 'columns' of cells that go down below the surface to determine their different attributes and connect to memory and recognition.

Ideas about how images are built by this system still remain highly conjectural. The process is being pieced together – rather like the fragmented image we have been considering – from many different disciplines, using experiments that explore the responses to visual stimuli in human and animal brains down to the level of the single cell, tests that examine the kind of visual hypotheses made in reassembling these into complex images, and computational models of brain structures.

From these emerges a picture that describes cells at all stages of the visual process that have a response only to one very particular feature of the neural particle they are in contact with, for example to its brightness, or orientation to the vertical. There are many varieties of single-cell response; if some respond to a single part of the image, others are 'fired' by entire complex forms such as a human image or a situation, for example movement to the right. The multiple connections between the many 'feature detectors' and 'filters' of the same section of the brain, and to other sections, allow the features of images to be recombined according to new principles. Psychologists refer to the recognition of contours, constants or 'common fate' as the basis for attributing characteristics such as edge, volume or continuity to what is seen.

These built-up images persist as each successive eye movement across the visual field supplants one set of messages with another one related to it. Any description, however short, lengthens and distorts the rapid nature of this translation of images of light into spaces, objects and relationships, and the continuity of its changing images, reconstructions and hypotheses.

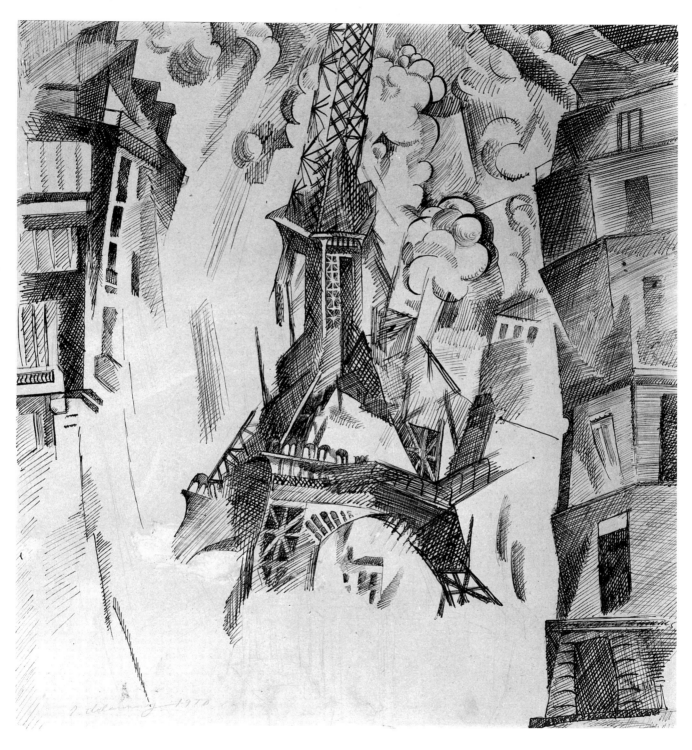

Robert Delaunay
EIFFEL TOWER 1910

*This drawing suggests, more than an
image from any single viewpoint, the
way in which we construct our images
by piecing together the fragments
that we see.*

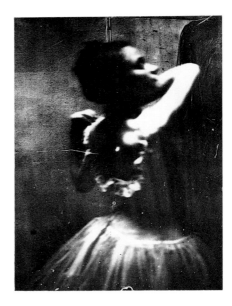

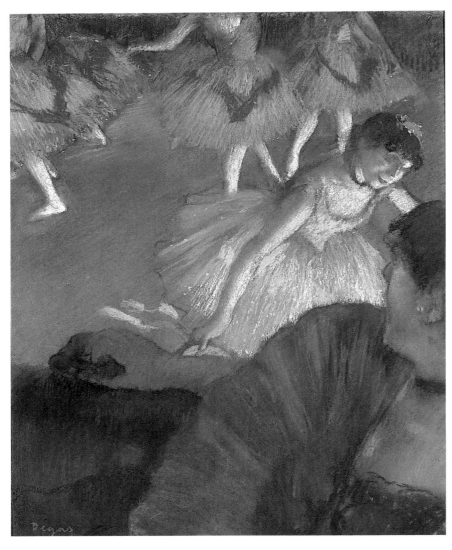

right **Edgar Degas**
BALLERINA AND LADY WITH FAN c. 1885

Degas was one of many artists who took up the new possibilities for pictorial organisation offered by the camera. In this drawing, the angle downwards and the framing of the image – the half-seen foreground figure, the dancers who disappear off the top of the picture – indicate the radical new devices that this vision offered. Degas took photographs himself, both in aid of his analysis and as an expressive medium on their own. The photograph, c. 1895, is possibly one of his.

CAMERA VISION

The eye is constructed like a camera, having a lens that takes in light patterns from the environment and transmits them upside-down and backwards onto the sensitive surface of the retina. Like that of a camera, the lens transmits different strengths and frequencies of light, and focuses at different depths of field. The iris, or aperture, opens up to account for different light situations, and the light-sensitive plate of the retina receives a two-dimensional image.

We can, however, make too much of the eye/camera similarity. Even if we discount the fact that we have two eyes and use them in motion together, the camera and eye differ in ways that make strict parallels impossible. The image on the retina is two dimensional, but curved, for example, and the retina itself is not just a passive light receiver. Our eye gives us a much larger visual field, and a relatively high level of focal resolution, but can only bring into focus a part of the field at any one time. It is simple to test the whole visual field by staring straight ahead with both arms stretched out at your sides and bringing both hands slowly towards the centre of vision. They can be seen when they are almost 180° apart, generally focused when they are 80° apart, but only sharply focused when they are quite close together in the area of dense focus.

A clear visual picture of this field can only be built up by the eye moving around within the area, focusing on each small part of it in turn, adjusting to varying local light levels, more like a video camera than a stationary one. Since each of these successive bombardments of the nervous system at the back of the eye must supplant the previous one, we are obviously engaged in the accumulation of experience.

The study of the eye has been important to both artists and scientists: Leonardo made many speculative drawings of the eye almost a century before Johann Kepler described the camera-like workings of its lens and retina in 1604. Earlier experiments into the properties of light had established that a pinhole in one surface of a darkened space would admit an image through it to appear inverted on a surface behind. The *camera obscura* developed from these findings, and was already in use in the sixteenth century. With the addition of lens and mirrors to turn the image right-side up, it continued to be an important tool in resolving the many questions of spatial representation that followed from the desire of scientists and artists to understand vision. Many kinds of these optical devices were developed and used by artists. However, their projections had to be interpreted through drawing in order to produce a still image. After three centuries of experimentation, the invention in the 1830s of a means to fix the image, produced the first visually uninterpreted permanent fact – indiscriminate and neutral.

In the beginning, that image had to be made slowly, but only a few decades after the first photographs, the camera became relatively quick, and in the hands of photographers such as Eadweard Muybridge (see p 140), began to resolve hitherto unprovable speculation about the way humans and animals move. As the camera became reasonably transportable it could be taken into increasingly unlikely situations to confirm how unpredictable visual experience could be before being encoded by the stabilising elements of the brain. The verification photographs granted to the unexpected produced a revolution in our understanding. Odd angles and positions, or the blurred image of recorded movement have strongly influenced pictorial description since then. Nevertheless, the fact that the camera plate is rectangular, with defined edges, has meant that photographs have been closer to the pictorial tradition of art than the amorphous field of vision of the eye.

Artists who ally themselves to camera vision most often do so to the pictorial aspects of the camera image – still, tonal images, with tension at the edges as the world moves 'out of frame', with odd angles and scale relationships, and with stopped or blurred action. In our mind, camera vision is allied to the original light image received by the eye, and photographic drawings are usually made up of continuous tone – suppressing any obvious marks or lines that might draw attention to the surface. Drawings that unify the forms within our visual field without placing them in an order of importance, make reference to the neutral 'scan' of the visual field we ascribe to the photographic eye. But drawings also isolate other features of the eye's camera vision. The edges of drawn forms are often made up of more than one contour line, as if the artist is incorporating the images from both eyes. The all-over focus of many of the images we might classify as realistic bears relationship to the way in which we focus around the visual field one part at a time. The simplest drawings focus on their subjects within loosely described larger fields, much as the eye does in any of its local shifts.

Charles Sheeler
FELINE FELICITY 1934

This drawing was made from a photograph, and refers directly to its photographic genesis in its evenly handled tonal surface. The setting of the space, slightly off the vertical of the page, suggests a situation 'caught' as it might be through a camera lens, just as the structure created by the light falling on the open frame of the chair is stopped in time, as it can only be in photography.

Look through your viewer at part of the room you wish to draw.
Draw a rectangle in proportion to the viewer, and draw everything you can see in the viewer, right to its edges.

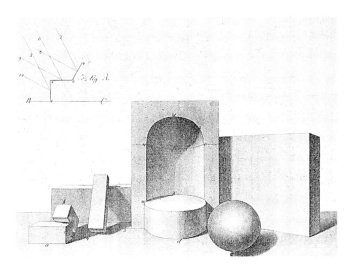

PERSPECTIVAL STUDY
from Peter Schmid's Das
Naturzeichnen 1828-32

*A study of the effect of a
single light source on simple
geometrical forms.*

OBJECTS AND MOVEMENT

To be effective, our eyes must first of all be able to
create objects and spaces out of light. In their jerky
movements around the visual field, the eyes alight on
the shapes around, and judgements are made about
what kind of solid form underlies them. This is done
'on the move'; even when we think of ourselves as
stationary, we are moving ever so slightly to supple-
ment the eyes' single image with other permutations.
The eyes, head and body are components of a system
designed for movement. When we move, the shapes
around us are changing at our every step, each image
a single planar version of its form. We slowly learn
from experience to make connections between the
permutations that seem linked and to construct the
'constants' of form they manifest. Concepts such as
'square' or 'cone' can be applied in many contexts.
We carry such categories in the mind, along with
innumerable situational clues to them.

A debate exists about whether or not these simple
forms, called primitives, pre-date learning and
are part of the brain's structure. Whatever their
physiological status, our ability to grasp the structural
features of the things we encounter relies on our
ability to organise their shapes into the most likely
clear forms.

Since we make and see objects using similar
constructs, it is not surprising that the buildings and
objects that surround us have basically definable
shapes; their usefulness relies on our ability to see
them and their functions clearly. But we apply simple
volumes to more amorphous natural situations as well,
breaking down even the most complex volumes into
component parts, seeing the cone within the moun-
tain. Some simple shapes – a figure, hand or square –
are immediately recognisable, but most shapes are
meaningless unless we can place structure on them or
determine their underlying form. This is an essential
feature of our understanding. In his novel *The Third
Policeman,* Flan O'Brien symbolises the hero's mental
hell by his inability to comprehend the shape of a
police station.

The 'constant' models we build exist outside any
single situation, and it is from this conceptual base
that we apply them. We might see an ellipse and think
'circle' in the same way we would correct our seen
image while watching a movie from the extreme end
of the front row. But the context in which any form
is viewed is important to the sense we make of it. In
pictorial description this is of paramount importance.
Any form depicted from a single position has an
ambiguity built into it that can only be resolved
by describing its context, as is easily seen in the
sequence of simple shapes on the facing page.

Light is the most important feature in recognising
volume. We rely on it to make sense of the solid form
within the outside shapes we see, and where objects
exist in relation to their surroundings. Shadows bind
together objects and spaces, and sometimes form quite
substantial shapes of their own. It is interesting,
however, that when the light situation presents us
with a confusing configuration of shadow and form
together, we are still likely to seek out the primitive
for the basic form, and we do not confuse objects
with their shadows.

We see objects in motion differently from the way
we see stationary ones. When our attention is directed
to a moving form in our visual field, the eyes focus on
and follow it in smooth patterns, unlike the jerky
ones we use to look at still objects. The moving object
is kept stationary in the eye, although within itself a
form such as a running figure will be changing at its
edges. Movement is signalled by the passing 'ground'
that is moving in the opposite direction to the eye, or
by the movement of the head. This followed shape is
impossible to stop at any single instant, and ways of
suggesting forms in motion have intrigued artists
through the centuries (see *Time and Movement,* p. 135).

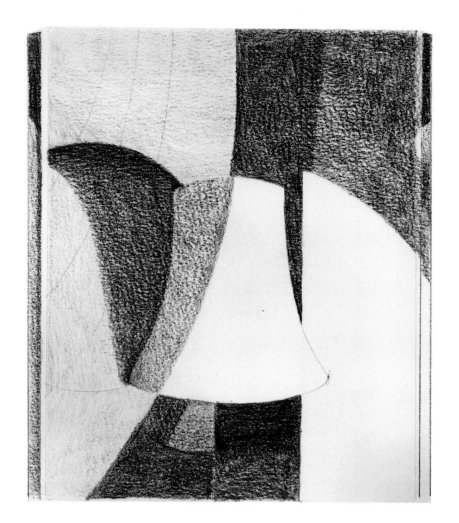

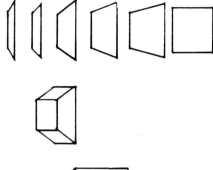

Draw a geometrical object a number of times, turning it slightly between each drawing.

above **Patrick Caulfield**
UNTITLED
from book of 32 drawings **1991**

This study of a lamp requires that we define the object and spatial relationships by making up possible different light sources. Nevertheless, we can still easily separate the object shape from its surroundings.

right **Joseph Piccillo**
EDGE EVENT XXVI 1982

The animal is depicted frozen for an instant in time. Such images are connected equally to poised Greek figures and action photography. However, the drawing also suggests movement through the form in rhythms of the body surface, and the wave patterns of the mane and tail.

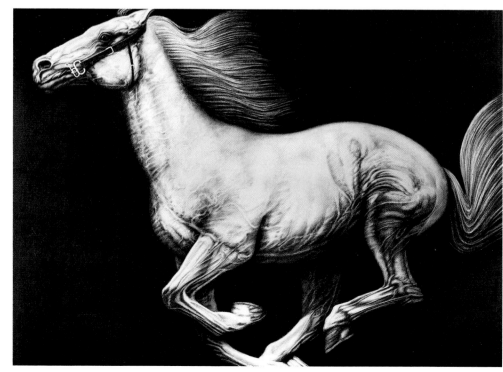

SPATIAL PERCEPTION AND REPRESENTATION

When we convert object-shapes into three-dimensional forms, we are initiating a process of spatial recognition. Our visual system is designed for spatial judgement. As we move fluidly through space, our body, head and eyes move together to take in a wide visual field, and the eyes focus stereoscopically as range finders to identify the solidity of forms and their distance from us. The angle of eye convergence itself delivers depth cues to the brain. During movement, the larger shapes, such as the walls of the space around us, are changing in the same way that smaller object-shapes do. We manage either to avoid or make contact with objects, and to orient ourselves to the changing surrounding space by assessing its hollow 'real' form in the same way we do the shapes it contains. While open spaces have boundaries dictated by the limits of our abilities to discern distance, spatial enclosures could more properly be considered as hollow objects drawn from inside.

There are numerous drawing approaches to the systematic construction of forms as they appear in spatial experience. Some of these systems are local and discontinuous, treating each object or enclosure in a different manner and placing them in a simple generalised larger space. Others are unified systems, which try to apply general rules to all of what is seen. There are many of these systems, evolved in different cultures, and for different purposes. They are directed at familiar geometries, within clear boundaries, and with a clear spatial axis.

Linear perspective is a unified system, developed from the increasingly sophisticated pictorial stratagems of the early Renaissance. Its invention is credited to one man, Filippo Brunelleschi, at the beginning of the fifteenth century. In paintings of the Baptistry and the Palazzo della Signoria (now known as the Palazzo Vecchio), both in Florence, he succeeded in organising a scheme for the regular recession of objects in pictorial space – appearing smaller in our vision as they are farther from us, receding up towards the horizon below our eye level, and down towards it if they are above us. These works created the illusion of the way space is seen to a degree not achieved before. They are certainly close to the basic spatial clues we use when we see. However, the illusion is limited to the subtle simplification of that narrow part of the visual field on which we can focus easily. The effect is that of looking through a surface at a space, rather than of being in one. Despite all the illusionistic scale

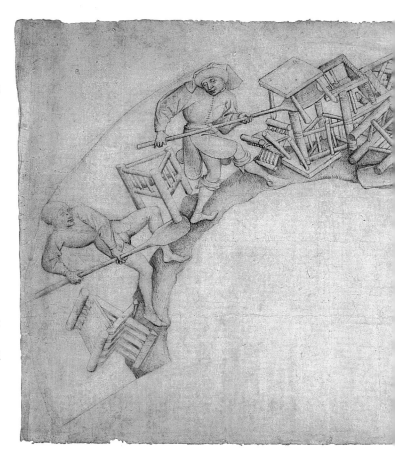

and architectural devices that have been used to connect perspective with actual space, it is the most fragile of illusions, since it can really only work from one viewing position.

Earlier discontinuous systems were eclipsed by this new vision, though in many ways their various viewing points suggested the way we move through spatial experience more strongly than any unified system can. Discontinuous systems have resurfaced periodically since then. Their multiple spatial corridors have been used much more than has linear perspective by artists of this century in their attempts to find descriptive devices for the ways in which we piece together our experience.

Spatial representation, then, is a matter of what we want to represent. The impossibility of drawing any actual space we are in with any single system can be demonstrated quite easily by attempting to draw a spatial container, such as a room. To test this, face the centre of a wall, holding a pencil or viewer in one hand. Line up the pencil, or the longest sighting line of the viewer, with the top edge of the wall, where it meets the ceiling. You can see that it is horizontal. Turn left or right, and match the pencil or viewer with the top edge of the wall where it meets the corner. You will see that it slopes away from the

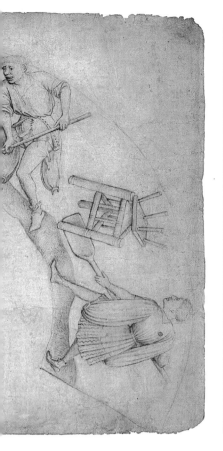

far left **Rogier van der Weyden (attributed)**
MEN SHOVELLING CHAIRS

The artist seems to be at the centre of the circle of the drawing, the action happening around him. The space suggested is one that starts from the focal point of the viewer and goes out in all directions, with no single disappearance point.

left **M.C. Escher**
First version of **HIGH AND LOW 1947**

The artist set up a single, seemingly logical, disappearance point at the centre of the picture, and then played games around its possible ambiguities. The view in the top half of the picture is seen as if from the sky down; in the bottom half, from the ground up.

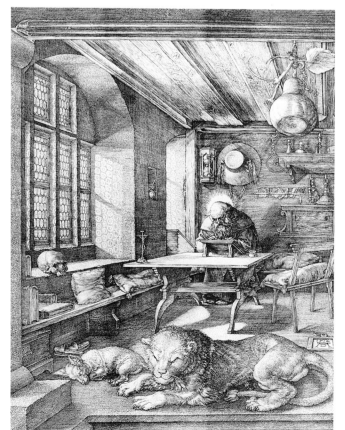

Albrecht Dürer
ST JEROME IN HIS STUDY 1514

Dürer was one of the great innovators in the use of perspective. The diagram next to the etching shows the features of the one-point system used in it for determining the recession of forms, and their depths.
(see Perspective, p. 144)

horizontal, forming an angle. Since the edge is continuous, it is forming a gradual curve. We can do a similar experiment, to test the verticality of the wall's edges with two pencils, holding one vertically at the centre of the wall and matching the other against its vertical corner. They will be tilted in relation to each other. Whichever pencil we concentrate our eyes on will seem to be the vertical, and the other, the tilted one. Why is this so? Our orientation obviously makes a difference, and suggests that we orient the centre of the space we are in to our own verticality, and that the axis we choose will be our principal reference point in drawing.

If we were to represent the wall, we would most likely draw our schema for the wall as we know it to be, with horizontal and vertical straight lines. In a pictorial sense, we would be moving our point of view back from the wall to represent it at a greater distance, where its straight edge is clear, and matches the mental 'picture' of walls that we have gained from experience. The visual paradox evident in the pencil tests emerged as a result of our attempt to draw out to the edges of our field of vision, and this paradox is increased when we orient ourselves to features that are sufficiently above or below us. At eye level, every vertical edge is seen as vertical, all horizontals as horizontal. Perspective systems aimed at the horizon accept all verticals and horizontals in this way. If we look either down or up to draw away from the horizon, no true vertical or horizontal reference exists and we must start making choices about them. Renaissance artists developed subtle variations to Brunelleschi's perspective system, in geometries with more than one vanishing point, as well as curvilinear systems, to address such anomalies. Various systems for spatial representation can deal with different orientations within experience (see *Perspective,* p. 144), but no single system, no matter how unified, can ever be more than local.

SPATIAL AXES AND PLANES

I once had an experience that made it clear to me what it is like to sense a change in one's basic orientation to the earth, when I had the opportunity to view the Rift Valley in East Africa from the Ngong Hills. It is vast and very flat, and the hill on which I stood allowed an uninterrupted view of it on three sides. It was the first time I had ever seen the curve of the earth while actually standing on it, rather than from an aeroplane. Each time I turned to see a new part of the plain, the horizon tilted, and I found myself shifting mentally, even, I felt, physically. The effect was profoundly disorienting, although my companion, who had seen the space before, wasn't affected. Since we spend much of our lives in bed, slouched in chairs or falling forward to walk, one would have thought that such small shifts could not matter. But verticality and horizontality are powerful visual references. The most fundamental early art device was the base line, which set the orientation of the action to the ground. Children regularly make use of this device when they draw, as well as of the sky line, which defines the top of the living space in between. In drawings of receding forms, the recessional angles are held in place by the vertical edges

Rackstraw Downes
VIEW OF THE WASHINGTON BRIDGE – BRONX SIDE 1983

This triptych creates a panoramic vista; the sweep of the visible space is suggested by the slowly curving horizon. The drawing is hinged on a cluster of buildings in the centre. The nearest buildings, at the right, are visually separated from those in the distance by the highways that shoot from the foreground into the deep space, but that also function as artificial horizons. The viewer is placed in the picture at the point at which the buildings are vertical, in the middle of the group of buildings on the right.

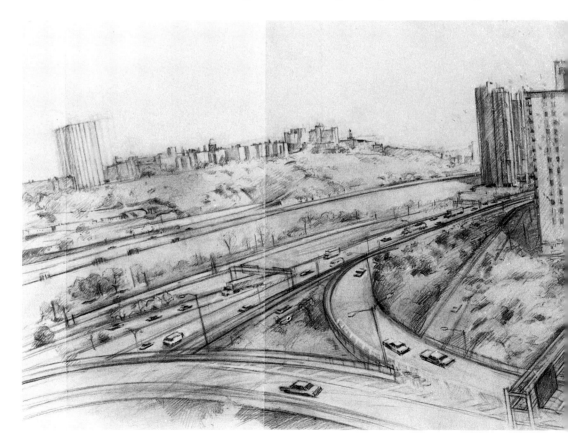

of forms and by horizontal planes of space. If these
disappear, the dynamic of the drawing immediately
becomes unstable, an instability that artists have used
to great advantage.

When we create pictures of deeper spaces, the
stability of the horizontal is the main referent. The
spatial clues we derive from stereoscopic vision are
not useful beyond the near distance, and our
assessment of parallax motion – the apparent change
in the position of an object resulting from a change
in the position from which it is viewed – is not useful
past the mid-distance. Only atmospheric conditions
give clues to farther distances at ground level. Objects
in deep space, such as the sun, cannot really be seen
as having any specific distance at all.

We divide pictorial distance into the equivalent
of our three distancing mechanisms and their thresh-
olds – foreground, middle ground and background.
These are most often constructed as separate planes.
Again, the horizontal/vertical systems are almost
universally applied; if any of the three planes is not
horizontal, it is usually the closest, set against the
stabilising larger world. Even when pictures contain
no horizon line, there is often an unstated horizon in
the counterbalancing of forms, and finally in the edge
of the picture itself.

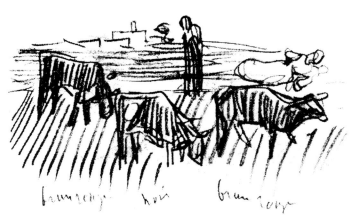

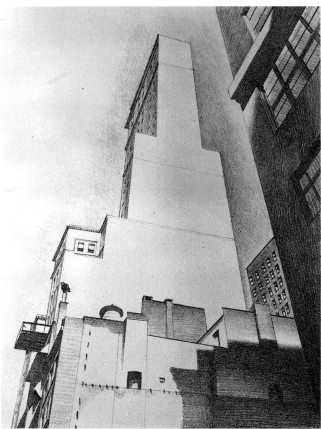

top **Vincent van Gogh
COWS IN A MEADOW** from an
Auvers sketchbook **1890**

*Van Gogh set up two distinct
planes, and with a few quick
lines, suggests the depth of
the far horizon from the
foreground figure and
animals.*

above **Charles Sheeler
DELMONICO BUILDING 1926**

*Sheeler depicted the most
common of experiences in the
city – that of looking up at
things. Focused away from
the horizon, the drawing has
no obvious horizontal or
vertical reference points. The
buildings are receding away
from us in three directions.
We orient ourselves to the
only vertical corner.*

SIZE AND DISTANCE

Since we know that things appear smaller as they recede in space, one of the simplest clues to their distance from us is their relative size. An object placed twice as far from us as another of the same size will appear half its size to our eye. This poses something of a mystery to children who initially believe that objects are actually getting smaller as they recede. Equally, our knowledge of the actual sizes of familiar objects can inhibit our ability to recognise their change in size as they recede. You can see this if you hold your hands out in front of you – one twice as far from your eyes as the other. Their difference in size will be evident if they overlap, but if they are held apart from each other at these same distances, they will both seem to be 'hand sized'. Nevertheless, we learn to make quite accurate scaling calculations of the relative distances of similar objects, or even for dissimilar ones, if we know their true sizes. But when we try to ascertain the size and distance of forms that are either not similar, or are unfamiliar, we generally weigh up probable distance clues to size, or size clues to distance.

In pictures, size often functions practically on its own to establish distance. We assign places in space to recognisable forms, such as figures, to suit what we know about their sizes, but if even a minimally drawn spatial description appears, it becomes the standard by which their sizes are judged. There are some spatial inferences we accept almost automatically that make some positional relationships more easily seen than others. A smaller form placed higher up on the page than a larger one, will be seen as farther from the eye without any other description. If, on the other hand, the higher form is made larger, this becomes less probable. The problem becomes more complicated when we want to suggest a divergence from the norm. In our lives, we have so many examples to use as comparisons that people are described as being tall or short without any particular heights being attached to them. In drawing, this has to be stated with comparative examples, but size must be clearly established in relation to distance and surroundings in order for us to be able to judge it.

When I was a child, I saw numerous representations of David and Goliath. The two figures were sometimes shown in the same plane, the clearest way of describing their difference in size. But David, the hero, was usually depicted in the foreground. The arrangement seemed natural, since I was being encouraged to identify with him; but I have more recently come to consider that this was the best way to depict just

below **SPIDER-MAN** 1992

The dramatic spatial construction in this typical comic-strip image is given a focus in the size differences between the two figures. Note that the web Spider-Man holds acts as an artificial aid to the perspective to accentuate the distance of the small figure.

bottom **AVALOKITESVARA AS GUIDE OF SOULS** 10th century

In this Chinese banner painting, size is used as the sole clue to spatial depth. It is also being used to depict the relative importance of the figures.

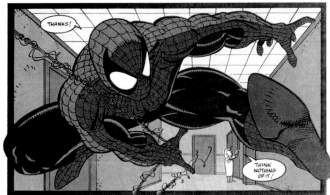

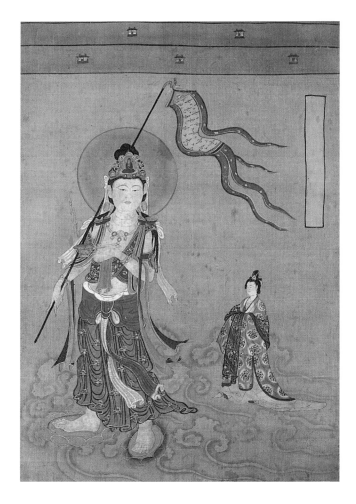

how big Goliath was. Any figure in the foreground could be big, but only a Goliath could be big in the background.

Pictorially, size is related to importance. We are likely to automatically make the features of a face, for instance, large in relation to the top of the head. More related to emotion are questions of how one indicates feeling small in the world, or hugeness on its own. The page surface itself is, finally, our pictorial world, and puny or huge can be clearly stated only in relation to it.

In addition to size differences, overlap, or the occlusion of one thing by another, is the other most basic feature of our vision. When we recognise forms, from the fragments of those we see, we must do so by making educated perceptual guesses, creating two or more forms by pulling apart the confusing compound image that confronts us.

The young child learns early in life to separate mother and father from what may be visually one form with two heads standing beside his or her bed. Knowledge, or depth perception, may allow us to do that, but when neither is adequate, we do so by making the assumption that the parts of a larger shape are more simply explained as incomplete separate shapes than they are in combination. The partially obscured forms are repaired in the mind's eye back into the whole shapes we think them to be, and we mentally make a space for them to exist in. Two things are being recognised: probable whole form, and the disruption of pattern, edge or volume that suggests separation. This act of completion involves a mental effort, and there seems to be some psychological tension in having to do this.

People for whom drawing has a magical function find incomplete images deeply unsettling. The ancient Egyptians did not depict overlapped figures until introduced to the concept by the Sumerians, and children invariably draw whole distinct forms.

In order to clarify these configurations pictorially, we have to make sure that the larger shape can be broken into constituent forms, and one shape must clearly be seen to disrupt another. Traditionally, artists have been concerned to keep these distinctions clear. In this century, they have just as often deliberately blurred them to exploit the ambiguous nature of images, deploying shared edges and adjacent voluminous shapes to flatten space. Others have heightened the effort required to pull apart the image, by placing, for example, the recognisable features of more than one person on a complex, flattened shape that then demands re-reading as a compound entity.

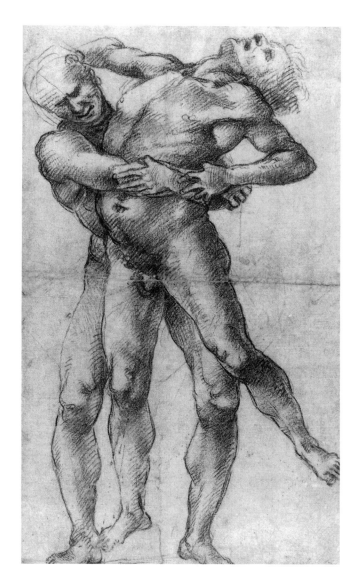

Luca Signorelli
HERCULES AND ANTAEUS

Signorelli created a complex overall form and, within it, made clear distinctions between the figures – note the opposition between the arch of the held figure and the arm and shoulder of the other – as well as linking them visually, as in the intertwined arms and continuous line from the leg of one figure to the shoulder of the other.

Moving objects around in relation to each other, measure their relative sizes and draw them in different positions.

GAMES FOR
CONSTRUCTING A SPACE

GAME ONE

The problem is to draw one wall and two corners of a room, including objects and furniture, in three connected drawings.

• Position yourself about 3 metres (10 feet) away from the centre of one wall.

• Draw the top and bottom of the wall, stopping well before the corners. Now draw the features and objects between you and this centre section of wall.

• Mark the height of the wall and the objects at the left edge of the drawing 2.5 cm (1 inch) from the right edge of another sheet of paper.

• Stay in place, but turn to face the left corner. Using the second sheet with its marks for scale, continue from the place where the first drawing stopped, and draw past the corner of the room, including all its objects. Use the viewer you have made to find the angles of the walls.

• Turn right to the other corner and repeat the procedure.

• Put the drawings next to each other. Note where they connect and contradict each other. They record your experience, rather than your knowledge, of the room.

GAME TWO

• Select three features that sum up the room – a spatial feature such as a window or fireplace, a favourite piece of furniture, and an object.

• In simple sketches, develop the possible relationships between the three in terms of relative size, possible overlap, and space.

Brendan Kelly
A ROOM IN THREE
DRAWINGS 1992

These drawings have been organised around the spatial well created by the light coming in through the window directly opposite. Since most of the surfaces directly facing the artist were unlit, the drawings developed through the tonal description of surfaces, and the emphasis of one against another. Notice the value relationship established between the nearest facing surface and the rug and bag on the floor behind, the handling of the light well between the counters, and the punctuation of the objects on the left. In the central drawing, the light of the window and the lit counter-tops contain a dark spatial box. On the left, the activity of lit against unlit surface is more dramatic. The simplicity of the right-hand wall provides a foil for the other more active ones. The door – ajar – offers its unlit edge to echo the others in the picture. The three drawings together establish clearly that the axis of the drawing is down towards the floor, and that the space expands from the floor to eye level. If we view each drawing separately, we can see that each has been readjusted to be vertical on the page. But in order to fit them together with some logic (the back counter has been made consistent), they must be fanned out, as the space is. Even then we can see anomalies, such as the evident change in direction of the counter in the foreground, or the curving edge of the fridge.

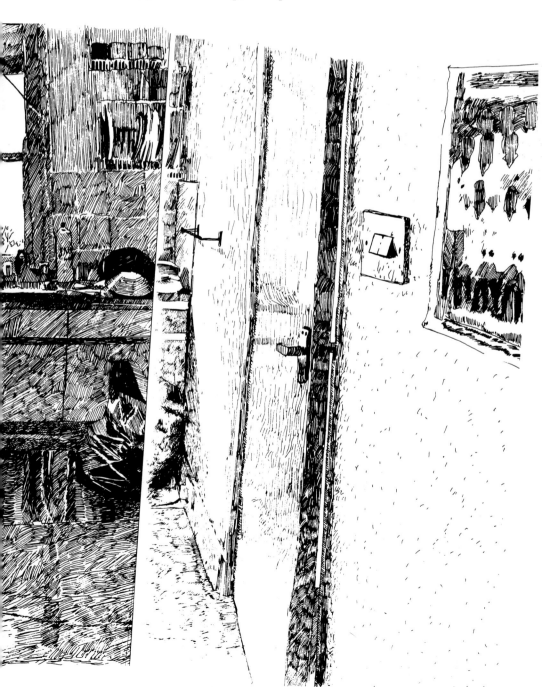

left **LINE AND EDGE DIAGRAMS**

The two diagrams indicate the degree to which we can find continuous edges or lines from partial information. The photograph and computer image of it (right) demonstrate the way in which computers programmed to find edges use them to turn indeterminate tones into solid areas.

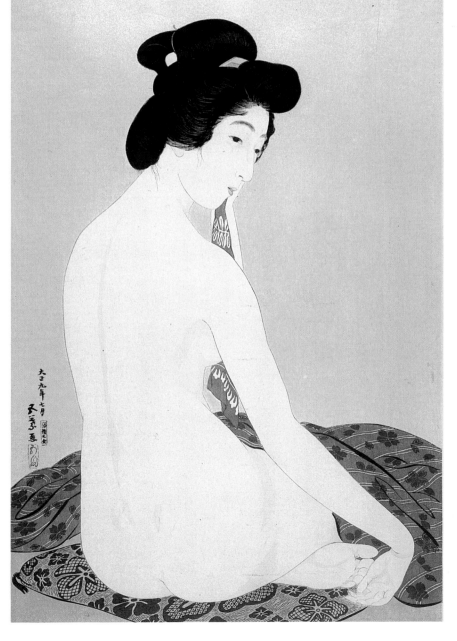

left **Goyo Hashiguchi WOMAN AFTER THE BATH 1920**

In this work, the artist utilised the edge as a container, but he also created with it an avenue for us to follow, and used its languid pace to evoke the sensuous quality of the subject.

Do a line drawing of objects using a pen without taking it off the page during the drawing.
Then draw only the essential edges of the objects.

Henri Matisse
NUDE, LEG CROSSED, STUDY OF LEGS
1925

Any reading of this drawing depends on our ability to see the line on its own as an edge, and to make solid forms by filling in the spaces between to make enclosures.

EDGES

Many of the line drawings that dominate this book, and the linear graphing of perspective spaces and objects that are used universally to 'put things in place', denote only the edges of the spaces and objects we portray. This seems the most natural method for describing form, since we identify objects by their boundaries. From childhood on, linear edge description is the most common form of representation. Even in tonal drawings, more often than not, careful distinctions are made between, for example, the edges of objects and their shadows.

Edges do not exist in the patterns of light and shade that come into our eye; they must be inferred. But since light often changes abruptly at the edges of things, some simple connections can be made between the two. In some situations this is easy, in others, less so. Edges cross different grounds and change value or colour themselves, and they are sometimes lost, virtually indistinguishable from the ground. Nevertheless, our need to identify objects is extremely strong, and drives our visual need to find their boundaries. The seeing process is set up to do just this, with cells that specially 'notice' or 'enhance' relational changes in light, and are less active across a field than at the point at which it changes. This happens irrespective of the intensity of the change. Consequently, the meeting points of two fields quite close together in value

would be picked out, in the same way as those at which black meets white. Since edges are continuous, the system has to search out connections in these heightened responses to change. Any pattern of these connections creates a cognitive 'line'.

Configurations that have simple, clear patterns are strongly reinforced as likely edges. But even if the pattern is discontinuous and crosses a field in which no edge information exists at all, we might propose one and complete it visually, using clues to where the 'object' is in any situation, at the expense of more obvious changes in value. We might, for example, visually follow or construct an object's edge within a shadowed area, even though the outside edge of the shadow is much more visible. We need only glance around to be convinced that we seek out the edges of objects and can follow them easily in the most complicated circumstances of object and surrounding form. The extreme to which camouflage must go to break down this ability is indicative of how strong it is.

In the seeing process, edges are enhanced and take on the quality of lines. Lines, however, are not edges, and are not always used to denote them. Rather, lines stand in visually for changes in the nature of things, at edges, or even on surfaces. As viewers, we see them as clear meeting points, or as containers, and tend to follow and construct them as we do in sight, by completing partial ones, and filling in edges to make solid forms.

FORCES AND FIELDS

The visual propositions such as completion or disruption that we entertain in order to recognise solid objects and spaces, raise a single question: how do we identify the 'forces' or positive elements in what is seen and distinguish them from those that act as a field for them?

In assessing our original light image, our perception that some shapes enclose or expand into others is directed to space and objects equally. Concepts such as expanding, contracting, surrounding, light or heavy give nuance to these relationships.

Our natural inclination to identify the solidity of objects is highly developed. Nevertheless, there are many situations in which a solid object is somehow seen to be negative, a container that makes the space around it suddenly seem, itself, more solid. We seem to find the meeting of two qualities in one object pleasing. Traditional craft objects, such as those shown, often combine expanding and containing forms.

In making two-dimensional representations, this interplay between space and object becomes most important, and the introduction of clues to see a form as positive or negative becomes a tool in the hands of the artist. Nowhere is this more true than in the most reduced black and white drawings, where the unused surface of the page automatically is a kind of space, but can equally be a form surrounded by the drawn black 'space' of space itself. Drawings inevitably play on and investigate this ambiguity, bringing us very close to the speculation that we use in seeing in order to complete whole forms. We play a game with the process of recognition, very close to the edge at which it operates. The unlocking of visual puzzles has great psychological impact: the harder the search, the stronger the sense of realisation.

However, there are times when we can't make up our minds about what we see. In some cultures this state is accorded a higher value than it is in others, where it might simply be termed confusion. It is induced in ceremonies through the use of masks that disrupt ordinary vision, such as those of the Northwest American Indians, which split the visual field of the wearer, having one vertical and one horizontal eye hole. Interestingly, these are designed in a way that suggests the yin/yang symbol of the East, with its equal force and field. The puzzles and double images that result from such evenly weighted forms and clues are invaluable to the study of perception and understanding, and intriguing even when they are reduced to the level of an intellectual game.

The development of all ideas involves some inversion of natural arguments and precepts in order to 'see' things from the other side. The natural order of object and field is one that can also be – and sometimes needs to be – turned around in order to facilitate the understanding of both forms. In drawing, the analysis of negative forms is integral to the establishing of positive ones, and 'drawing negative space' is used by virtually all artists in arriving at a higher level of understanding of what they are describing.

Salvador Dali
HEAD IN PROFILE

With equal clues to the possible positive and negative readings of the space, this drawing can be seen either as portrait head or twirling figure on a stage. But it cannot be seen both ways at the same time – we must switch back and forth between the two readings.

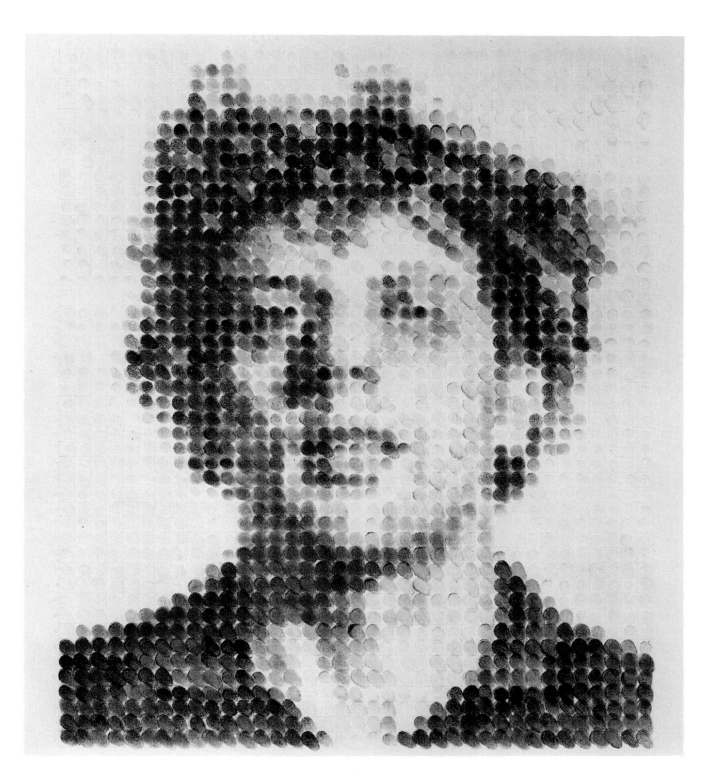

Chuck Close
PHIL/FINGERPRINT II 1978

In order to see the figure we have to be able to mass the lights and darks of the image together into an integrated whole. The white space of the page is read as a solid in one context, and as a space in another. Close made the marks so obvious that we are aware of the cognitive leap we must make in order for the image to appear.

Draw the same objects as before, concentrating on connecting them through light and dark. Try to keep objects and field in close balance.

Build up a drawing of a space by drawing the related forms and patterns in it — first horizontals, then similar angles, verticals, elipses, etc. Concentrate on these patterns.

above **Paul Klee**
SLIGHT DETERIORATION 1927

The maze-like structure recalls the experience and forms of the city. Its overall even pattern comprises many variations of shape and inter-val. We are led through the drawing by our successive recognitions of similar densities and patterns.

right **Zandra Rhodes**
AYERS ROCK 1973

The landscape image of the rock has been overlayed with patterns derived from the experience of it close up — rock forms, textures of surface — as well as others, such as heat rays, that suggest the conditions and drama of the experience.

above **Raphael Santi**
NUDE WARRIORS FIGHTING
FOR A STANDARD c. 1506-08

The varying weights of the lines emphasise the rhythmical nature of the event. Its tensions are described through the opposition of the figures on the far left to all the others, and especially accented in the figure at the centre-right, while connecting rhythms run through all the figures at the centre of the action.

right **Allen Jones**
Study for **CLINCH/PASO DOBLE**
1982

The artist made the two figures into one, and drew the rhythm of the dance onto the entwined bodies.

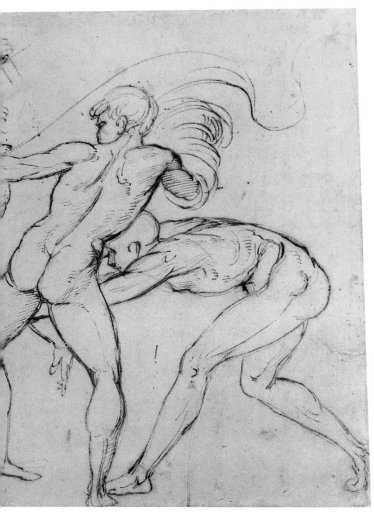

PATTERNS AND RHYTHMS

The potential for action in our visual field makes us acutely aware of any relation between forms and actions within it. At any one time, we may be identifying the possible relation or repetitions of shape or movement in different parts of our field of vision – similarities of direction, tensions of balance, and the rhythms of change that accompany our movement. We might come to accept a certain amount of visual randomness in life as 'normal', but there is a strong dynamic at work to spot possible relationships and connections. In experiments, even random dots are interpreted as forms or patterns. How would we feel, for example, if on entering a room everyone in it turned towards us, or moved left? We would be aware if only two or three people did so.

We are responsive to all patterns of repetition and rhythm, and recognise in them abstractions such as harmony, opposition, stasis and movement. Any recognisable repetition that appears in our field of vision is a kind of pattern. We spot like patterns in different parts of the field easily, though it seems that a single unchanging repetition on its own is visually intolerable. Visually it calls up what Sir Ernst Gombrich refers to as the 'et cetera principle' – since each part of it conveys absolutely no new information, we simply turn it off.

Visual rhythms are based on the more dynamic connections we make within or between forms, movements and actions. Our own physical experience of the world, from the natural rhythms of seasons to the way we move in space, establishes qualities we apply to conditions of being, movements or actions. When we first draw, we give special attention to the identification of things, but as we become more visually perceptive we are more likely to notice these visual dynamics or relationships as subjects in themselves. Artists speak of drawing 'through' form to find this continuity. The rhythms we find in drawings are the feature we identify most with the artist's deepest response to the situation.

When we see, we make larger connections between forms that may not be near each other at all. These identifications across space are our means of identifying relationships within events as scattered, or in opposition, or continuing. Over time, we internalise these patterns, and see in them symbols for relationships within our larger experience. They form the basis for the compositional arrangements we use to establish our symbolic pictorial world, and within it, the dynamic relation of one part of a picture to another.

top **Hans Meyer**
MI FORMO IN MONTE E MI
RITRASSE IN CARTE/NATURA
A CASO L'ARCIMBOLDO
AD ARTE early 17th century

*Our response to the image
relies on the visual pun – the
kind of connection we make in
everyday experience when we
notice that a thing looks like
something else. Unlike optical
illusions, both images can be
entertained at the same time.*

above **Salvador Dali**
Study for THE DREAM
c. 1931

*Dali used the free associations
made in dreams as a reference
for the double image – the
undulating forms of the shell
recall the waves, then the
wavy hair of the figure. The
water-borne shell becomes the
container for the succession
of associations that wash
over us.*

SPECULATING

Seeing involves a complex relationship of the
cognitive abilities developed over millions of years in
humans, reinforced by individual experience and
knowledge. Experience is essential to it. People who
have had their sight restored after blindness cannot
immediately 'see'. The relationship is not simply one
of 'seeing' and 'knowing'. There are physiological
responses in the process that operate in spite of what
we know. Optical illusions signal one thing even after
we know another to be true.

These responses may be developed or depressed
within different cultural contexts. For example, the
Zulus, who live in round houses and sow circular
fields, do not demonstrate the same ability to assess
angles that we do in our rectilinear culture. South
American forest dwellers have no experience of deep
space and see distant figures as small people.

In all visual situations, we are guessing and
speculating about the most probable solution based on
our experience. This guessing element is important to
us. If our system does not allow an element of doubt,
we would not be able to adapt to change, and when
the conditions of experience change quickly, this can
be a matter of survival. The rapidly increasing speeds
possible in this century have been the cause of
innumerable accidents based on our inability to credit
this novel situation visually. The introduction of small
foreign sports cars to American roads was followed by
a succession of accidents in which those involved
described seeing the car farther away than it was. It is
not that human beings cannot react to a totally new
experience – it is, in fact, debatable if such a thing as
a totally new experience exists. What is more likely is
that aberrant or odd features of what we see are
overlooked in favour of typical ones.

To counteract this, we keep the guessing element
alive in speculation, projecting sets of possible forms
onto visual clues by making unlikely references in
seeing games. The coat on the back of the door may
resemble a figure, or a cloud might look like a camel.
People in all societies have played such games. They
have all, for example, projected images onto the
constellations of the stars; the projections have been
completely different, depending on cultural reference.
Our Ursa Major or Great Bear is a scorpion in South
America, and a lobster somewhere else.

At the end of the nineteenth century a number of
astronomers discovered what they saw as straight lines
across the surface of Mars. These were to become
'canals' and an entire Martian civilisation was

constructed around them. Not until Mariner 1 flew by
the planet in 1965 was it proved that there were no
canals – or anything that could be constructed as
such. But when I grew up, not only was it generally
believed that there were canals on Mars, there were
also maps to prove it.

Such speculations keep us visually awake; they
give us room to manoeuvre. It is the same room to
manoeuvre that artists have fought for, as they
have fought hard to overturn their own pictorial
conventions. In doing so, they have won the right
to be able to see things differently.

Albrecht Dürer
CELESTIAL GLOBE, NORTHERN
HEMISPHERE

*The constellations were the
meeting place for scientists
and myth-makers.
Unapproachable, they became
the playground for the
integration of our most
rational and poetic impulses.*

front of us? Conversely, how do we manage to 'find' him or her in the many other people who are either much older, younger, shorter or taller, leaving us wondering how we could have made such obvious mistakes? Our seeing process operates on many different levels simultaneously. Our assessment of objects and spaces may be taking place at one level, while the assessment of the relative importance of activity within the space is being made at another, and the recognition of friends at yet another.

FLIGHT OF THE MASKED MAN
from the Tomb of the Augurs,
Tarquinia, Italy **c. 530 B.C.**

The placement of a figure onto a flat surface requires that the artist consider the most recognisable features of the image. The Etruscans inherited the classic arrangement for the figure from ancient Egypt. The legs, feet, hands and face are shown in their most clearly definable positions as silhouettes; the upper body is turned around so that the shape of the torso, shoulders narrowing to waist, is also clarified. Contemporary body cults are directed towards the display of a 'classical' physique. They depict the figure in positions related to classical art, turned towards an audience, so that essential features are evident. The weight-training advertisement, shown left, makes the important points – you, too, can have a narrow waist, large pectoral muscles and an arm that will support both a dumb-bell and a willing companion.

opposite right **Pablo Picasso**
THE ARTIST BEFORE
HIS CANVAS 1938

Picasso freely constructed the figure by combining profile and frontal images into a composite portrait of essential features. The method is comparable to that used to depict the Masked Man and weight-lifter.

HIERARCHIES OF VISION

Prolonged observation provides us with a canon, or set of essential criteria for the things we know, to which we match each manifestation presented to us by experience. These criteria are our perceptual base for approaching new objects and forms. The combining of essential features underlies all art. The Egyptian figure and the Cubist guitar are, in different ways, reconstructions of their subjects from essential features.

They are hierarchical, in the sense that they are extracted by assigning levels of importance to features of things we see. Such hierarchies are essential to the function of vision, and the place at which it meets language. The different levels of importance we attach to the various aspects of what we observe are essential to higher levels of understanding. A botanist would immediately see differences between two flowers that would go unnoticed by the layman.

The complex and different levels at which we respond to what we see is evident from our ordinary recognition of people. The process of recognition is impossible to pinpoint. How do we suddenly pick out the familiar face of a friend from the crowd of faces in

Recent research suggests that this is not just a matter of receiving neutral eye information and making thought judgements about it. Single cells in the visual cortex of a monkey are found to respond to the movement of figure shapes. One will respond only to a figure moving from left to right and facing right. The figure is therefore being 'seen' by one cell rather than put together by many. Other separate cells respond individually to different directions, actions, and even intentions.

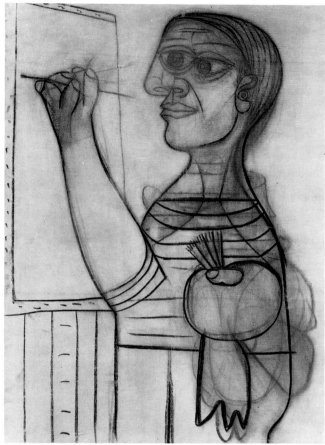

When it comes to seeing other human beings, our complex overall identification includes smaller assessments specific enough to interpret attitude, stance or possible relationship to us, and initiates feelings of danger, surprise, well-being or desire. Any figure in a room immediately energises the space around it. One can speculate about the 'direct' recognitions possible in the brain to contribute to this.

Historically, representational canons were developed for the essential depictions of all subjects – the Renaissance figure, the profile head, and later the three-quarter portrait – changing when a new, more essential vision evolved. These were also applied hierarchically: much more freedom being allowed in depicting the incidental than the essential images of the world. Egyptian slaves were represented more naturalistically than their pharaoh. Later, street life was drawn more freely than official portraits were. Subjects in art, from the earliest depictions, have themselves been descriptions of those things considered essential. Perhaps they are important not only at the conscious level, or even at the subconscious level, but because they ring mental bells at the level of our individual cells.

GAMES FOR
RELATING OBJECTS & IMAGES

GAME ONE
• Continue with, or remake the mirror self-portrait you started, in line, but extend it to include other objects in the space.
GAME TWO
• Return to the objects, and draw them in definite relation to each other – together and apart. Turn them over, lean them against each other and write down the relationships that you think are implied.

Daniel Preece
STILL LIVES 1992

It is worth noting the difference between the two arrangements of the same objects. In the top one, the space recedes from the lower left to the upper right, and is ordered through the repeated horizontal ellipses of the forms. The lower drawing varies the positions of similar shapes. We make connections between the circles and ellipses, the faceted planes in different positions. In this configuration, we are drawn into the central enclosure between the objects, and invent a space for the flask at the rear by completing its form.

Daniel Preece
SELF-PORTRAIT WITH
OBJECTS 1992

*The artist has placed himself
quite high up in the picture.
We wander through it in a
circle around its edges, from
face to foreground and
background objects, leaving
the centre of the drawing to
the space itself. This
centrifugal organisation is
accented by the attention paid
to the relationship of the
objects to the edge of the
drawing. The artist has
emphasised the edges of the
forms, and their relationship
to each other. These create
deliberately flattened
patterns, like that of the
connecting sugar bowl and
shirt pocket, as well as clear
overlapping forms. The similar
surface areas of shapes, such
as the face and beaker, flatten
the space, while the depth of
the space can be inferred from
our knowledge that the objects
in the foreground are
relatively small ones and must
be close to us.*

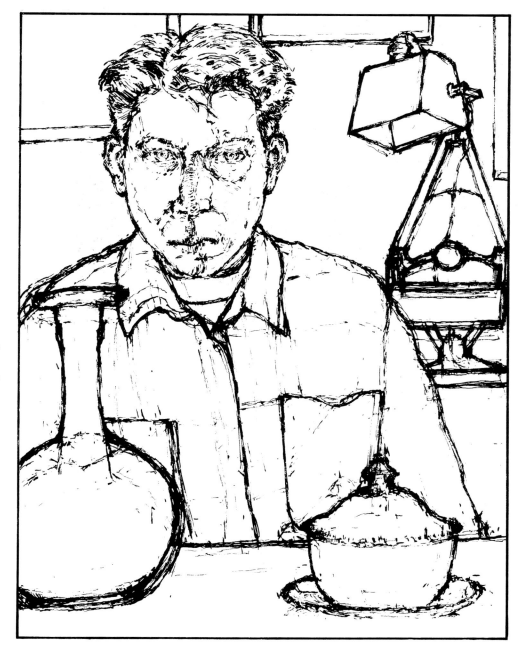

Christo
**THE PONT NEUF WRAPPED, PROJECT
FOR PARIS 1985**

*Through his preparatory drawings,
Christo clarifies his original ideas. The
drawings are used to help the authorities
and his engineers visualise what he
intends to create and to generate the
funds to pay for the project.*

Gerald Atkinson
ANEMONE GLAUCIIFOLIA 1925

*This botanical drawing combines careful
observation of the surface of the plant
(note the hairline description of the
filaments of the stem) with information
collected over time concerning its structure
and growth phases.*

Juan Gris
**STILL LIFE WITH GUITAR AND SHEET
MUSIC 1923**

*Gris dismembered the guitar into its
distinctive features and recombined body,
neck, frets, strings and hole into a
'guitar' image not dependent on a single
viewpoint. The repeating lines of the frets
and strings are echoed in the lines of
music notation to suggest the musical
nature of the guitar.*

CHAPTER 2
DRAWING STRATEGIES

When we start to draw we either consciously or unconsciously direct ourselves to certain questions of organisation. What are the essential features of what I want to describe? What is the best descriptive language for it? The initial position we adopt is in response to these questions. We may not always be able to control where we place ourselves or what aspect of our subject we draw. Our eyes may register something that seems important and we follow this instinct, but we still make selections and decisions based on what is visible. In any case, this point of view only begins the drawing process. We may decide that the subject is not what we thought it was at all, and then make descriptive and pictorial decisions that elaborate, modify or change it.

We develop the language of the drawing from the descriptive codes that are available to us historically. After all, we have inherited 25,000 years of pictorial experimentation. We have learned about our world from representations of it as well as from experience, and many different kinds of realities have been presented to us. From an early age, we are able to deal with the many shifts between them, acknowledging each as a separate facet of the real world, and understanding that no representation can possibly 'say it all'. When we draw, we also shift between different forms of description and different aspects of what we depict. If each of these successive strategies is seen as a game, then what we make will only be real within its rules.

The games in this book are an introduction to game strategies. What follows are what I consider to be the basic pictorial problems around which we develop the strategies we use to initiate and develop drawings.

Ivon Hitchens
STANDING FIGURE 40

The figure was drawn rapidly, in movement. Hitchens was most concerned to get it down quickly and to suggest the strength and vitality of the movement. The activity of the line is our guide to both the activity of the figure and the artist's empathic trace of it.

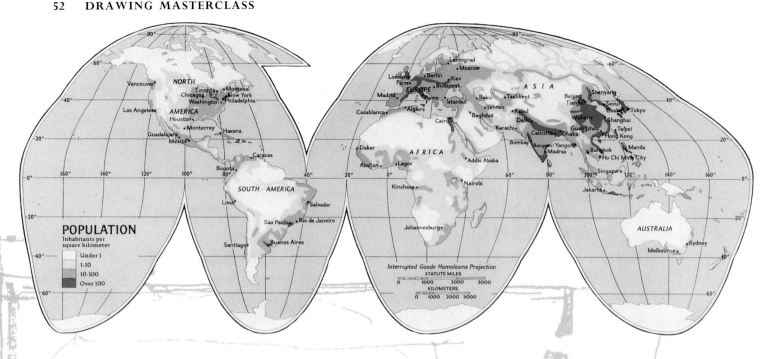

POPULATION
Inhabitants per
square kilometer

Under 1
1-10
10-100
Over 100

Interrupted Goode Homolosine Projection
STATUTE MILES
0 1000 2000 3000

KILOMETERS
0 1000 2000 3000

WORLD MAP

(Interrupted Goode Homolosine
Projection)

*This projection is related to
the way we might peel an
orange in order to keep its
surface skin relatively whole.
It was developed to keep the
continents intact, while giving
all parts of the globe equal
representation in area. The
shapes of the continents are
only correct at the equator,
and we can easily see increas-
ing distortion farther away
from it. Though the land
masses have been shifted
towards an oblique distortion
as they get closer to the poles,
their relative masses are
proportionally accurate. We
could compare this projection
of the earth's surface with the
one that appears on p. 10.*

3D INTO 2

Pictorial strategy starts with any attempt to
reconstruct the three dimensions of the world on a
two-dimensional surface. To highlight the kinds of
problems inherent in this, we might start with a
depiction of the world itself.

Any map of the world intrigues me, since it is a
drawing of something none of us has ever really seen
or experienced in all but the smallest portion. It is
one of our greatest cultural achievements: a commu-
nal drawing based on the centuries-long process of
establishing points on the surface of the earth from
astronomical calculation, and filling them out with
local features recorded in exploration.

Maps can be packed with layers of information –
political boundaries, geographical features, longi-
tudinal and latitudinal lines and time zones. Each
description employs a somewhat distinct code. On
maps that include political boundaries, we generally
believe the borders shown, although some may have
recently been altered, but that does not mean that we
believe that a large line physically exists along the
border between the United States and Canada, nor do
we assume that longitudinal lines float on the surface
of the sea. We accept these lines in a different way
from those that delineate physical features such as the
edges of land masses. Within the linear description,
the regular and irregular configurations can be easily
separated. The lines have two meanings, and we easily
accept both.

Even more interesting are the radical distortions
necessary in order to depict the whole of a rounded

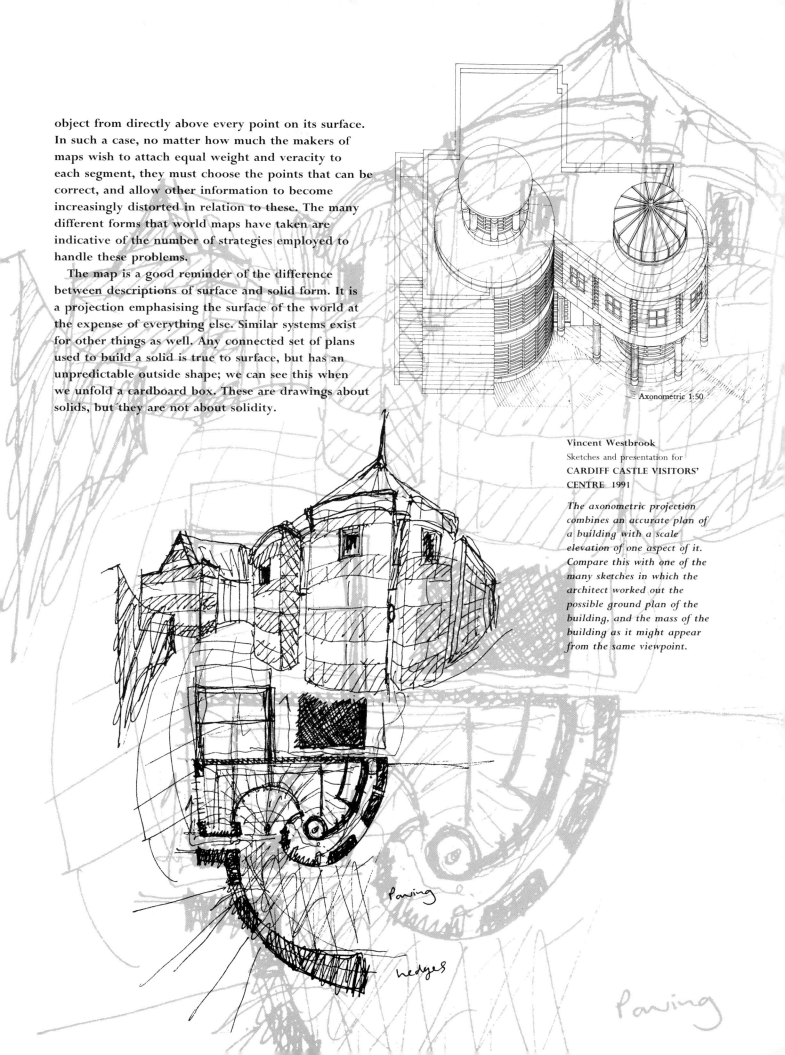

object from directly above every point on its surface. In such a case, no matter how much the makers of maps wish to attach equal weight and veracity to each segment, they must choose the points that can be correct, and allow other information to become increasingly distorted in relation to these. The many different forms that world maps have taken are indicative of the number of strategies employed to handle these problems.

The map is a good reminder of the difference between descriptions of surface and solid form. It is a projection emphasising the surface of the world at the expense of everything else. Similar systems exist for other things as well. Any connected set of plans used to build a solid is true to surface, but has an unpredictable outside shape; we can see this when we unfold a cardboard box. These are drawings about solids, but they are not about solidity.

Axonometric 1:50

Vincent Westbrook
Sketches and presentation for
CARDIFF CASTLE VISITORS' CENTRE 1991

The axonometric projection combines an accurate plan of a building with a scale elevation of one aspect of it. Compare this with one of the many sketches in which the architect worked out the possible ground plan of the building, and the mass of the building as it might appear from the same viewpoint.

paving

hedges

Paving

OBJECTS AND SPACES

If we wanted to describe the solidity and shape of the earth, we would probably adopt one position and draw it like a ball. A single outline would not be adequate and so some surface description would be necessary, but the irregular forms of the continents would probably not be of much help. We might instead give precedence to the longitudinal and latitudinal patterns that cross it, or use a simple notation for light and dark.

We can compare the kinds of descriptive priorities used for either the map or the ball with ones we would use to describe another solid, rounded object, such as a head. Drawings of heads generally give priority to facial features and take a position at the front or side. There are very few pictures in art of the backs of heads. But it is not uncommon to find that the viewpoint has been stretched out, not unlike the method used for the map, in order to put more of these very important features on the surface plane.

The strategies for depiction used for the map, the globe or the head are in answer to the questions that

below **Victor Newsome**
PROFILE HEAD 1982

This formalised description of a head combines tonal development of the mass of the form, with cross-sections of the structure at equal distances in depth. The head is also extended horizontally, as it might if the actual distances between features were measured, rather than observed, from a single position.

right **Henry Moore**
ELEPHANT SKULL ALBUM PLATE XXVIII 1969

The skull was drawn emerging from, and energising the space around it. The tactility of the surface, massive solidity and mysterious recesses of the form mark the drawing out as made by one involved with the sculptural relation between solid and space.

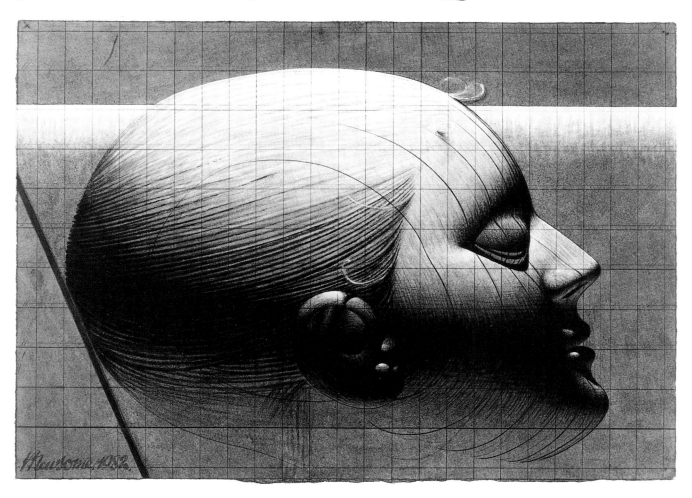

The page surface itself has enormous potential. When we draw an object with disconnected lines, we are letting the page into the drawn object, integrating page and image. This seems to imply spatial depth without further description. Alternatively, the page is sometimes treated as a solid, and the process of drawing becomes one of carving a recession back from it, in the manner of a sculptor. Finally, there exists the possibility of knowingly using the most 'unsophisticated' device of all – simple enclosed cut-out shapes on a page left evidently flat.

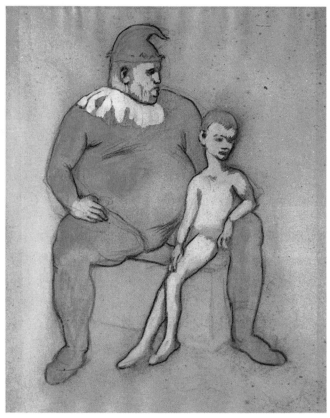

above **Pablo Picasso**
SEATED SALTIMBANQUE
WITH BOY 1905

The solidity of the two figures is suggested principally through line, and the few tonally lighter areas, used as accent. The figure of the small boy calls attention to the mass of the older man, and accents the spatial enclosure formed by the legs of the larger figure. The space is minimally described.

I have discussed for the depiction of something in space: where does the viewer/maker place him or herself, and which views and features of the object are most important?

To establish the solidity of the globe image, we gave precedence to the development of its form over its surface features. But solid objects exist in space, and so the reserve – that part of the paper left untouched – must be turned into a space in which something solid could exist. Even the simplest horizon line might be sufficient to do this, but however we do it, the ideas of solid and space are integral and when we develop one, we must necessarily consider the development of the other.

Space may seem tangible to us, but it is both a presence and an absence, and its form is perhaps the most difficult thing of all to turn into marks. Atmospheric effects aside, logically we can really only describe it by its boundaries with other forms. But to swamp a drawn space with a full description of everything within it would be counter-productive, if not impossible. Selection is essential. A drawn object may seem to need enormous space around it, or very little. Only a part of the visible space may seem pertinent – that radiating around an object, or between object and field. Descriptions in drawings range from such selective deliniations to marks that suggest fleeting edges or simply stand for nothingness.

Draw an object and the space around it, concentrating on the way they affect each other.

MAPPING AND MEASURING

As a drawing proceeds, and begins to include more than one form, selective spatial description becomes increasingly important in establishing the relationships within it, and simple measurements of the relative size and position of objects become useful. But we can take the process of measurement much farther. If we continued to draw across the horizon, we would eventually establish ourselves inside a circle, and if we then continued up and down from points on it, we would eventually construct a picture of the concave 'globe' of our vision, more irregular but very like the map image with which we started, and with identical problems. The horizon line, like the equator of the map, would be accurate and continuous. Consider, though, what happens at the bottom of a drawing like the sketch on the facing page, as it descends towards our feet.

Jacques Villon
LE PETIT DESSINATEUR 1935

The artist drew himself drawing, clearly stating the importance of the horizontal and vertical references he used in measuring as determining the form of the work, and as part of the subject itself.

As with the map, an attempt to take such a drawing towards an all-encompassing statement could plainly overstrain its conventions. However, if we measure the relationships of objects and space across only a small segment of the surface of this globe, we can establish their features and relationships very accurately, and can be said to be mapping what we see.

The map we are making is a map of the image that is projected onto the back of the eye. It is two dimensional, and cannot, for instance, denote the relative distance of things from us. If two objects are in the same part of the visual field – no matter how far apart in depth – they will appear next to each other, their relative distance signalled only by size.

In order to build an accurate drawing by measuring this way, we have to construct a careful procedure. Each of our eyes receives a slightly different image of this field, and so we must first choose which image we are going to draw, and close the other eye. Since any movement changes the relationship across this field, we have to establish our position. While drawing, we will not be able to move from it, nor, it goes without saying, will anything that is being drawn. Then we must decide upon an accurate means of measurement.

Between the sixteenth and nineteenth centuries, numerous measuring aids were invented for drawing. Most consisted of a grid and a sighting device to ensure that the eye position was constant. But there also grew up the convention for using a measuring stick or implement in the hand and moving it at arm's length across the field of vision, measuring along it in different directions. Such measuring methods have been the basis for countless drawings since they were adopted in the Renaissance, as a 'scientific' approach to drawing what is seen.

Measuring systems developed to become the mainstay of art academies everywhere, giving us the stereotype of the artist with arm aimed at the subject, confirming the idea that the first purpose of drawing in art was to establish a faithful record of what the eye sees from a single position. Since those who work from observation almost always find it useful to measure, loosely used versions of measuring systems remain in wide use today. Even casual application of measurement can release the most surprising observations of placement, shape and scale, but it is at root quite a rigorous activity. Those who adopt the strict limits of the procedure, do so to find a method for isolating questions of visual paradox and, in its arrested image, a connection to permanence. For them, method has become subject.

Euan Uglow
GIRL WITH ARMS AKIMBO
1986

A set of spatial enclosures is set up carefully in relation to the figure. The spaces formed by the arms seem particularly important, allowing access to the space behind that is described around the upper figure as a container for it, and again where the feet meet the ground. The foreshortened blocks of the floor, which we assume to be square, establish the relation of the ground plane to the vertical wall, setting the distance of the figure and wall from the picture plane.

Consult the section on measuring.
Draw a section of your room by measuring across the objects and spaces within it.

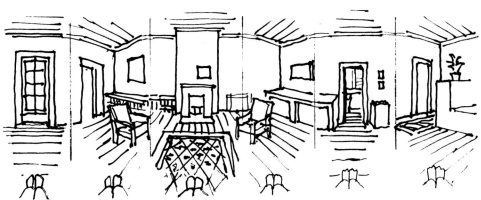

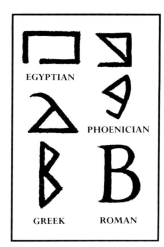

HIEROGLYPH TO LETTER

The Egyptians required hundreds of picture/symbols to write their language, although they spoke it by combining relatively few sounds. To write sounds, ancient Middle Eastern tribes appropriated some of these pictures for their beginning sounds. The hieroglyph for house (bet in Semitic) became a bĕ sound, then the Greek letter beta and our B. Its visual change is shown left.

top **Fay McCaul**
A HOUSE 1992

Fay arranged in simple terms what her experience of a house consists of – an enclosure with a roof, windows to look out of, a pathway, chimney and a door to enter by. The smoke suggests a more abstract concept – warmth.

above **Keith Haring**
UNTITLED 1981

The artist mixed pictograms and symbols to suggest an emotion with the most economic means – a gesture of connection with radiating marks. The equation is figures plus rays equal radiant relationship.

Describe the features of your face in a short written statement.
Then draw your portrait in the simplest possible terms, focusing on your written description.

NAMING

When we admit images into our perception, we identify them by naming them, matching them against typical images in the mind. The device might be linguistic, but it would be a mistake to think that therefore it does not contain visual properties and possibilities. We start drawings by naming what we want to draw. We continue to organise the identity of forms within drawings as we make them – simplifying shapes, clarifying detail – in order to keep them clear.

The process of classification that began in early childhood, has become incredibly complex by the time we are adults, the initially simple categories of object dividing into sub- and sub-sub categories. Experience gives us increasing numbers of positional images for each. Knowledge contributes other quali-fying distinctions. I could return for an example to the botanist and his flower mentioned in Chapter 1.

However, in the middle of this complexity, there are still the simple first images. It takes only the attempt to re-create something we have seen in order to realise how little information can be recollected other than these named features, and how quickly images made away from outside stimuli revert to basic signs. All drawings made away from a subject reflect this simplifying process. Taken to its extreme, this simplification provides us with a whole range of useful and immediately recognisable images, such as the figures at pedestrian crossings. Any simple gener-alised representation of an object around which we have built up experience is really a hieroglyph, or pictogram, and functions as picture-writing.

Our earliest known images, those found on cave walls, show that these pared-down representations

**AIRLINE EMERGENCY
INSTRUCTIONS**

*The depictions combine simple
figures and signs in order to
describe emergency procedures
without words. We know from
their low-keyed images that
we are to remain calm, that
the emergency tab on the
door is to be pulled up, that
we do not take luggage with
us, that we jump onto, and
do not simply sit on, the
emergency chute.*

existed alongside more naturalistic images – to name
and depict both being forms of re-creation. In ancient
Egypt, these had developed into separate defined
hieroglyphic and pictorial languages. Both construc-
ted the image out of its typical aspects, but with
different intent. The depiction of a noble person's
house would necessarily elaborate or list all of its
features for a future life, while the hieroglyph for
house, ⌐⌐, had, by a process of selection, discarded
all specific features until it could be applied to all
houses.

This is a minimal essential image. Poised midway
between fully developed images and 'empty' letters,
such a sign can obviously be developed in either
direction. It can, however, only go in one direction
and remain visually active – back towards images. Its
typical and known features are a shell for complex
depiction. Because it is generic – it stands for all
things in its category – typical features by which we
differentiate images within the category must be
added back onto it to specify a sub-category within
it. 'Man' qualified by 'old' immediately must become
more complex in order to fulfil the pictorial demands
required to make the image sufficiently specific. We
may only be able to apply the features we can name
for 'old' through substantial changes or elaboration. If
wrinkles are important, their definition reintroduces a
new level of surface description.

In the process of listing and deploying these
features, we are identifying the typical elements we
use when we look in the first place. This process of
analysis is important for the making of easily under-
stood forms. In description, we have to establish the
category or type of an image before we elaborate it,
differentiate within it or deviate from it.

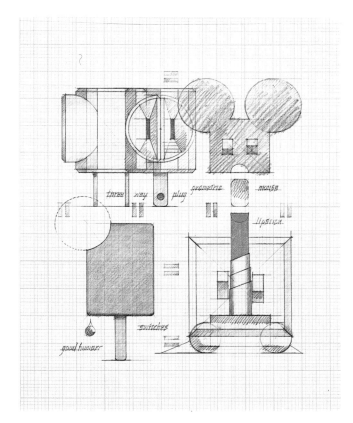

Claes Oldenburg
SYSTEMS OF ICONOGRAPHY – PLUG,
MOUSE, GOOD HUMOR, LIPSTICK,
SWITCHES (1970) 1971

*Oldenburg takes familiar images and
tests the strength of their identities by
reducing them to simple geometries,
playing on the possible visual similarities
underlying their identities.*

GAMES FOR
MAPPING & MOVING IMAGES

GAME ONE
• Draw your fist as it is turned over in a continuous drawing.
GAME TWO
• Return to the mirror to draw a multiple portrait. Starting at the farthest angle at which you can see yourself, draw first one side of your face, continue on to a full facial image and then draw the other side, connecting them as you go.

Justin Mortimer
MULTIPLE IMAGES 1992

The moving hand has been drawn in almost continuous motion. The life of the form is more apparent than any single image of it. The portrait has been more difficult to approach in the same way. The artist has chosen to draw it as a series of developed 'arrested' images. This moving around of your self-image is important in order to find the many forms that can exist within the same familiar one.

• Transfer the drawing onto tracing paper. Use it and the drawing of your hand to make a composite picture based on one of the positions, but include important information from others.

GAME THREE

• Draw a grid on the mirror of 2.5-cm (1-inch) squares, at least 25 cm (10 inches) wide, and 35 cm (14 inches) high. Draw an identical one on a piece of paper.
• Mark your position on both the mirror and paper. Mark on the mirror to establish the positions of everything you plan to draw. Develop the drawing on the paper from the grid positions of all the things you have marked.
• Wipe the grid off the mirror and continue the drawing.

Justin Mortimer
SELF-PORTRAIT
THROUGH A GRID 1992

The drawing points out the value of using a grid to investigate the pictorial possibilities of one's surroundings. The notations of the rectangles at the top of the drawing, though minimal, indicate a deep space in an obviously high room or studio, and establish, in their rakish angle, an odd spatial dynamic. This is a centralised drawing. The artist has placed himself just left of centre in it, leaving space for the plant that he obviously wishes to serve as accent to his image. The development of face, clothing and plant is quite dramatic, contrasting surface patterns with structural and spatial descriptions. Notice the way the plant and pullover create and connect similar patterns, and that a visual container is formed for this activity between the dark accents of the left side of the figure and the dark rectangle at the right. Contrast the movement back in space to the right of the figure, with the jump into the deep open space on the left of it.

THE QUALITY OF FORM

The qualities we associate with the rhythms and relationships we experience in active sight, for example whether an object seems heavy or light, flows or is static, often form the first impression we use when we begin to draw. These responses are closely connected to our own body experience, and we remake them visually through the manner in which we physically approach or attack the making of the image, leaving an action track to be followed. This is the part of drawing that connects our experience to the nature of marks as empathic traces, and to our enormous capacity for metaphor.

Anonymous
DANCING FIGURE
16th century

The rhythmical quality of the figure and its drapery acts as an aura, or visual field, within which the figure enacts its dance.

In order to explain what these qualities contribute to, and how they relate to other forms, I will start with visually neutral forms like the letters on this page. I have already described letters as visually empty since they are signs that always signify the same thing. Letters have distinctive forms, but we suppress their visual associations – an 'O' resembling a wheel, for example – in order to read them without diversion. We can, however, easily give visual association to whole arrangements of letters by placing them in different kinds of patterns, and we regularly place visual presence back onto words with drawn form. Classical letters were developed to match the aesthetic goal of the Greeks; their balances say as much about Greek civilisation as other art forms do. Succeeding eras invented new forms of letters to fit their own visual needs. Albrecht Dürer, for example, constructed letter forms that reflected the classical ideal of the Renaissance, and the typeface in which this book is set, Perpetua, is an example of a classic typeface, and suggests an historical connection.

Everyone has, at one time in their lives, felt the need to add meaning to a word by drawing it. Handwritten party invitations are good examples, in their attempts to suggest not just any party, but a really lively party, *my* party.

The two versions of the word 'hotel' shown on this page are different from each other because they have been taken over by different drawn forms. We recognise the same word meaning but we assign completely different qualities to each. This may be just a form of advertising for us, but cultures with strong ideogrammatic traditions, such as that of Japan, assign the status of high art to calligraphy, for the insight it brings to the concepts contained in written symbols.

We apply the same criteria to more fully developed images. Two standing figures can seem to be completely different from each other, while depicting the same thing, through the quality of form we extract from them. In some contemporary art, this element has been divorced from either outside subject or word. Elevated by the importance we attach to the individual signature or unique mark of the artist, it often carries the whole burden of content on its own.

But whether drawings are with or without subject, or give nuance to signs such as words, the qualities of hard or soft, solid or flowing that we identify in them result from our subtle response to the activity of the lines and forms in front of us, and bring us back to the idea of empathy discussed in the introduction.

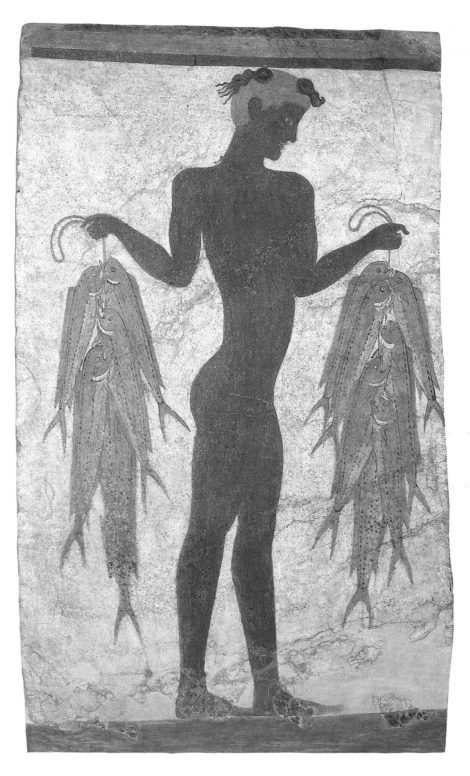

Draw the palm of your flexed hand starting from the middle outward.
Concentrate on the quality of the surface, looking at the hand rather than the paper.

THE FISHERMAN from the West House, Thera, Greece **c. 1,500 B.C.**

The slowly undulating silhouette of the fresco figure leaves us with a powerful sense of the image that is both formal and sensuous. Just as the words above are given nuance through their visual form, the 'idea' contained within the classical Japanese character for dream is accorded a dynamic and a degree of drama by the speed and handling of the brush.

OBSERVATION

I have described observation as one of the reference points for drawing. The majority of the drawings in this book reflect this and are drawn from something, although for many different reasons. The first universal reason for observational drawing is to build the stock of visual and drawing experience. It is based on the belief that by remaking what we see, we gain insight into both our surroundings and our perception of them. This emphasis on the surface phenomena of the world, and their possible divergence from our ideas about them, is important. Even artists who have worked from observation for years still speak of the surprise or unexpectedness of the seen. Considering my description of the seeing process, we know that it would be impossible simply to copy what we see. But when we draw from observation, some sort of matching is going on that tests the unique event we encounter against our expectations of it.

The art of our century utilises so many equally held pictorial conventions that the forms that observational drawings take may vary enormously. Nevertheless, their focus on the specifics of experience is its own 'convention of the particular'.

When we draw observed images our response to them becomes more specific with each successive encounter. Time is necessary to raise our level of insight, and the ability to sustain a drawing is important in this process. Historically, the drawing

right **Paula Rego**
Study for **THE FITTING** 1990-91

Rego emphasises the human element in her complex narrative works (see pp. 90-91) through the convincing attitudes and gestures of their many figures, developed in preliminary drawings such as this one.

opposite top **Rosa Bonheur**
(attributed)
STUDIES OF A SHEEP

The movement of the sheep while the drawing was being made was noted in a second image; the change suggests the time element in the making of the work.

Do a careful drawing of your hand, which combines surface qualities and form.

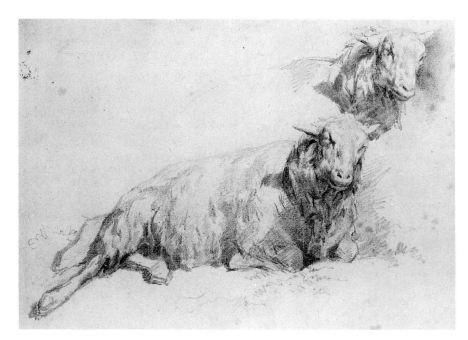

above **Ron Bowen**
PHILIP'S KNEE 1980

This drawing was developed around a 'photographic' sense of focus. The fragment of the figure and the bed cover in front of it are highly focused, the small area of floor and bed farther away have been handled more softly, to suggest that they are out of the area of intense focus of the drawing.

above right **Piet Mondrian**
CHRYSANTHEMUM c. 1908-09

Mondrian initiated the process that led him to a basic geometry by carefully analysing natural forms in drawings such as this.

abilities of even those artists concerned primarily with action have been developed by careful and sustained looking. As an image evolves, each new section or stage of it is a corrective against which we can match our previous attempts at description and is a challenge to our strong, most human urge to justify our first statement. Those who draw from observation expect more of themselves the more they do it, and test what they can see by addressing increasingly complicated visual problems.

In the attempt to draw observed 'facts', we are led to consider what fact is. It is not merely an accumulation of detail, but rather an ordering of essential features. It is paradoxical that if we do a drawing in which we attempt to include everything, the first thing we become aware of is what we must leave out. The selective nature of drawing requires that some mediating language must develop through which veracity or fact can operate.

Fundamentally, observational drawing is based on the belief that only what can actually be seen should determine what is put down. The pact we make with ourselves when we do this is that we will not jettison those aspects of what is seen simply because they do not easily fit our scheme. This is a pact that only we will know about. No one else will know what was in front of us, and the drawing will not give this away. Nonetheless, it is the most important of agreements. Art involves us in a continual reassessment of the prejudices we bring to experience. Observation is our principal means for making these reassessments.

UNDERLYING FORM

In the kind of simple patterns and structural drawings we make to order things, we are linking ourselves to a universal fascination with essential relationships and pure form. Symbols that seek to describe such essential relationships have always been with us. In a world context, the vast majority of visual energies has been directed towards developing such symbolic forms. In sources as diverse as nomadic carpets and Melanesian carvings we find similar simple geometric formulations, which reach a pinnacle of complexity and artistic achievement in Islamic visual patterning. By comparison, naturalistic traditions have developed in only relatively small segments of the globe, appearing episodically for short periods of time.

The polarities of constancy and change in our existence – which mirror the way in which we first perceive the world through touch and sight – inevitably leave us with questions of where the reality lies in our experience. The question has been crucial for philosophy, and the proposition that the real world lies behind appearances has long been with us.

The Platonic philosophers denigrated the nascent naturalism of Greek painters because they could only construct the appearances of things, which were pale imitations of the things themselves, and because they led others to believe that reality and surface experience were the same. Plato used the metaphor of flickering shadows and lights on a cave wall for the transience of surface phenomena of the world.

Within the Western pictorial tradition, artists have fought to make a synthesis between the observed world and the pure form beneath it. Renaissance artists made the attempt to confer on the pictorial surface the solidity of architecture, the clarity of mathematics, and to link it to essential realities such as natural growth. As architects, natural scientists and mathematicians in their own right, they left copious notebooks in which they investigated the essential relationships of man to the natural world, and constructed pictorial systems for them, such as the 'measure of man', the golden section, and perspective. These were not merely methods, but metaphysical instruments that would bring the picture closer to the 'real'. In these analytical drawings we find a great elegance, which, today, we admire for its own sake. These artists were also aware of the possibilities of unadorned geometry, and as designers of both buildings and public spaces, took the opportunity to make bold, pure geometrical statements.

At the beginning of this century, a renewal of expressive interest in simple and underlying form accompanied the Modern movement in its attempt to redefine fundamentally our artistic heritage, and to form a new classicism based not on surface, but on the essentials of shared human experience. Cross-fertilised by the international aspirations of the political, social and artistic revolution, geometrical form, or 'form laid bare', took over all the arts from architecture to decoration. What better language to serve as a universal medium for expression than one that starts from the fact that, as humans, we are all vertical and the horizon, tautologically horizontal?

right **Piet Mondrian**
THE SEA 1915-16

For Mondrian, the horizontals of the land and sea, and the verticals of growth took on symbolic meanings. His stated intention was to induce a sense of 'calm and unity' through these essential markers; in this drawing, to convey the interconnection of sea and sky with the larger universe.

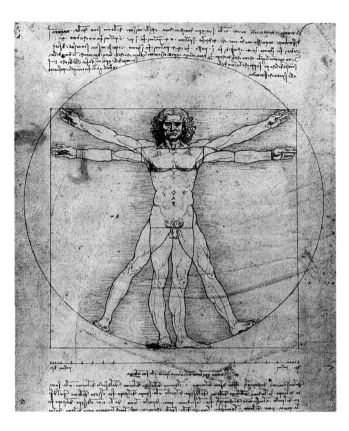

left **Leonardo da Vinci**
FIGURE OF MAN IN CIRCLE
c. 1485–90

Leonardo was one of many Renaissance artists to relate the human figure to Platonic geometry. Here, the height of the ideal figure is the same as the width of the outstretched arms, and the standing figure in its different positions is related to both the square and the circle.

left **Liubov Popova**
STANDING FIGURE – BACK VIEW

Popova looked past surface detail to search for basic geometry within the figure. The sense of dynamism in the drawing is a clue that the investigation was based on the new social order of post-revolutionary Russia.

above **Tess Jaray**
MINARET 1984

The title of the work makes clear its relationship to the subtle geometrical systems of Islamic art. The spatial illusion is both surprising and evocative. The ordered progression elicits in us a sense of fundamental elegance and serenity.

MENTAL LANDSCAPE

In order to synthesise the many kinds of observations and ordered forms we construct in drawings, we need a system for exploring their possible connections. The mixture of descriptive languages found in notebooks and diaries are evidence of the importance artists have attached to the re-ordering – or disordering – of this body of images in their speculations. The 'stained walls' that Leonardo encouraged as the starting point for calling up images were a device for encouraging the internal imagining process.

This process has preoccupied this century as it has no other, and is treated as the central feature of individuality. The idea of the individual that grew out of the humanist tradition came increasingly to be an image of strain for the Romantics. Since Freud, this internal strain has come to be seen as so rooted in individual development, that its ties to a communal reality have almost snapped. The highly individual picture of the world that each of us carries is now the starting point for the discussion of reality, with as much credence as any outside or objective perspective on the world. If anything, it is the idea that there can be an objective world that is debatable. The fragmentation of visual language is part of this communal splintering. But the imaginative extension of reality has always been with us. Before the humanist

Alfred Kubin
THE DREAM OF A SERPENT
c. 1905

The world of this drawing is a primordial one: the setting for much imagery concerned with basic emotions. The projection of our psyche through the invention of half animal/half human creatures is also basic to our imagination, and a central feature of myth. The combination of the powerful, the deadly and the sexual, establishes a connection between desire and fear.

tradition, mediaeval monks were making odd
'devilish' postscripts in the corners of sacred books.
Heaven and hell have both served as handy vehicles
for the depiction of what goes on in the imagination,
and as is obvious from an artist such as Hieronymus
Bosch, the devils often get the best of the bargain. But
whatever the overriding value system, images closely
related to deep-seated fears and basic desires are
common features of depictions that call up imagined
worlds.

Artists in our century have taken particular refuge
in the suspension of morality that present-day psych-
ology ascribes to the imagination, and have used it to
say the unsayable. The Surrealists, in their campaign

above **Pavel Tchelitchew**
Study for **HIDE AND SEEK** 1941

*For Tchelitchew, natural form
was the starting point for
fantasy. An aged and gnarled
tree, with its clumps of
growth, becomes a metaphor
for growth, raw energy and
decay; its densely knotted
branches, a metaphor for the
many neural pathways and
connections of the brain.*

left **Marc Chagall**
Study for **BIRTHDAY** 1915

*This is the drawing by which
Chagall organised what is
perhaps the best known of his
paintings. The drawing
strongly evokes the way we re-
invent and hold events in the
memory. The gently flowing
lines of the figures re-create
the lyrical world of the lover
made explicit in the kiss.*

against the bourgeoisie, endorsed this as policy, but
policy runs counter to the spirit of the enterprise, and
when their work is deliberately outrageous, it has a
dry didacticism about it.

Depictions from fantasies can be based on virtually
anything in our world around which we can weave
our imagination. What they all have in common is that
they make connections by encouraging the suspension
of ordinary rules – either physical or moral. They are
ways of moving in our mind freely, without the constr-
aints of social concerns or doctrine about what is real.

Since what goes on in the imagination is ultimately
based on experience, such images are really extensions

or inversions of our ordinary world. Something
fantastic can only exist in relation to the ordinary.
They must, above all, be logical, even if the logic is
an extended one.

Such works force an interaction between personal
and accepted social realities. Some, like the paintings
of Bosch, were made to be seen publicly. But it is in
deliberately private drawings, like the thousands by
Leonardo, or the equal number by Turner that Ruskin
felt obliged to burn at his request, that our physical
and moral universe is most intensively examined. It is
in drawing that we can speculate, and that we can be
honest with ourselves.

right **René Bouët-Willaumez**
FASHION DRAWING 1939

This drawing is a statement of elegance of lifestyle as much as costume. The slim, elongated figure is depicted in a position of social poise that encourages us to imagine and aspire to its social setting.

far right **Natalia Gontcharova**
COSTUME DESIGN

Ballet costumes are designed around the ideas and setting of the dance, but the designer must consider their relation to the demands and energy of the performance. Gontcharova drew the costume as she imagined it would look on the figure at its most expressive.

FORM AND FUNCTION

Drawing is fundamental to the articulation of ideas required for visual problem-solving. When we choose a working method and order the importance of descriptive elements in a drawing, we are making a description of what need the drawing fulfils. It is the idea of need in a work that leads to pictorial experimentation. In order to fulfil our need, the drawing is assigned a function. The concept is easily related to drawings such as the map we considered, or architects' plans, because they must be used practically. It may not be so easy to ascribe to works such as artists' drawings, except in relation to a finished work, such as a painting.

I have been treating drawings done for applied purposes and 'expressive' drawings together because I believe that they share and resolve similar problems. In any case, the pictorial devices developed by artists and designers of all kinds in response to specific problems have been traded quite freely throughout history. This is important to remember in a society as complex and fragmented as ours. There is a tendency both from inside and outside the sub-branches of the visual arts to view their specialised concerns in too

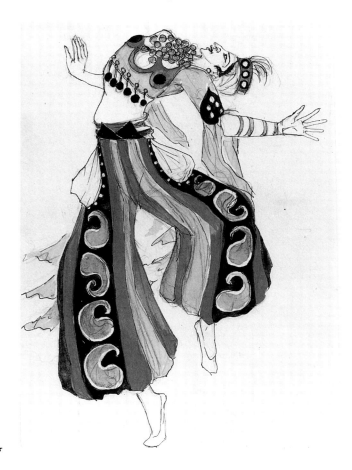

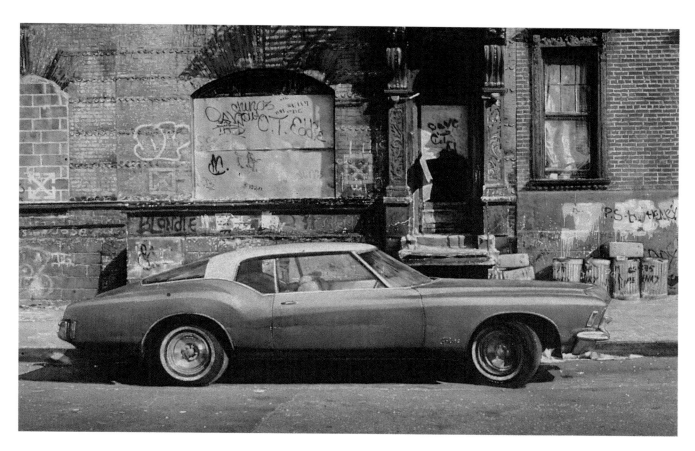

narrow a way, and to accept visual conventions
without question. It may be more important to find a
form for imagining than an ideally suited convention
for describing. In a glance sideways at other kinds
of pictorial problems, we may find ways of dealing
with our own.

The most interesting aspect of this larger canvas is
the discovery of the variety of solutions engendered
by a wide range of pictorial demands. If the appear-
ance of some drawings is determined by their ability
to be acted on (plans, mechanical cutaways) it can
also be led by correctness or knowledge (botanical
illustrations) or by the need for exhortation or per-
suasion (fashion drawings). A draughtsman may need
to compress more than one kind of description into
one image, and the pictorial code within it must shift
or split to accomplish that.

During the process of drawing, the image itself will
start to have needs through which we move forward
to new insights. In the fine arts, this ascribing of first
cause and its subsequent modifications have no out-
side control: the artist determines both. The degree
to which the first cause continues to determine the
work, or modification substantially changes it, is a
game in which the artist exercises his or her right
to change the rules.

John Salt
PARKED RIVIERA 1982

Salt depicted the car as an
object of devotion, an icon for
American values, and then
brought these into question
through the decayed setting in
which he placed it.

CITROËN 2CV ENGINE

This drawing is used to locate
parts of the engine that need
regular maintenance. The
viewpoint is chosen carefully;
it is the one from which we
view the engine when we open
the bonnet.

GAMES FOR
FINDING STRUCTURE

GAME ONE
• Make a portrait of yourself holding your head in your hand. Organise the image so that the two forms relate to each other to form a structure which seems more evident than either the hand or head on its own. Try to direct the drawing towards this structure.

GAME TWO
• Now make a portrait in which you emphasise the underlying structure of the head rather than the features.
• Use this drawing as a starting point for drawings in which the structures take off on their own, without being related to portraiture.

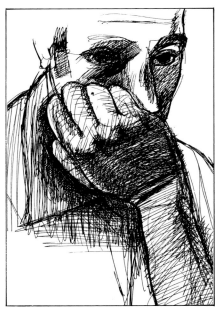

GAME THREE

• Draw your face as a structure without looking in a mirror, but only by feeling it with your hand. Try to determine the size of the features and put them down in this real size. Since this picture will not be related to a single point image, it may be more related to an opened out 'map' image. Keep the drawing related to the structure as you feel it.

Marcus Grey
HEAD IN HAND 1992

These two drawings are from a series in which the artist investigated the variety of structural relationships in the combined forms.

Sarah Weatherall
STRUCTURAL PORTRAITS 1992

Left: *The conventional image evident at the right side of the face was developed into a structural analysis of planes and forms on its left side.*
Below: *The image was made by* *feeling the head from the nose outwards to the ears, placing the actual sizes of the forms on the paper. To do this, she set up a rule that the forms would be drawn with pressure equal to their hardness, and* *that those that felt soft were to be left undrawn. The mask-like result is comparable to a map, since it has been constructed by collecting inform-ation across its surface, and has no definite outer edge.*

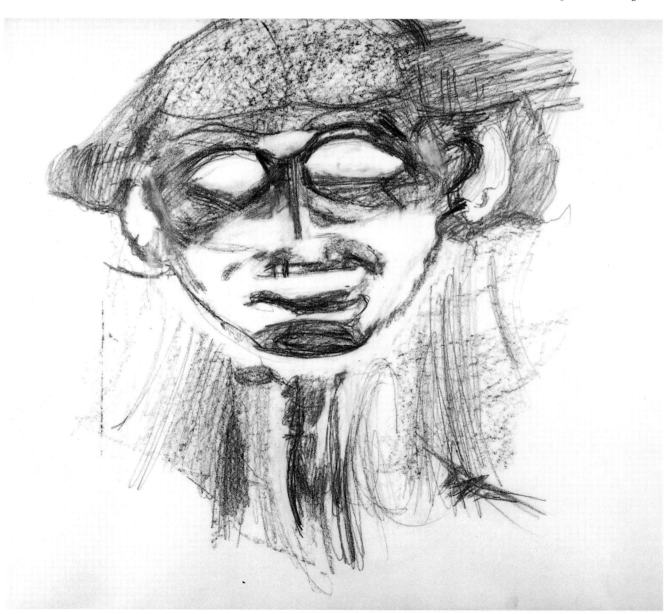

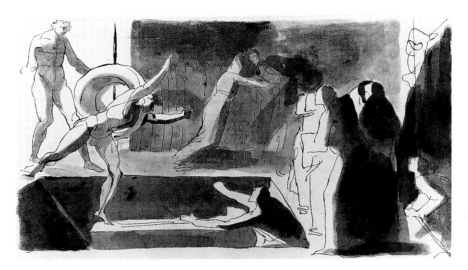

Jan van Eyck
CARDINAL NICCOLO ALBERGATI c. 1431

The soft use of tone directs us to the gentleness of the artist's eye. The features, which have been picked out linearly, punctuate the description and reinforce the sensuous attachment to surface.

Henry Fuseli
HAMLET AT OPHELIA'S GRAVE

Tone is used boldly to give a dramatic theatrical event a powerful sense of light. Shapes are massed and set spatially by the strong side light, which is also used to place the frenzied figure of the prince in relief against the static mourners and still corpse. Line punctuates the image throughout, used somewhat independently of the tonal description. We might also notice the connection of the figure on the left to that of Hamlet. Moving from the standing figure to the falling one, we create movement.

Vasily Kandinsky
Study for **IMPROVISATION 28**
(Second Version) **1911-12**

The work is given its dynamic and movement through the powerful linear rhythms, which act to hold the highly coloured description in place.

opposite **Amedeo Modigliani**
SEATED NUDE 1918

A simple linear outline sets up a swinging motion of curves that leads us, as viewers, through the figure at a leisurely, even pace. The unit of the curve reoccurs in both large and small forms, from torso to lips and eyebrows.

CHAPTER 3
DRAWING ELEMENTS

Drawings are essentially composed of only the elements of line, mark and tone on a surface. Each of the elements we use in drawing has properties that suggest distinct features of our seeing process, and we are led by suggestion to re-create images from them. Colour has been largely excluded from the drawing process since its beginning, the re-creation of colour experience evidently producing a cognitive problem so large that it had to be taken up on its own by painting. When colour is included in drawings, it is used in a way that is either schematic and clearly subordinate, or as a counter rhythm on its own.

It is a uniquely human ability to be able to reconstruct visual experience from two-dimensional configurations. Other animals make marks: elephants pick up sticks with their trunks and make patterns on the ground with them, and drawing chimpanzees were once commonplace news items. But only humans can decipher pictures of the seen world from these patterns.

Artists are free to make their description using only one of the elements of drawing or all of them, and to vary the degree of description greatly. We are used to encountering drawn images that range from simple silhouettes to all-over 'photographic' representations, though such complete descriptions are rare. The means by which drawings are made are normally so obvious that they exist in the mid-ground between what they portray and what they physically are. As viewers, we actively complete the image, empathically following the maker's directions, following lines, leaping from one mark to another, going along for the 'ride' of the description.

To describe these elements in terms of their descriptive roles and relationships is to imply that a language is being developed in the drawing, and that we can view drawings in terms of grammar.

THE SURFACE

The first element to consider when we start a drawing is the surface itself. From the earliest known images, drawings have been made on almost all surfaces – the earth, clay pots, stone, metal, wood, canvas, animal skins, and, since its beginnings in ancient Egypt and China, on paper. This has developed into a standardised shape about half as long again as it is high, termed landscape or portrait, depending on whether it is turned horizontally or vertically.

Paper is ideally suited to drawing. Its development was a necessary pre-condition for drawing to develop as we know it today. The relatively small scale on which it has traditionally been made has determined the scale that most drawings take. There is enormous flexibility in an image on this scale because the artist/viewer is visually in control of all of the surface. When we look at an image of this size we 'telescope' our visual response and project ourselves into the scale of the thing depicted. This is harder to do when the image approaches a human scale. Paradoxically, quite small images can have a sense of grand scale that may be harder to achieve in larger works.

The placement of an image on a surface is the first step towards pictorial statement. The page immediately becomes a 'world', and its edges, the world's boundaries. There is always tension in drawing close to the edge: children invariably position an image centrally on the page, and even experienced artists are reluctant to carry an image past it.

The page is both a surface and an implied space. Drawings of single forms most often make just enough spatial reference to allow the image to exist spatially without challenging the edge. Many spatial systems deploy the page surface as if it were a window onto a depicted world. If the space is drawn right out to its edge, the frame of the window is usually drawn or a border left on the page. When it isn't, the page edge itself becomes the window frame and the drawing is seen to go behind its edge. This paradox of solid paper and negative space is visually difficult to sustain unless the drawing is placed in another frame. There are, however, expressive advantages in suggesting that parts of the image continue past the edge, where viewers must complete it for themselves.

All these questions of the page suggest that the size and dimensions of the paper define the drawing, but the development of the image can equally determine what we do to the surface. Paper is the most flexible of materials, allowing us to alter its dimensions. If we want to extend or change a drawing we can simply add on to the page and allow the surface to follow the image. Alternatively, we can cut it up, select a part of a drawing, and repaste it on another sheet.

Paper is now made in quite large sizes, and contemporary artists have expanded the scale of their drawings accordingly. Others have developed drawings into enormous works on all sorts of surfaces, sometimes directly on walls, even on the earth.

Georgia O'Keeffe
EAGLE CLAW AND BEAN
NECKLACE 1934

The shadow suggests that the page is the surface on which the objects are placed. The angle of the depiction requires that we convert this surface into an inclined plane.

opposite Diego Rivera
STEAM 1932

Rivera constructed a defined space behind the picture plane. The strong containing edge emphasises the way in which the surface has been cut away to reveal a densely packed world on the other side of it.

Jennifer Bartlett
THE GARDEN 1981

*This drawing was made to partly surround
a real door, and the juxtaposition of real and
imagined openings heightens our awareness of
the nature of the 'door' of illusion.*

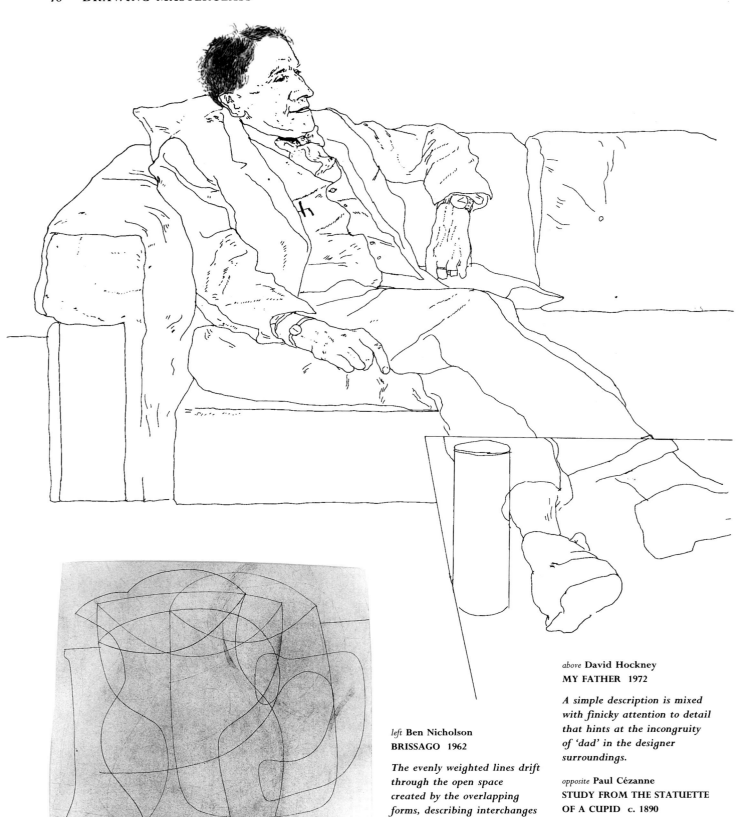

left **Ben Nicholson**
BRISSAGO 1962

The evenly weighted lines drift
through the open space
created by the overlapping
forms, describing interchanges
of object and space with
simple linear contours. The
elegance of the image conveys
the purity of form Nicholson
finds in ordinary objects.

above **David Hockney**
MY FATHER 1972

A simple description is mixed
with finicky attention to detail
that hints at the incongruity
of 'dad' in the designer
surroundings.

opposite **Paul Cézanne**
STUDY FROM THE STATUETTE
OF A CUPID c. 1890

The linear description moves
from edges onto surfaces to
emphasise structure and rythm
and is tonally accented to
suggest light and space
around the form.

LINEAR DESCRIPTION

Line is the first and most essential drawing element.
Lines set up a sense of direction along their length,
and we follow them. But they also automatically call
up associations with containing edges. This cognitive
connection between line and edge is perhaps the
strongest of all perceptual/pictorial connections. It is
hardly surprising then that the most common use of
line in drawing is to define edge or contour. The
earliest drawings used line to describe the outside
edges of the shape (see p. 63). In classic descriptions
of this kind, the line is continuous; to break it would
be to make an incomplete description. The simplicity
of such works, and the ordering of priorities in them

to the edge, at the expense of internal description or
structure, required that the artist draw a recognised
shape or silhouette, and emphasise the typical features
of the image. The continuous edges of these forms act
as enclosures that are, by nature, static.

When lines are used to describe visible edges that
appear within the outer silhouette or 'true' edge of
images, we give them rather different descriptive
functions depending on the kind of form we are
drawing and the cognitive importance of the parts of
the form they describe. On a hard, geometric form,
such as a box or a table, the inner contours – where
the top meets the side, for example – are structural,
and as apparent as the outer edge because they meet
in sharply defined edges.

We are unlikely to apply linear description
structurally to figures in the same way. Lines used to
suggest the inner contours on the surface of figures
are likely to be used primarily at the edges of those
parts of the figure we have symbolic pictures of in our
mind – lips, or eyes – or anecdotally deployed where
definite lines appear on skin or in the folds of
clothing. Even if a structural edge, like the change in
plane of the cheek, is visually obvious, we know it to
be a 'live' or soft form, and hold back from such a
definite, analytical description. When such a
description is used, one finds it softened, or lightened
a little, to give a hint that this part of the description
is not a hard edge. The difference between the way
lines are used to suggest the surface and symbolic
features of the figure, and its structure, is apparent if
we compare the David Hockney drawing on the
facing page to those of Paul Cézanne on this page and
Tom Norris on page 83.

When forms cannot be described by definite edges
at all – for instance, in landscape drawings – lines are
often applied as suggestions for the possible edges of
ephemeral forms. Clouds and trees do not have
definite edges, and we must infer transience from the
fleeting qualities of the description of their shapes.

Partial or fleeting edges such as these can be
applied back onto the solidity of a figure in order to
animate the way in which we look at it. As viewers,
we reconstruct the form by alternately following lines
and leaping across spaces to find the next partial
edge, re-creating the sense of the form's existence in
space through the vehicle of the drawing.

Lines used on a form can suggest surface or texture
rather than edge, as in the cross-hatching of many
etchings. They can also be used to suggest the inner
life or activity below the surface, as in the Dubuffet
on page 81.

LINEAR ACTIVITY

In relatively even description, the dynamics of the line are subordinate to its descriptive role. Such description requires restraint on the part of the artist. It is rational, ordered, under control.

Drawings that are extremely evenly made can develop a kind of weightlessness. Greek drawings have this quality. But lines that describe a form can suggest its weight themselves – the thicker the line, the heavier the form will seem to be. Renaissance artists developed a sense of gravity and dynamic in their linear drawings by varying the weight of linear description, emphasising the counterbalance within the figure, or the pressure the body exerts on the floor. In more complex constructions, they emphasised the psychological importance or 'weight' of different figures or events through the weight of description.

A line conveys the speed and force at which it is made, and acts as a pathway for that force. Its qualities – slow, fast, soft, hard, deliberate, impetuous – determine the sense of what it describes and indicate the nature of the artist's procedure. Some lines seem to know just where they are going, and others seem to be searching for what they describe. When artists use line to search out and 'find' form, the many paths and turnings of that inquiry may be more pertinent to the description than the certainty implied by a single finished statement.

Though we can easily vary the speed and accent of the drawing at will, this should not be used indiscriminately. When students first learn about the possibility of accenting lines, they often use accents at every turning point. The result is like being in a car when the driver is either stepping on the accelerator or jamming on the break. Accents have to be orchestrated across drawings to achieve the desired qualities of speed or movement.

Active lines call as much attention to themselves as they do to the description; when artists use them, they convey the idea of display. As the drawing speeds up, it becomes a form of cursive writing. We follow the

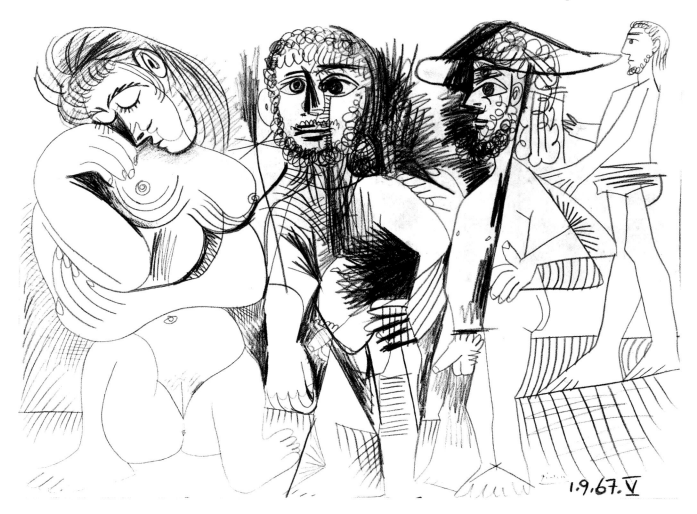

left **Susan Rothenberg**
UNTITLED 1982

This drawing was made at high speed, and the figure is imbued with the energy with which these linear wrappings were drawn. The drawing is not as much about the appearance of forms as much as it is about the simple forms that are inherent in them. The artist seems to be using speed to arrive at this iconic simplicity. The final image is recognisable as a figure, but also as an arrangement of symbols/forms.

rhythms made by the hand as a subject in its own right, and fit described form into them. Baroque drawings turned this calligraphic element into a rhythmical pattern that often would leave edges entirely in order to operate simultaneously as rhythm and surface description. In these drawings the subject emphasis has shifted to the line itself.

The qualities of different materials greatly affect the sense that lines convey. A brushed line may seem to float across the page, to exist liquidly on top of it, while a pen line can almost seem to be cutting into it. I mainly draw with pencil because one can use it for a wide variety of expressive purposes, and, since it can be erased and changed, seems to be a rational material, albeit not a very risky one.

opposite **Pablo Picasso**
SUZANNE AND THE OLD MEN 1967

The curving, sinuous lines that describe Suzanne are contrasted with the blunt descriptions of the men. The array of Cubist spatial devices that tears apart the two central male figures stands in contrast to the solidity of the rather classical female. The scratching and cross-hatching that is used throughout emphasises the different qualities of these forms.

above **Jean Dubuffet**
CORPS DE DAME 1950

The subject here is the life within the figure, rather than its outward appearance. The line whips around the figure to describe this; the outside edge describes the edge of an arena for action more than it does any obvious form, and the scribbled lines that fill the form suggest its features as well as its tactile surface and the sense that the body is being drawn at the level of the cells that make it up.

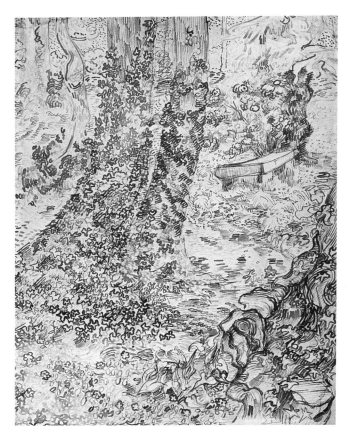

Vincent van Gogh
TREE WITH IVY

The dense, overlapping forms were built up from rhythmical systems of marks that establish both the richness of surface and the spatial interweaving of the foliage.

MARKS

The short dash-like marks and stationary points that are often used in drawings cannot function on their own in the same way that lines can. They can work together to suggest form or movement, but no individual mark can suggest these on its own. These marks share one quality with line: we follow them along their direction, and will jump across a space visually to make the connection to the next one. If other marks reinforce the direction of the first, patterns form that convey direction and energy. When they are used to counter and block the directions of other marks, they create a grid of static patterns. Many drawings combine the two, some marks blocking action and denoting static forms, others combining themselves into energy patterns like those of iron filings in a magnetic field.

Because they are not containers for the image in the same way as lines, marks are not associated with edge to the degree that lines are, and are able to be more clearly used to describe the textures or tactility of surfaces. Sets of mark systems used together suggest the complex relationships that can exist between the many qualities of surfaces, rather than the positioning of edges, in space.

João Penalva
UNTITLED 1992

A conscious orientalism is part of the game being played around the dual nature of all marks, most evident in the mysteries that surround foreign languages, which we know have meaning beyond what we see. The marks in the drawing seem to be calligraphic figures, but also become real ones, and the 'written' description across the page surface then becomes the possible description of surfaces in space. A conversation seems to be taking place about language, using symbols we associate with it at all levels. We are encouraged both to see and to talk our way through the drawing.

Tom Norris
UNTITLED 1991

In the search for the architectonic nature of the seated figure, points on the surface have been established as particularly important, or simply noted as they seemed relevant. Some have slowly connected into larger patterns, and lines and edges derived from them. The record left is that of the search for form, as well as of the form itself.

Impressionist and Post-Impressionist artists like Claude Monet and Vincent van Gogh used marks to build up form in this way, just as they built form through colour in their canvasses. The obvious marks in such drawings also heighten the tension between the surface of the page and the implied space of the image. At their most obvious, they seem as much a description of page surface as of subject.

When marks have no implied direction they become stationary points of reference, like the reference points I have mentioned in discussing observational mapping. Such a mark can be made at any point on a surface that seems to have significance either to the subject, or to the process of the drawing itself – it could be halfway across the visual field and be used to mark the centre of the drawing and as a memory aid to keep the placement of a part of the subject in mind. Marks used this way can act simultaneously as mental markers, references for measurement, and as parts of the surface description of the subject.

As a drawing proceeds, these stationary spatial positions will provide the basis for the evolution of linear descriptions and solid form. But in this context the line is being used to consolidate, rather than lead, the description, and one is aware of spatial positioning more than linear force or pathway.

Marie Laurencin
SELF-PORTRAIT AT THE TABLE
1906

*The drawing describes the
local value of things – that
the skirt and hair of the
figure are black – at the
expense of any notation of
light or atmosphere. However,
there is a sense of brightness
that results from the dramatic
interplay of white and black
shapes.*

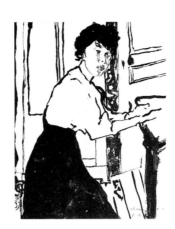

Leonardo da Vinci
THE VIRGIN AND CHILD
WITH SS. ANNE AND JOHN
THE BAPTIST

*Leonardo developed his art
around, and wrote about,
different qualities of light,
and here carefully used an
evenly filtered light to model
the overall massing of the
figures and to pick out their
individual forms in the space.*

opposite Arshile Gorky
THE ARTIST'S MOTHER
1926 or 1936

*The larger forms are distin-
guished from each other by
tonal change, but the careful
modelling of the head and
scarf establishes a solidity of
form that makes them the
focus of the drawing. From
them, we move out to other
tonal relationships to establish
the space of the work.*

TONAL DESCRIPTION

The tonal organisation of drawings is valuable in
indicating different planes of action, and allows
complex forms to be orchestrated in relation to each
other. But it is essential in the depiction of the
lightness or darkness – the value – of objects, or the
effect of light on them.

When tone is used to represent the local value of
something, it describes what we know to be a
constant property of the form, and has nothing to do
with light. We remember that Susan has black hair,
irrespective of light situations that might alter its
value. This is the simplest form of depiction, used on
its own when the black, like the black of Susan's hair,
has particular meaning. At the other extreme we can
choose to overlook the different local values of a form
altogether to concentrate on the way in which light
falls on and clarifies it. Most descriptions deal with
the interplay between the two, and make reference to
the local values of things even when they are
organised around light (see the Seurat drawing of
Aman-Jean, p. 10).

Tone is the pictorial equivalent of shade, and can
only indicate light by describing its absence. It is
primarily from the assessment of light and shade that
we invest objects with mass or volume, and tone
allows us to do that pictorially. The direction of light,
the level and quality of light, and the massing of lights
and darks in relation to each other are all
considerations in establishing volume through tone.
Artists focus on this in differing ways. In the Cézanne
drawing on page 79, the point at which the light
changes is seen to be of paramount importance and is
heightened, while the rest of the tone is used lightly
so as not to interfere with the edges. This notation of
change of plane is common in drawings for paintings,
marking where colour will change.

The more developed tonal forms of da Vinci's *Virgin
and Child (*on this page) are aimed at creating a sense
of sculptural solidity. He creates, in the drawing, a
well of darkness out of which parts emerge like
boulders on a hillside. This making of enclosures –
dark surrounded by light, or vice versa – does not
suggest a light source as much as a common light level.

The same orchestration of light and dark mass is
achieved in El Greco's drawing (see p. 86) through a
clearly stated light source. Both the da Vinci and El
Greco weld solid and space together through tone
that describes a light atmosphere. The atmosphere
indicated by tone is a most important expressive
device. First of all, it situates the image. The massively

enveloping light of some drawings, the minimal notation of it in others, are hints to the setting of the image, even when it is not depicted.

The organisation of the light atmosphere is perhaps the most important consideration in the depiction of large spaces or complex events. Drawings in which clarity is paramount re-create the situations in which we can see most clearly. Things in front of us are most defined when the light is above and behind us, coming from over our shoulder at an angle. In this light, the forms we see have light falling partially across them, and their shadows and the spaces they define can be clearly seen. This is the light we most often apply to images. Interestingly, it is almost always coming from over our left shoulder, which may have to do with our right-handed writing, or with the fact that we read pictures from left to right.

When the light comes directly from our side, we lose some definition of the surface of what we are seeing, but can gauge the distance more clearly in terms of distinct planes of space. Consequently, this cross-light is often used to clarify space.

In addition to its role as a clarifying device, the organisation of the light atmosphere is our principal means of making psychological references to the

above **El Greco**
STUDY FROM MICHELANGELO'S 'DAY'

The massed lights and darks of the figure re-establish the solidity of the sculpture from which it was drawn.

right **Jean François Millet**
SHEPHERD SHOWING TRAVELLERS
THEIR WAY 1857

The journey from dark into light, or enlightenment, is a universal metaphysical one, and light is clearly being used symbolically in this work.

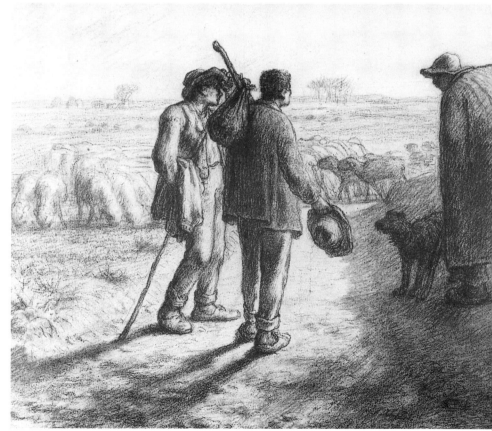

world, and establishing the emotional 'tone' of drawings. Psychologically, our most basic feelings are related to light, and it has taken on the strongest symbolic meanings; rationalists and metaphysicians have vied with each other to claim 'God's light', or the 'light of reason' as their own. In order to transform the emotional possibilities of various kinds of light into pictorial lighting schemes, the artist must create a kind of theatre for these references.

The clear light I have just described implies a rational world. Other light situations have more complex emotional undertones. If, for instance, we are looking into the light, faced with only the backlit sides of other forms, it is generally much more difficult for us to see. We sense our loss of control, but also that we are, together with everything we see, *in* a light. The superior and all-embracing nature of this light has often been used to suggest a larger mystical or religious force.

Light situations, such as twilight, night and firelight, all have powerful emotional overtones and have been used extensively by artists. So, increasingly, has reference to artificial light. The most widely used of these implied light sources is the theatrical spotlight, or searchlight, which goes back from the picture plane into the dark of the space. This suggests that the artist/viewer is the one throwing light on the subject. There is a strong element of exposure in such pictures. As the light reveals those things nearest to the picture plane, it also suggests the possible unseen dangers in the recesses of space further from us.

Artificial light can also come from unexpected directions, and can disturb our normal psychological expectation that the light will come from above eye level. When light comes from below, it disturbs our basic visual methods; familiar forms such as faces are transformed into strange masks. The device suggests an irrational, upside-down world.

Since the Renaissance, artists have been increasingly interested in depicting a variety of different kinds of light – internal, external, natural, artificial. Modern artists have extended this interest to the many conflicting light situations of modern life, depicting objects cut apart by light, or light or dark spatial wells that act independently of each other. In all of these cases, the pictorial possibilities depend on the analysis of where the light is placed, what patterns of light and shadow it would throw on objects and spaces within its field, and the psychological impact of light on the situation.

Ron Bowen
CAT BURGLER 1986

The flashlight at the bottom left becomes the light source for the picture, which is set out as a set of separate experiences, each locally lit, as they might be by a mobile light source moving through a room. At the perifery of these local light centres, other forms are seen half lit, or only vaguely discernible as they might be in the dark.

right **Paula Modersohn-Becker**
SELF-PORTRAIT (?) c. 1897

The soft handling of tonal values across the drawing sets the gentle emotional tone of the work. The lines that define the edges and features in the description are used quite independently of the tone, unlike the integrated use of the two elements in the drawing by Gorky on p. 85. They move discreetly around each other, neither ever intruding on the other mode of description, but occasionally helping it along.

below **Camille Claudel**
WOMAN OF GERARDMER
(VOSGES) 1888

A more gestural and active description than that of the Modersohn-Becker, the somewhat rough handling matches the honest peasant stock of the subject. Again, two systems of description are at play – the lines used to build tone take on a slightly different nuance from those that describe edges.

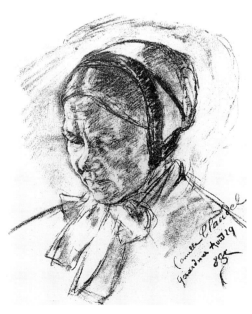

GRAMMAR

We depend on identifying the logical relationships in forms in order to understand any drawing, but we also need variety and difference to keep drawings alive and to move around within them. We distinguish things from each other by their differences. The meeting of complex and simple forms, large and small, patterned and solid, are necessary to keep us looking. The organisation of the use of line, mark and tone in a drawing is the basis for the grammar that develops within it to allow these to operate clearly.

The beginning strategy with which we start a work sets up its overriding structure. The use of a particular spatial system, field of focus or quality of mark will determine the sort of grammar that will develop around it. At the beginning of a work we can decide just how rigidly structured the work will be. If an

Chuck Close
SELF-PORTRAIT – WHITE INK
1978

Close set out a strict grammar for the drawing. A photographic image was divided into a grid, within which each square or unit was ascribed a single tonal value: white, grey or black. Interest is excited by effort required to build up the subtle image from these brutally applied decisions. Features such as mouth or nose can be seen as the complex forms we know them to be, and then dissolve to become abstract patterns as our ability to hold onto the image fades. There is little room to change the system once it is set up. Decision-making can, however, exist in the development of each local pattern, and if these diverge significantly, might be applied back onto the entire work.

operating 'rule' for the use of an element is applied to a work at this stage, the finished work will have the determinacy of the process apparent in it as it progresses. But as the use of the elements in a drawing is developed along the way, in relation to organisational or descriptive need, it becomes important that we respond intelligently to the developing dynamic of the work and expand its grammer to accommodate this.

Even the strictest set of rules might need to be modified slightly in order to describe adequately those things that need to be apparent. Most drawings are hybrids of purpose and, within them, single elements may be used for differing purposes, or different descriptive systems may be used together.

Most often, we set up a loose rule for the function of the element we are using, and start to adapt the element to the different situations we encounter as we proceed. A line might take on the sense of edge in one

place, or imply shadow in another; at one point it might mark a definite change in tonal value, at another, an edge within a single tonal field. We might not necessarily make the line different for each of these situations, and assume that the viewer has the ability to make these distinctions.

In other situations we might need to accent the lines differently in order to clarify the drawing. In the study for *The Seven Deadly Sins* (see p. 91), Otto Dix carefully distinguishes the lines that wrap around the volume of the forms from those that describe their edges and features.

Tone and line are often used with each other to suggest solid form. Used in mutually supporting ways, neither of them will need to carry the whole burden of description. A line describing an edge might not be necessary in that part of a drawing in which a tonal shadow describes it as well. The separation of

descriptive roles may allude to different qualities within what is drawn. Tone may be given over to soft features; line to hard edges.

The purpose of the drawing is a consideration in how much of the description an element will need to take up. The shading of an architect's elevation of a building might provide valuable clues to its solidity, but without complete and accurate edges it could not be built. Such a description would be unnecessary in even the most careful portrait, since the head does not have to be built, but mentally rebuilt.

The complexity of the subject is also important to the development of drawing grammar. In any complex drawing, we must inevitably attribute differing levels of importance to various parts and emphasise them unevenly. These weighted depictions reflect the layering of interpretation and hierarchies of interest we apply when we see. They can be divided into two grammatical types of description.

If different elements add up or support each other in their variety of roles, the description could be said to be consistent. Other descriptions are deliberately inconsistent. In *Suzanne and The Old Men*, (see p. 81), Picasso has set brutal cross-hatching in one area against the simple line drawing of the whole, without any thought to integration. Such descriptions suggest underlying paradox, or conflict, and literally draw out the many-layered aspects of the real.

If parts of a work are developed so differently from each other, how do we make sense of them? I believe that, as viewers, we can relate any two marks on a page no matter how different they are from each other. Nevertheless, random descriptions are not necessarily good drawings any more than overly even ones are, and they raise questions of what kind of overall form can exist in such a work. A drawing *must* raise such questions. If it doesn't, we have most likely not taken the risks necessary to challenge our prior understanding of what we have drawn.

Paula Rego
Study for **CRIVELLI'S GARDEN**
1990

Line and tone are used to construct a rational space that the viewer is able to 'walk through'. But through changes in handling, we are invited to look at each part separately, and size differences and strange events suggest that the world is not as rational as it first appears.

During the making of a drawing, it can at times seem to be making itself. But drawings don't make themselves; rather, the person in charge of their making goes forward in bouts of open investigation and then must somehow verify the nature of what has been made by considering it, and weighing things up.

To do this, we really only have to consider what the drawing tells us. If the forms, no matter how dissimilar, have clear relationships, we will be able to see what is going on. The criterion of information theorists – that only new information is information – seems a good criterion by which to assess the worth of the description. This, in turn, requires that the drawing be succinct. If the scheme we use eventually leads us to draw every eyelash of a figure, that must be essential to the subject; if not it is a wasted and diluting effort.

Edouard Manet
DON MARIANO CAMPRUBI
c. 1862

Freely combined brushmarks, lines and blobs function diversely as edges and features, such as beard, hat and costume. The subject is well matched by the showy technique.

Otto Dix
Drawing for THE SEVEN
DEADLY SINS 1933

Dix made sense of a complicated large shape by accenting important features. The figure in the middle becomes a focal point, and those behind are left as background. While the edge of the combined front figures separates them, their faces are highlighted so that we are led back into the mass.

GAMES FOR
USING LINE AND TONE

GAME ONE
• Make a linear portrait of yourself in a space. Consider the way lines can indicate space and structure.
GAME TWO
• Start by greying the whole page with charcoal. Sit in front of a mirror with the light falling across your face. Position yourself far enough back from the mirror so that you are part of the space, rather than in front of it.
• Make a tonal picture of yourself and the space. Look particularly at the way the light organises the space, and concentrate on drawing the light to realise the forms within it.

K.D. Bahashtion
SELF-PORTRAIT 1992

The artist has placed himself in a complex spatial construction of objects and mirrored surfaces, and describes his containment in this set of enclosures. The line is used in a variety of ways, building up into tone and surface detail. Bahashtion states his close connection to surroundings, for instance, in the drawing of his right hand almost as an extension of the sofa beyond.

Andrew Pankhurst
SELF-PORTRAIT 1992

This drawing has been organised around the effect of the light coming from the left on the objects and the space. Within a space carefully framed by the canvasses on the left and right, the light has been analysed on each surface so that the local value of surfaces – the white T-shirt, for example – and the solidity of the light construction are equally noted. He has not given precedence to his own portrait; it is handled as any object would be. The resultant image is one of calm order and solidity.

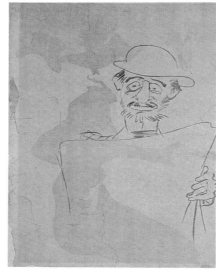

Henri de Toulouse-Lautrec
SELF-PORTRAIT

*The humorous self-image is characteristic
of the incisiveness and economy that
exemplifies Lautrec's descriptions of his
surroundings. The liveliness of the
drawing is in contrast to the obvious
seriousness with which he and his
photographer (far left) together
approached the photographic record.*

opposite **Anonymous**
18th-CENTURY CARICATURE

*Caricatures such as this were distributed
in prints as part of a new political
openness. They were often scathing
attacks that played upon the physical
characteristics of public figures.*

Anonymous
**THE EXECUTION OF MARY QUEEN OF
SCOTS AT FOTHERINGHAY CASTLE 1587**

*There is no appeal to emotion here. The
distanced overview is formal, detached
and carefully historically accurate.*

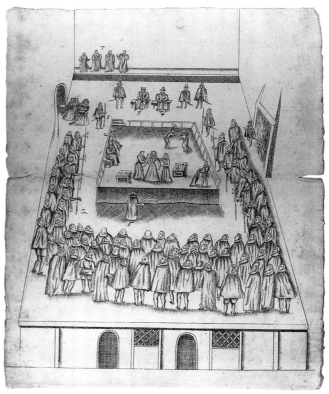

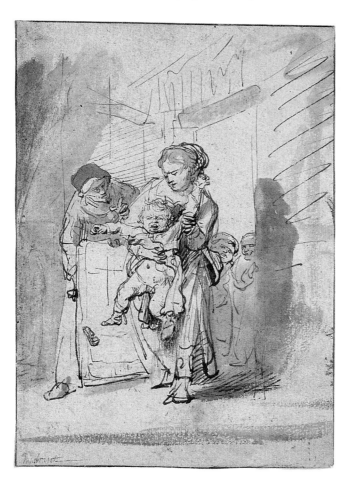

Rembrandt van Rijn
THE NAUGHTY CHILD c. 1635

*It is in his drawings that Rembrandt
reveals most fully his humanist's eye by
recording the richness of all manner of
observed human conduct. The control over
narrative content that pervades all his
work grew from a drawing process that
developed his abilities of immediate
response and the orchestration of a wealth
of anecdotal observations.*

CHAPTER 4
DRAWING TO RECORD

Drawings can be described as reports to the future about our experience. The previous chapters of this book describe the drawing process in terms of choices about the nature of that experience: choices of visual clues in the seeing process, choices of strategy and language for depicting it. The investigation is a cumulative process in which we find out what works by trying things out. In order to put these experiments into some kind of order, we give value to one over another depending on which image seems more real. What is right in depiction is determined by our first purpose in drawing – the proposition made at the beginning of this book that drawings are first and foremost affirmations of existence, and that all such affirmations are records, not only of what is depicted, but also of the artist, through mark and language. In this inseparable union, the connection to the thing 'out there' is the generator that initiates the process.

The record of the past that we derive from drawings consists of ideas and plans as well as of physical presences, relationships, actions and events. If we can record what is out there, we can also record what is in the mind's eye, with the same need to give our projections independent existence. We can project the recording into the future, since the mental process by which we piece together our histories is little different from that by which we construct a notion of a possible future from our experience. In considering what is out there, the artist must also take into account the part to be played by a prospective viewer, and add this future audience to the equation of drawing concerns.

OBJECTIVITY AND SUBJECTIVITY

When I ask students to use drawing to simply record something, they often react as if I've taken their souls away from them. In a cultural milieu that places a high value on individuality, artistic expression and dispassionate description are seen to be incompatible. The separation of subjective response from objective reality is based on the view that the seeing process and objective recording are both passive activities. At the other end of this projected polarity, the subjective participant expresses how he or she actively feels.

We know, however, that the seeing process is extremely active and speculative, so much so that it would be virtually impossible for any two of us to give the same description of a shared experience. Descriptions of the objective world inevitably also identify the consciousness describing it. The objective and subjective meet in description. The only question that matters is 'If I describe this for the future, will it be a true reflection of how it is?'

To consider oneself before considering the external subject of a drawing is to put the cart before the horse, or more properly, the response before the subject. At any rate, subjective response more often than not involves picking up a drawing method and using it automatically as *my* style. The imposition of such formulae is a modern equivalent to the use of academy pattern books that describe how to draw figures in basic shapes, and is equally constricting. It might work well to start with, but will eventually short-circuit any possibility that exists of learning from the experience of looking outwards.

It is an easy trap to fall into. The cult of the individual has shaped our idea of history, and we identify artists by their styles, overlooking the variety of approaches they have used to arrive at images, and the larger cultural stew of visual languages they appropriated. Without such experiments and exchanges, ideas of reality would never have changed in either culture or art.

We live not at the end of a single historical line but at the end of many, from different cultures and epochs. The wealth of descriptive languages in use in our eclectic culture presents both great freedom and real problems of choice. If we can choose from these languages and mix them freely, where do we start? Our only surety is that we must build an idea of the connection between the existence of the thing being drawn and its image, developing and testing the language of the work around the essential features of its subject.

As this language evolves, we search for that which fits our formulation, but also for what doesn't fit. The record we make grows through such discrepancies, our successive changes becoming part of a more sustained response to the subject. I am an advocate of developing the complexities of this outside existence – through the development of oppositions, alternate simplifications, changes and elaborations in one or many drawings.

This experience across drawings builds a larger idea of the reality into which single experiences can be placed. This larger response is one that we might identify as style, but the word is too smug and static. Our response must remain fluid and open to the possibility that each new experience will contribute to the evolving formula.

Memory plays a role in this process. Artists such as Rembrandt or Leonardo, whom we associate with acute observational abilities, have been credited with prodigious memories. The convincing street scenes of Honoré Daumier were not often drawn from life, but remembered. The most important thing for us to acknowledge is that these artists directed their memory responses outwards to the subject rather than inwards to themselves.

opposite **Honoré Daumier**
A CLOWN

*Daumier was a shrewd observer of street
life and public activities. He did not,
however, draw the activities directly, but
relied on his strong visual memory and
retention of detail to re-create the events
afterwards. The image was intensified
through this sifting process, and
channelled towards its main ingredients,
while the frenzied handling and
convincing gesture restore immediacy to it,
conveying the sense that the action had
been 'caught' during a performance.*

Vincent van Gogh
SELF-PORTRAITS

*This page of studies is indicative of the
importance that Van Gogh attached to
fidelity and honesty in his work. In
images of himself and his immediate
surroundings, he set up objective reference
points by which one could enter his
intensely subjective vision of the world.*

Thomas Gainsborough
Study for **A PORTRAIT OF A WOMAN
WITH TWO CHILDREN**

*The artificial studio set-up and carefully
posed group are typical features of the
family portraits that softened but retained
the symbolic features of the official
portraiture from which they sprang.*

above **Jean Cocteau**
PROFILE OF JEAN MARAIS

With the simplest of descriptions, Cocteau depicted the star quality of the actor, as part Greek hero, part flamboyant dandy.

left **Hans Holbein**
HENRY VIII WITH HENRY VII 1536-37

The elaborate detail of this drawing creates the sense of richness and grandeur that confirmed the greatness of kings. The setting of frieze and architecture is a microcosm of the Renaissance world that was embodied in the court. At the centre of it, in a stance that states power in no uncertain terms, is the king, his lineage included in the figure of his father.

opposite **Ron Bowen**
DRAWN FROM THE HEART 1982

This image of the body is seen from a position centred on a point from which a blood sample was taken. It deliberately emphasises the sorts of distortions that occur when images are viewed at very close range.

SELECTION AND ELABORATION

In his book, *The Mind of a Mnemonist,* A.R. Luria describes the life of 'S', a man who was unable to forget anything. He was given a state job as a reporter, but failed at it. With no ability to forget any of what he saw, he lost all sense of the relative importance of its parts, and his reports of events were incoherently buried in disconnected facts.

Selection is inseparable from recording. When we decide what has to be included, we simultaneously determine what is left out. In drawing, selections are often quite radical. If one small part of the whole defines the character of what is seen, we might do away with the whole form altogether, leaving only the fragment to represent it.

Elaboration is equally important. Lacking the dubious benefit of total memory, we must sometimes bury ourselves in facts to find out which ones are important. Drawings inch forward in a game of adding and taking away. One should try at least once to draw every leaf on a tree in order to understand what each one is worth. Once we have seen one leaf, the amount of new information carried in other leaves is infinitesimal. One leaf will do, perhaps, as well as the form of the tree. But we seem not to be strict informationists, and there can be value in repetition, just as there might be in the specifics of an image, such as the number of buttons on a coat. Elaborate records have a lot to do with enumeration, but they are also our responses to the richness or complexity of what is seen. The central question is still that posed by Luria's subject: how to control the description so that the parts don't bury the whole.

I have tried, like most artists, to draw every leaf and petal of a group of plants, only to become acutely aware of the intricacies of surface that I was leaving out. If I draw a plant at a distance where I can see all of it – control its form – I cannot see these things. But if I get close enough to adjust the coarseness of my representation, I lose sense of the whole plant. I could decide to adopt one of these positions and accept only the information available to me from it, or alternatively draw as a botanist might, from both positions, combining the two descriptions.

There are strong references implicit in the distance at which we choose to represent something. The distance at which we can see whole figures without undue distortion allows us to feel visually and psychologically in control. We try to maintain this control in everyday life, and this socially neutral distance is the one most often used when we draw.

We live our personal lives at much closer range and routinely correct the visual distortions of images at this distance towards our mental images of them. Any attempt to draw objectively – in a measured drawing, for example – at such proximity creates quite extreme distortions. The most interesting aspect of recording at such close range is that, in the great disparity between mental and visual image, nothing is really predictable. The uncertainty set up is in itself a springboard for re-interpretation, and is given an emotional dimension by the unexpected quality it gives to the familiar. In adopting such a position we are suggesting our place in the description, drawing attention to our position as viewer and describing our close engagement with the subject as part of its existence.

DRAWING AND THE CAMERA

I am developing this connection between drawing and recording in a society that insatiably records itself. Owing to a glut of mainly photographic images, we tend to think of documentation as the area of the camera. We have also become accustomed to the idea of effortless photographic recording, though images made effortlessly are rarely satisfying, and tend to end up shoved away somewhere in boxes. They confirm that the camera is relatively indiscriminate, even when it is intelligently focused or aimed. Studio techniques that add emphasis to photographs, and other devices such as cropping and retouching, are used to bring camera images back towards the selectivity of drawing. But these require effort, just as drawings do.

To begin with, it was the indiscriminacy of the camera that appealed to artists, because they were attempting to break down their own constricting pictorial formats. The dialogue between camera and drawing has continued to be invaluable to all image makers. Those who draw appropriate a multiplicity of camera images and methods in order to understand the state of flux surrounding them.

Whether we actively use camera images or not, our image of the world has been fundamentally changed by pictures of the earth, of the fetus in the womb, the structure of minerals, and X-ray pictures of our bodies.

These images of existences beyond our direct experience are now part of the mental picture we bring to bear on everyday visual experience.

The camera has freed those who draw from the need to record as it does, and the use of drawing and photography, side by side, has clarified the fact that, though photographers may attempt to create enduring images, they can only record the ephemera of situations, while the most fleeting drawings are centrally about establishing existences and are not about ephemera in the same way.

Early photographs were necessarily posed for posterity; now we photograph ourselves in states of transience and select from the expressions on our faces those that are most legible. Photographs often appear with texts, without which most are equivocal. We have come to identify the uncertainty implicit in such images with our idea of experience, but though the idea of making images about uncertainty might appeal, uncertain images are still largely unreadable.

In order to draw expressions, for example, we must actively develop a code for facial expressions. The person drawing invents and simplifies by making choices a photographer cannot make. In such decisions, drawings identify the recognisable core of existence within the ephemeral. We only have to look at the relative lack of odd expression in any drawn image to understand the way it is being pulled towards

this core. Expression, gesture and oddity can only be dealt with in drawing through the establish-ment of recognisable schemes. As artists, we don't have the capacity to make what we cannot understand; our attempts at making and understanding go hand in hand. In photography, the image is deciphered after it is made; the chosen photograph drawn from the many that cannot be understood.

far left **John Marin**
BROOKLYN BRIDGE 1913

Marin was only one of many artists who depicted the Brooklyn Bridge as a symbol for modernism. The energy with which he imbued his image places the existence of the bridge in a communal idea about the 20th century. It makes an interesting contrast to the photograph (left) which, though it seems to be aimed at a similar statement, has a very different sense about it – we are made much more conscious of a specific historical time in which the image was taken.

right **Jean Cocteau**
BALLETS RUSSES POSTER 1913

The image is of the prima ballerina Tamara Karsavina, also depicted in the photograph above. It was drawn from a photograph, or more likely composed from more than one, and the two can be viewed together as a demonstration of the different sorts of decisions that graphic and photographic artists might make when selecting from many images in order to arrive at the most expressive statement.

EVENTS AND HISTORIES

We remember our lives in terms of situations, which are steady or slow-moving states of affairs, or as events. When we describe things that have happened to us as events, we are placing them in mental 'frames' to give them form and meaning. Like sentences, events have subjects, objects and verbs – something complete has to have taken place. When we depict an event, we construct an overall form for it – a visual parallel to its meaning – into which we place the human elements of actions and gestures. Historical events such as the founding of America are really quite abstract. To depict them, the artist must choose from among the various possibilities to construct an image that symbolises rather than *is* the event.

Our history is a communal narrative that has been constructed, and reconstructed, through such images. It is a narrative that depends on and elicits consensus. The cynical Napoleon called history a lie upon which we have chosen to agree. We know, when we look at history pictures, that we are being set up, that a piece of theatre is being presented to us. Drawing has been used on its own to depict historical personalities more than historical events. Nevertheless, drawing remains the means by which these historical abstractions have been given form, as well as a human dimension.

If drawings provide the underlying structure that tells us how an event is to be seen in the collective imagination, they can only depict this as a simple geometry – things positioned together, in opposition, or scattered. An example might be the pyramidal structure often used in pictures of events, which conveys a sense of energy collecting itself towards a peak of importance, and dispersing afterwards.

In order to convey the complexities of events, drawings dissect them into their constituent parts, connections, actions and gestures. Hands, eyes and gestures act as indicators that lead us through the picture. We follow these directions of position, glance and gesture to make the connections we need to decipher nuances of the narrative.

right **Jacques Louis David**
THE OATH OF THE TENNIS COURT AT VERSAILLES ON 20 JUNE 1789 1791

The dramatic curtain signifies the wind of change blowing across an epoch. The important event is a still point and apex of the composition. We proceed forwards to it from the left, and are pulled back towards it from the right.

opposite above **Francisco Goya**
Drawing for **LOS CAPRICHOS**

The war-sick and brutalised Europe of the Napoleonic wars was chronicled by Goya in works such as this, which focuses on the inhuman behaviour and misery of the times.

opposite below **Reginald Marsh**
Study for **CONEY ISLAND BEACH** 1934

Marsh celebrated the activities of ordinary people. He gave events a sense of heroic energy in packed compositions, like this one, which catch us up in the precarious building of the symbolic pyramid along with the participants.

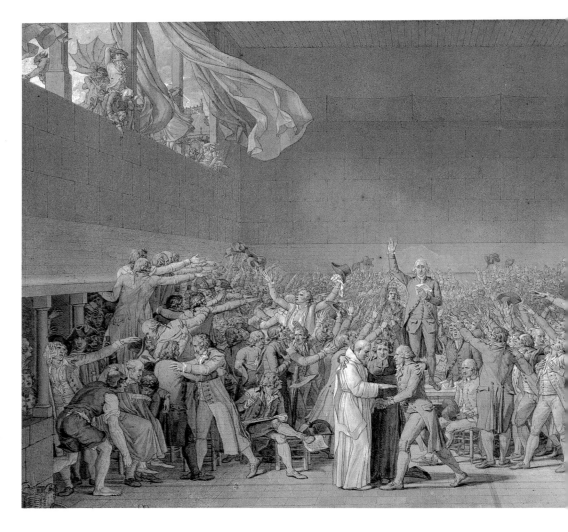

Actions and gestures allow us to read historical meaning at the human level, in terms of our own bodies, emotions and possible actions. While grand, or rhetorical, gestures are indicators of the symbolic scope of events, more minor gestures also communicate to us, and clarify them at the level at which drawing works best: that of individual existences. It is at this level that artists have depicted events critically, from outside the consensus, in images of suffering, or of the body, that remind us of the possible human cost involved in grand historical ideas.

On a human scale, any relationship of actions can be a kind of event, and makes its own history. Now that the depiction of our cultural history has been taken up principally by film, drawings are more likely to portray events at this everyday level. Still, we often use the same structures to suggest a peaking of energy in time, and the same problems apply: of assigning a meaning to an overall form, and placing individual intentions and actions into it.

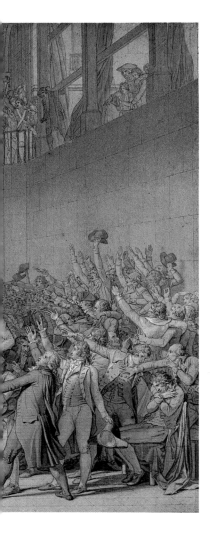

TYPES AND CHARACTERS

When we see, we place images into categories, or types, and define individual differences in terms of deviation from them. Our vocabulary of social types needs to be highly developed to allow us to cope with the different sorts of behaviour and personality that we might encounter in our everyday lives. They provide us with the stock of images we use to depict people and events. When we draw particularities we can only do so against these general identifiable types.

Culturally, it seems we both define our ideal images and depict our differences from them. Renaissance artists arrived at a canon for the ideal, but made portraits and genre paintings that described far from ideal personalities, undermining them in humourous sketches and subversive caricatures of the famous.

The Enlightenment, and the democratic revolutions that ensued from it, created new social conditions from which personality types and behaviour emerged that we can recognise and understand now. These sweeping social changes heightened, if anything, awareness of the great gap between cultural ideals and the realities of human nature.

While high art pursued its elevated themes of grand events and myths, artists such as William Hogarth reacted to the obvious hypocrisies of the times in images of satire, humour and rage, and the emerging popular arts – which were essentially drawn and printed – identified the way the world was experienced at street level.

An all-out cultural effort was needed in the eighteenth and nineteenth centuries to develop ways of establishing normative values for this new non-aristocratic and increasingly urban society. In this dramatic shift of focus downwards, to the group, images were influential in identifying the visual characteristics by which new forms of social behaviour could be categorised. The emerging discipline of psychology spawned multiple theses about the physical traits that typify personality, and artists became engaged in the pursuit of images to express them. In their attempt to establish the normal, artists looked to the abnormal and deviant, visited asylums in a bid to identify where their own tenuous claims to sanity lay, and depicted criminals by category. They developed the exaggeration of individual differences from the norm in caricatures. From these evolved new pictorial types distinct from the ideal of the academies. By the mid-nineteenth century, a new cast of characters had infiltrated all the arts, high and low, and the new, modern play was ready to begin.

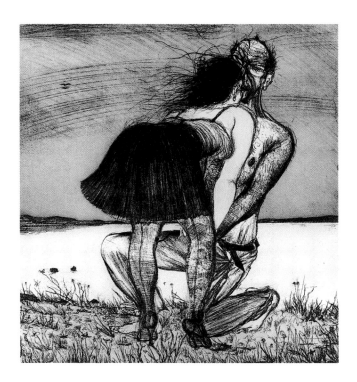

Today, we can still identify with these images. And some of the many sub-casts are still there to be read in the art of our time: the political cast, the street cast of low life and slum folk, to which we have added our own – the muscle beach cast, for example, or the teenage cast, and I guess, finally, the existential outcast. Since this stock of types has been taken up by film, television and visual narratives such as comic strips, as well as by artists, the exchange continues to take place between images that are aimed at very different audiences.

Virtually any work we make about the public domain will have to set up its casting structure so that it can be understood. But we must also be able to adapt and change our images to new conditions in our surroundings. We are more likely to find the basis for new types below our developed public perceptions, in the private domain, where characters do not fit facile categories, but retain their complexity by the power of individual characteristics that suggest 'existences' beyond stereotypes.

opposite above **Henri de Toulouse Lautrec**
Study for **THE LAUNDRESS** **1888**

Lautrec and his contemporaries were fascinated by the lives fleetingly glimpsed on the streets. This drawing is centred on the class of the woman depicted, and his response to her situation.

opposite below **Jean Etienne Dominique Esquirol**
INSANE PATIENT from Esquirol's Des
Maladies Mentales **1838**

The treatise typifies the efforts of the new behavoural sciences to catalogue physical characteristics that were indicative of aberrant social behaviour.

above **Jock McFadyen**
CRAMOND 2 1992

Cramond is an island in Scotland – undeveloped and remote, but quite near Edinburgh. It is the kind of place that urbanites might visit for the day, and in his image of a courting couple, McFadyen has focused on the overt sexual play that we associate with such forays into nature.

right **William Hogarth**
GIN STREET

The drunkard has remained a social stereotype. Cheap gin was one of the means by which people were kept in their place, and there is also a more general critique of society implicit in this image.

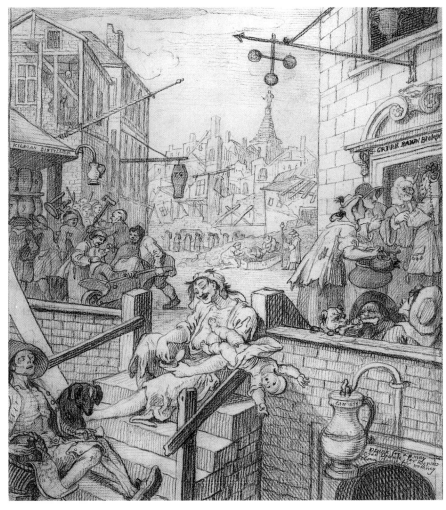

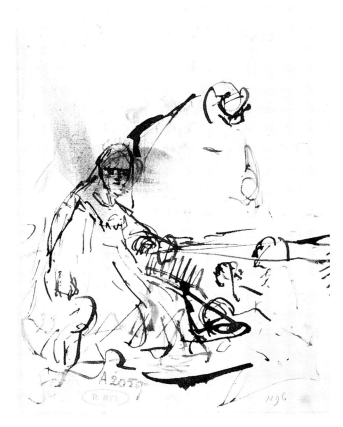

left **Rembrandt van Rijn**
HAMAN KNEELING BEFORE
ESTHER AND AHASUERUS

below **Sergei Eisenstein**
Sketch for a scene from
IVAN THE TERRIBLE

opposite **Ron Bowen**
Preliminary reconstruction of the
AUSTRALOPITHECUS
ROBUSTUS, FEMALE 1979

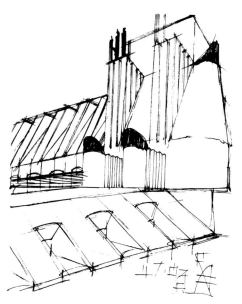

above **Merce Cunningham**
Notes for SUMMERSPACE

Cunningham defined the
overall structure of the space
in order to analyse a form
that will only be realised over
the time in which the event
takes place, and which will
raise it from being merely a
sequence of events.

right **Antonio Sant'Elia**
POWER STATION 1913

For Sant'Elia, the most
important buildings of the
new city were those that
embodied its real energy, and
he centred his vision of it on
the electricity that was to
make it run.

RECONSTRUCTING THE PAST
CONSTRUCTING THE FUTURE

We construct a credible existence or history for
ourselves by convincing ourselves that life is, or was,
as we see it. But the further back we go into our
personal or communal past, the less sure we might be
of what in fact took place. Nevertheless, we feel the
need to realise as completely as possible what might
have been or what might still be. Conviction and
uncertainty have always had equal footing in
historical and scientific investigation.

Records of this sort are statements of our belief at a
certain time – to be revised and even subsequently
disproved. In such constructions, single images stand
for entire value systems. This was demonstrated to me
during my involvement in drawing reconstructions of

Homo Habilis and other protohuman creatures in East
Africa. Reconstructions of these creatures have
changed as information has accrued about them.
Dating techniques have established that they appeared
on earth much longer ago than was previously
imagined, and full skeletons have been found, making
a more convincing case for posture, and so on. But
the physical information hasn't changed nearly so
much as representations have. In 30 years, the
depiction of one such creature has developed from a
hairy and rabid one holding a thigh bone, to a rather
more gentle one holding young ones. The stance has
become more upright, the hair shorter and less
obvious. These features all suggest that the creature
is visually closer to us, but the representations are
based on no truly verifiable information. What we
are making here is a type with which we can identify.
Over the years, the debate about the beginnings of
humanness has shifted, against much opposition,
from a centre in Europe, and challenged the predis-
position to justify aggression in evolutionary terms.
The images made around this changing picture were
chosen for their iconic ability to encourage this
change of awareness.

In such depictions we promote the idea of certainty
about the past. We also need, sometimes, to establish
some certainty about the future. We visualise how
things might be, as a framework for further analysis,
by making notes to ourselves. The process differs
greatly, but in all fields, people who plan complex
projects use such notations.

Choreographer Merce Cunningham makes many
sketches of possible movement groupings in which he
plots where his dancers will go, using his own hand
action as a guide to the speed and dynamics of move-
ment he wishes to employ. Sergei Eisenstein is only
one of many film directors who have used drawings
similarly, in order to break down the complexity of
their ideas into visual forms they could control.
Painters also use drawings in this way. The one by
Rembrandt, on the facing page, is only one of many
sketches he made of different aspects of the biblical
story of Esther, as part of his intention to paint it. In
all these cases, the 'reporter' is making personal
notations, serving as his own, and only, audience.

We may, however, want to display certainty about
the future to an audience. We have been psychologi-
cally prepared for air and space travel, for new cities
and styles, as well as for new ideas and utopian
visions, in drawings such as those of Antonio Sant'Elia,
which attempt to convince us that this is the way a
new idea will make us feel and act in the world.

A GAME FOR
RECORDING

- Make a drawing for the record that includes a self-portrait with objects carefully chosen for their personal associations.
- Choose your point of view carefully, considering the angle of description, and your distance and placement in space. This should be an almost full-figure drawing. Consider your relation to the objects – you can hold them, have them closer to the picture plane than you are, or surrounding you. Try to integrate a gesture or stance into it that you think is typical, or even symbolic, of you. Develop this as a sustained drawing, to be returned to a number of times.

left Yolanda Chetwynd
A SYMBOLIC SELF-PORTRAIT
1992

The artist has placed the important centres of her life around her – her young son, a picture of her husband with symbols of his profession, and her working materials as an artist. One can only admire the Herculean task of drawing with a young child held in one hand, but she may be used to it. The work was made with a variety of materials, brush and ink, gouache and chalks, and is on the borderline of becoming a fully painted image.

opposite Hannah Moody
SELF-PORTRAIT WITH
OBJECTS 1992

The image seems to be a casual one, but has been rather formally constructed. The garland of flowers, the landscape and animal forms of the paintings in the studio room, and the fact that she is bare-footed, all establish the artist in relation to nature. She has also included some favourite objects, such as a necklace she often wears, and holds one of the small statues of horses that she has collected. The difference in scale between her hands and feet, and her body, indicates that the picture was made quite close to a mirror, and we can feel the closeness of the portrayal.

right **J.M.W. Turner**
**VENICE, VIEW FROM THE
LAGOON 1840**

*The drawing of natural forces
was at the centre of Turner's
work. Like many artists, he
travelled to see both natural
and man-made wonders.
Venice, a great edifice that
had been built by the
imposition of control over the
sea, was in many ways the
perfect Romantic's setting for
his themes. In this work he
combined the two great
subjects of natural force and
cultural grandeur.*

below **Francesco Clemente**
UNTITLED (SELF-PORTRAIT)
1984

*The use of drawing as a
continual journal has been a
major theme for artists in this
century, and Clemente is one
of the many who have used
self-portraiture as the central
image in an extended
psychological documentation
of their lives.*

opposite **Michelangelo Buonarroti**
THE RISEN CHRIST

*This image typifies the way in which
artists of the Renaissance depicted the
male human body as a symbol for the
restless energy of their epoch.*

right **Christopher Wood**
SIAMESE CATS 1927

*Animals in both their wild and tamed
states are a major subject of drawing. In
this calm domestic setting, the image of
the cats summons up the sense of comfort
that permeates the drawing.*

CHAPTER 5
DRAWING SUBJECTS

We come to recognise the central focus, or subject, of a drawing as we make it. In that sense, every drawing has its own subject. But when we connect our drawings to those of other artists working throughout history, we can identify themes that run across our culture and through time. These themes form bonds between our visual experience and that of other artists and cultures that go back to the earliest images. The complex relationships that exist between natural environment, communal existence and individual identity are universal features of the human condition. Traditional subjects in image-making have developed as symbolic reference points for represent-ing these universals, building up to allow increasingly complex ideas to be developed around them, changing as these ideas have shifted.

With rapid changes in living patterns, the pace of these shifts has accelerated enormously, and the development of print, photography, film and television has meant that the profusion of images through which we define these relationships has increased accordingly. But essential subjects have resurfaced, reinforced by their ability to withstand the assault of change.

As psychological foci, subjects transcend all the images of a culture; popular culture and advertising have provided a larger base for the development of symbolic visual imagery than the fine arts ever could have. Within this image base, drawing has taken a role independent of the major arts as a tool for recording, and has developed distinct approaches to subjects on its own. If there is a cultural goal embedded in this shift towards a continual drawing project, it is no less than the cataloguing of all living and cultural forms. Each drawing functions within it as a single part of a large mosaic, to be reassembled in groupings like the ones in this book.

Charles Lebrun
EAGLE AND MAN

The identification of human visual characteristics includes totemic associations. This one *of a large set of human/animal types drawn by Lebrun, clearly indicates the symbolic strength of the animal as reference point.*

above **Eugène Delacroix**
AN ARAB ON HORSEBACK ATTACKED BY A LION

The primeval struggle at the heart of the Romantic vision of the world was often given animal form. Two of Delacroix's most used animal images — the powerful but tamed strength of the horse, and the wild cat — are here combined in a typically exotic image of that struggle.

above right **George Herriman**
Original drawing for **KRAZY KAT**

Dogs, cats and mice have lived around humans since the earliest settlements, and feature prominently in the safe narrative territory of cartoons, where we can take pleasure in their innocent aggression, and even provide them with the weapons with which to act it out.

right **George Stubbs**
SIX STUDIES OF A LEMUR

As an inheritor of the scientific revolution, Stubbs was an untiring investigator of animal form. His best-known pictures of dogs and horses were meticulously researched, based on numerous dissections and anatomical studies. The curiosity with which he approached these stranger creatures is as evident in the drawing as is his attitude to anatomical detail.

ANIMALS

In today's world, most of us have little direct contact with animals, yet we retain a great deal of contact with them at the symbolic level. We surround young urban children with animal images and cuddly toys, encourage them to name animals they have never seen, and generally give them a place in, and control over, a symbolic animal kingdom. We use animals as national, local and team symbols to describe our group identity, and we confer animal qualities onto individuals when we speak of a friend as moving like a gazelle, or being as strong as a bull.

These associations connect us directly to the magical relation to animals that is at the heart of our first cave images. These were images of control, but also of transferral of energy, and identification. The Shaman figure in the Lascaux cave is depicted, or dressed, as part animal. What is apparent in these early depictions is the complexity of the symbiotic relationship between human and animal, and the admiration that animal qualities inspired in humans.

This totemic identification continues in both events and images. Ancient rites of struggle and transferral are still enacted in circuses and bullfights, though in the latter part of this century we have become increasingly uneasy with both. Representations of our symbolic relationship to animals permeate art. Images of the subjugation of the wild, the domestication of animals, or of the establishment of an idealised peaceable kingdom bring together cultural history and religious ideal to symbolise personal integration. It is the wild part of ourselves that is being brought under control, the lion in us that is lying down with the lamb.

Following the emergence of the natural sciences, the recording of animal types, structures and habitat became part of the effort to catalogue the variety of forms in the natural world. Despite the rational and ordered spirit of the enterprise, the disturbing disparity between image and process – artists such as John James Audubon killed as many as 25 creatures in order to make the essential image for the future – indicates just how complex our attitudes can be towards other living creatures.

To make any retrospective judgement of Audubon's methods is to look back from a current situation in which animals in the wild have not only ceased to be a threat, but have to be kept alive. Our attitudes to wild animals have changed with the knowledge that those we used to fear from afar are now our wards. We have de-fanged the wild creatures, and now depict them as maternal, familial, humanised.

Our depictions of animals contain ambivalence at all levels that seem essentially related to the duality between empathic identification, and the realities of the use of animals for food. Artists have been drawn to depict both the contented sheep in the field, and the carcasses of slaughtered animals as if they themselves were hanging on the hook.

The bond between human and animal is universally expressed in our identification with our pets, and our appreciation of them as personalities. These days, we display our animal identities through ownership. The person who might once have been ceremonially named 'The Bulldog', is now more likely to own one.

Drawing allows us to focus on the power of single images as symbols. In drawn representations of animals we have reappropriated the symbolic qualities we attach to them, and we deal with these through attitudes ranging from the highly romanticised to the comic. If we are surrounded with animal images now – and we are – we are using them as cartoon creatures to act out our lives.

NATURE

The vast cultural complex in which we live has developed strict controls over nature at all levels. There is no part of the globe that is not the subject of some kind of human development or control. We have images of our global natural environment that confirm the breadth of control we exercise over it, even as they present natural disasters beyond control. Nevertheless, the first warm day after winter can remind us of our individual connection to a larger natural rhythm, just as any severe storm can reawaken in us the state of awe in which humans have always lived in their natural environment.

Yet, we are basically tourists in our natural habitat – or those parts of it we maintain in a 'natural' state – and when we choose to experience nature, we move out into those natural features carefully and with fully developed support systems. Our symbolic representations of nature are formulated in cities or urban complexes, and are made at some remove from raw experience of it. This is not changed by the fact that drawings or paintings can be made in the landscape; they are the images of visitors who view it in terms of 'framed' symbolism.

Even in the smallest artificially natural spaces, like the parks and gardens we use as refuge from urban life, we still find symbolic identity. These symbolic frames exist at all levels of perception, whether we are finding the underlying form in a flower, identifying ourselves with wind-torn trees, or constructing images that combine several perceptions to give us command over a panorama of natural forms.

Drawing is instrumental at all these levels – at the first, as the principal means for the investigation of the details of natural form; at the others, as a means of piecing together the rhythms, symbols and forms ranged around us when we construct our symbolic landscape in time.

We have inherited attitudes and visual histories for these subjects from the different relationships that our ancestors established with their environments. From the Mediterranean cultures that had subdued and radically changed the lands they lived in and largely deforested them by the time of Christ, we inherit the classical tradition for depicting nature as a set of clear, controlled and orderly structures. The Romantic aesthetic that rose out of the very different environment of northern Europe – which remained forested until the late Middle Ages – stressed the feel of its mysteries – and events, and seems existentially caught up in the exhilaration of its forces.

Landscape as a subject on its own has only been developed since the increasingly urban culture of Europe in the sixteenth and seventeenth centuries divorced most of its citizens from any direct contact with the land. The ability to travel increased tremendously during this time, and tourism as we know it started then. The grand views encountered by these travellers perfectly suited the new symbolic needs of this changing world. Artists were very much a part of this travelling class, and drawing was their principal means of depicting these views, presaging the act of painting in the landscape by two centuries.

During these centuries, the landscape had come to symbolise, on one hand, expanding horizons and ideals of nationhood, and on the other, something lost, an essential relationship to be regained. From clearly arranged pictorial views, to wildly heroic vistas, landscape subjects represented different symbolic natural orders. Our notion of where symbolic beauty lies in nature is still changing. Areas we have come to see as having great natural beauty at the end of this century were completely dismissed – not even seen – at the beginning of it.

Even if we now exercise a control over nature to a degree impossible to imagine at the beginning of the century, our sense of place in it is, if anything, more uneasy than ever. The ecological argument is a debate about our connection with, or control over, nature that challenges our most imbedded traditions. It has refocused artists' attention on the land, and the drawing of landscape has had a great resurgence, seeming to represent that natural part of us that we are now in danger of extinguishing.

below **Henry Tonks**
TREES BY A RIVER BANK

The tactility of the depiction of the glade with its web of interlaced forms suggests the kind of intricate, mysterious enclosure that was to symbolise the landscape for European artists as diverse as Titian and Jacob van Ruysdael.

above **Paul Cézanne**
LA MONTAGNE SAINTE-VICTOIRE 1902-04

The subject is one to which the artist often returned in his attempts to place pictorial structure on natural form. The classical origins of the work are apparent in its strong sense of control and the way in which the forms of vista and mountain have been ordered.

right **Hans Hofmann**
UNTITLED 1942

Hofmann treated the land-scape as all over pattern, without any real focus. The land, buildings and clouds are described in a cursory but very tactile way, which leads us to climb through and across the forms rather than view them from a vantage point.

CITIES

The sprawling urban complexes in which the majority of humans now live stretch for hundreds of miles, and the support structure developed for them covers the globe. If all roads no longer lead to Rome, they lead to one of the hundreds of cities to which humans have continued to gravitate since the Middle Ages.

Cities are the centres of image-making in all cultures, and city images have come to symbolise our political and cultural identity in the same way that landscape images do our relation to nature. Whether, as artists, we respond to the grandeur of cities, or their crowded and chaotic surface, we are using these elements to stand for the nature of our communal life.

As planned structures, cities are symbols of order. Cities such as ancient Rome were symbolically oriented to the world, with principal streets, the *cardo*

above **Karen Bowen**
Photograph of **PARIS GRAFFITO** 1991

An example of the sort of anonymous artworks that are features of all cities, but which differ from one to another. If those of New York are made up of elaborate signatures and those of Berlin politically inspired, Parisian graffiti are most often based on cultural and film stereotypes.

right **Georg Grosz**
STRASSE 2

Grosz sited much of his biting social satire in city images. He depicted the city as a disjointed, chaotically busy, somewhat sinister place, throwing up a multiplicity of images, stories and juxtaposed lives – both a voyeur's paradise, and a moralist's hell. The drawing might be compared to that of Hogarth on p. 105.

and the *decumanus,* oriented north-south, east-west.
Such large complexes provided protection for wealth,
and the means for some of the group to be relieved of
responsibility for anything but thought, as well as art.

However, they also required the people within
them to become directly dependent on larger political
control in order to eat and sustain themselves. The
fact that the *agora,* the original political meeting place
and forum for ideas, was the market-place, emphasises
the importance of the distribution of food to city
dwellers. Revolts against the political order have most
often been sparked by food riots, and the institution-
alised dependence of city dwellers underlies the
disturbing disparities between wealth and deprivation
that we recognise in cities today. Cities are above all
political centres, and the ways in which we live
together in them, and the images artists use to depict
them, imply some kind of political stance.

Cities are also psychological centres, bringing the
complexities of human nature together in situations
that break down any sure patterns of communal or
family life. Traditional bonds may have to be snapped
in order to gain intellectual and artistic freedom, but
their loosening produces social strain, and under it,
cities become the centres of the worst excesses of
behaviour. The sense of dispossession we now

associate with cities has always been associated with
them, as has the display of sexuality and decadent
behaviour that follows social dislocation.

Drawings have been used to describe the city in all
its aspects. They have been the instruments for
planning the ideal city, from Thomas More's Utopia to
present-day plans for new cities. But cities are not so
much planned as they are the result of historical
accretions. Such complexes are beyond our visual
scope and we use drawings of streets and transport
systems to make up the mental maps by which we
place ourselves in them. Drawings can uniquely
describe the proliferation of images that confront us
at street level, and graffiti mark the sometimes
desperate attempts of city dwellers to establish
identity within such enormous organisms.

Great cities have distinct and heroic personalities in
our communal mind through which we channel our
ideas of cultural grandeur. We react to the rejoining
of the two halves of Berlin the way we might to
someone who has overcome a terrible illness.

Despite their apparent logic, cities throw people
together without any order. Living in them, we have
images thrown at us in the same way, juxtaposed and
packed close together. We refer to the phenomenon of
urban overload; the condition of simply not being
able to make sense of our environment. Artists, as
principally urban creatures, have responded
ambivalently to this confusion, representing the city in
terms of its absurdities, attracted to its energy and
visual possibilities while repelled by its human cost.

Even now, the city is changing from definable
conurbation into megalopolis — vast urban/suburban
tracts that stretch from Washington to Boston, or
make up Greater Tokyo. These have fractured the city
in unpredictable ways. The *agora* has become a
thousand shopping precincts.

Paul Cézanne
STILL LIFE

In the theme of still life, Cézanne found a vehicle for uniting his search for pictorial permanence with everyday

existence. The convention of using fruit, the most impermanent of subjects, is traditional in such pictures.

left **Vincent van Gogh**
SKETCH OF A BEDROOM

From this simple drawing of his room, it is easy to feel the way Van Gogh lived in it — where, for instance, he hung his coat or washed. It says much about his devotion to a simple life.

opposite above **Edvard Munch**
MAN AND WOMAN IN BED
1890

Tenderness is rarely so unequivocally stated in the artist's intense look at human relationships.

opposite below **Mary Cassatt**
THE COIFFURE 1891

Nineteenth-century European pictures of women dressing or bathing were strongly influenced by the Japanese prints that appeared at the time.

AN INTIMATE WORLD

As the communal spaces in which we live become more densely packed, our private space takes on the role of an essential psychological refuge. We surround ourselves with objects that make us feel secure,

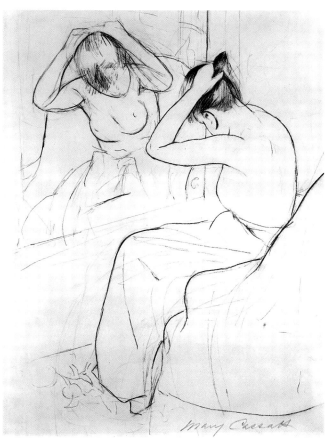

choosing them carefully, and identifying our personality through them. The measure of our affluence is determined by what we can gather around us. We signify our attitude towards affluence, as well as our taste and refinement, by the things we choose to gather together.

Our living spaces, and the objects we fill them with, reflect both our position in the world and our family, and individual separation from it. When we invite others into our living space, we are giving away part of our identity – making ourselves vulnerable – and this vulnerability is overcome by the ritual of the invitation, and by symbolic profferings, like the food or drink we offer to guests.

Images that refer to the gathering and display of personal objects, and to rituals of hospitality identical to those we use now, appear in ancient Greek and Roman art. In the ruins of the villas of Pompeii there are depictions of bowls of fruit that seem clearly intended as offerings of hospitality to the visitor or viewer. They are given no specific historical context, but are placed in a dimension in which the symbols work on their own across time. These are the beginnings of the subject of still life, through which artists have affirmed both the sensuous nature and symbolic order of domestic existence in the representation of familiar, everyday objects.

Still life developed as a vehicle for depicting the intimate world of our senses at a time when domestic spaces were relatively public centres for the extended families of merchants and those who worked for them. Between the seventeenth and nineteenth centuries, the formal hospitality that these houses embodied was replaced by increasing emphasis on privacy, as a new breed of merchant or civil servant poured into ever-larger urban centres. Within cities, village-like patterns of local activity were diffused. Communal activities, such as washing clothes or bathing, were drawn into the house. Family units became smaller, and the intense intimacy of these smaller family groups was followed by a psychological shift towards privacy within the family.

Images of domestic space have taken on this new shading. The house that was the focus of earlier depictions has changed from a social arena to become an intensely private one in the hands of nineteenth- and twentieth-century artists. The image of the central role of women in domestic existence has shifted from that of organiser to that of intimate companion. Families, which used to be portrayed as social units, are now as often depicted in terms of an intense and complex psychology.

PORTRAITURE

Portraits confirm our connection with other people across time and space at the most direct and empathic level. They have often been images of power and status, but have come to be focused on the face, the psychological centre of our presence and connection in the world. By looking at history through the images of individuals, we are establishing an identification that requires us to consider our own place in it, as subject, inheritor and equal participant, and to understand history in terms of individual existence. As official portraitists, artists have functioned to confirm the achievements and positions of individuals in history. They have also affirmed their own personal existence and place in the historical record through intimate portraits and self-portraiture.

The first conventions for portraiture did not require individual likeness. Name, social position and symbols of office sufficed to denote the person. The first identifiable self-portrait, of the artist Niankhptah (2,650 B.C.), is of a schematic figure seen from the side, with art implements to describe his role.

The most common portrait convention prior to the High Renaissance was the silhouette, or portrait from the side. It could be said to be essentially a tribal description, the shapes of the nose and head being distinct features by which one group could be distinguished from another.

This was gradually turned around to become the portrait we associate with 'the direct gaze'. The change towards this viewpoint parallels the emergence of the idea of the individual over the group. The availability of mirrors to the affluent, who could now 'view' themselves clearly, gave precedence to this mirrored, confrontational point of view. The image is dramatically changed. As viewers, we are turned from onlookers at the tableau of history, into participants with direct, personal connection.

This shift to individualism introduced a new element of psychology into portraiture. The introspective self-portraits of artists such as Rembrandt have shaped emerging ideas of the psychology of the individual. In his life-long series of self-images, there exists a penetration of understanding that speaks directly to us three centuries later. These are arresting images; the artist seems to challenge us as he challenges himself to a new level of understanding.

The direct mirror image has become a self-portrait convention. But we have a lot of visual information about ourselves we can use without resorting to the mirror, and artists who use their self-images to

Käthe Kollwitz
**SELF-PORTRAIT WITH THE
HAND OF DEATH 1924**

In the presence of the inevitable, the aged figure is both strong and vulnerable; the half-protective gesture she makes affects us even without our being able to place it fully.

James Gillray
**PORTRAIT OF GEORGE
HUMPHREY JNR**

The drawing, made at the time when Gillray was losing his sanity, has a certain lunatic quality about it. Nevertheless, he lost none of his observational acuity or wit, and the drawing has a real sense of the person that he is depicting.

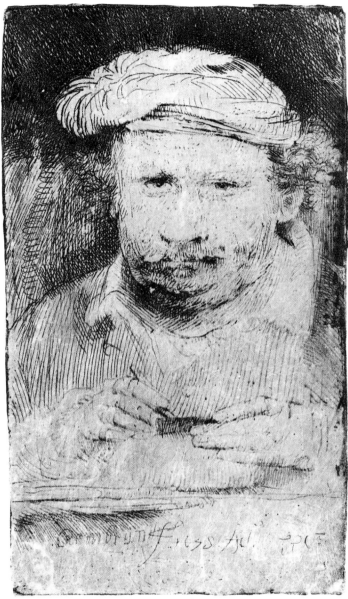

Otto Dix
DADA SELF-PORTRAIT 1920

Dix drew himself as the social rebel, laughing in the face of absurdity. The image is a general likeness, rather than a careful one. The likeness is intended to reflect his declared social stance.

Rembrandt van Rijn
SELF-PORTRAIT 1658

In his search for his own image, Rembrandt confronts us with the uncompromising nature of honesty. The work transcends any reference to personality and comes to be about self-examination.

indicate emotional or psychological states objectify themselves from other positions that do not imply the mirror connection of self to self-image.

Portraits require a pact between artist and subject about a symbolic if not literal truth. Without this level of intensity, portraiture is debased; in the service of the vain, portraits simply become cosmetic lies. They must operate at all levels of truth; symbolic form, stance and relation to the viewer are as important as likeness. When Gertrude Stein complained that Picasso's portrait didn't look like her, he replied that it would in a hundred years. Seventy years later it has become the image by which we recognise her. And by which we judge whether photographs of her look like her as well.

A SHORT NAKED HISTORY

As social animal or natural force, as our own experiential site for growth and decay, and for desire, the body is itself the most potent symbol for our deepest levels of connection to the world. It is both a mental and physical 'bodyscape' on which we act out extreme conflicts between our ethics – the constraints we place on our animal natures – and our desires. Artists have continued to find ways in which to use this powerful symbol with some freedom, in and around the taboos that surround its image.

The body is a focus of such powerful energies on its own, that artists have often been able to deal with it more freely in drawing than in the complex narrative context of painting. Nevertheless, the symbolic narrative histories in which we place the nude are important, and it is essential to understand the way in which these historical meanings still determine our attitudes towards representing the body.

The first images of the body we know are from a set of small statuettes and carved images that have come to be called the Venuses, which date from as far back as 30,000 B.C. They are blatantly sexual images of the goddesses of the female cults that were at the centre of cultures that depended on the female lunar calendar to assure their livelihood. These images disappeared with the cultural change to solar-oriented agrarian cultures, and although images of the sun were given male attributes, the naked body disappeared as a subject until the rise of the ancient Greeks.

Classical Greek culture first developed images of the body around the male figure, but continued on to develop both male and female images as god-like personifications of cultural ideals as well as psychic states. Each had a place in a mythical universe that combined psychological insight and cultural metaphor.

The goddesses that they allied to the natural forces of forest (Artemis) and sea (Aphrodite) were also those of the female-worshipping cultures they had displaced. The male Apollonian gods were identified with the sun, reason and control. They acted out their mythical conflicts and attractions in a relatively amoral sexual atmosphere in which the observation of codes of respect was important, but the notion of sinfulness we attach to the body didn't exist. Dionysiac cult figures were depicted alongside the idealised gods – all manner of behaviour existing in a state of divine grace.

With the advent of Christianity, these ideal figures were buried but never quite lost, and they emerged in new biblical forms, as Adam and Eve, saints, and in the symbol of the body of Christ himself.

FOUR ATHLETES c. 525 B.C.

Greek art developed around the image of the nude, particularly the active male body. Images such as this one exude the pride and self-confidence that typify Greek attitudes towards it. The images on vases were those of mythical events, but also of the sports and games in which men competed naked. The Greeks attached great importance to this nakedness, since it signified the conquest over inhibitions that they considered primitve. With such images, they integrated this pride in the body into the ethos of human wholeness that was central to their thought.

above **Pablo Picasso**
STANDING FEMALE NUDE

Picasso was strongly influenced by classical images of the female nude in arriving at his own modern classicism. This drawing makes straightforward reference to that imagery. The pose suggests the coiffure, the bath and the mirror, all associated with Venus. In its modelling, the drawing aims at the solidity of classical sculpture.

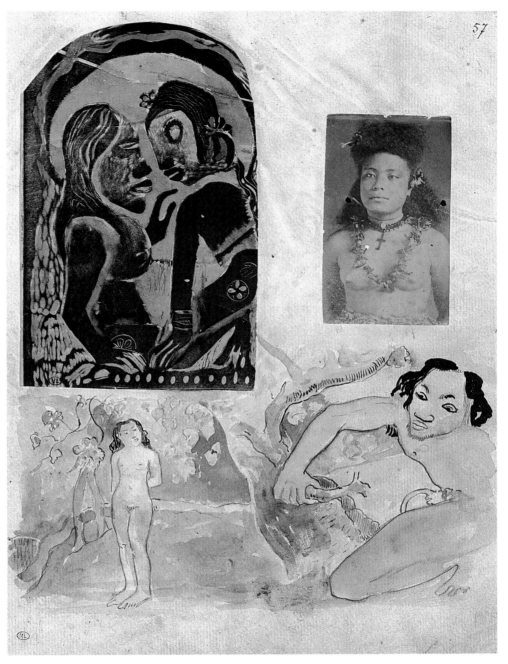

above **Paul Gauguin**
Page from **NOA NOA 1901**

The works that the French painter made in Tahiti combine native, classical and Christian references, with exotic surroundings and a Rousseau-like romanticism. The many references are evident in this page from the chronicle he made of his Tahitian sojourn. In it, the figure is depicted as a primitive idol, and also as a classically posed Aphrodite or Eve, with the heavily sensuous features of his Tahitian mistress. In his Romantic's heart, the South Seas were a perpetual Eden, even if he was aware of their increasing corruption during his visits. His Eve waits in this Eden of the Tahitian landscape for the Adam in hiding.

In the Renaissance, these Christian symbols were represented alongside their re-emerged classical prototypes, and the two narrative histories allowed artists to represent both psycho-sexual and moral struggles. The humanist interpretation given to the Christian focus on suffering and transcendence, and its strictures on sexual conduct, contributed to the body image becoming increasingly a centre of conflict, martyred as Saint Sebastian, flayed as Marsyas. The sciences affirmed the new scientific order by dissection, the fate of common criminals. There were numerous historical events to promote this sense of unease – recurrent plagues and social diseases racked Europe over these centuries.

In the face of all this, the mythological universe carried on as a central pictorial theme, both as playground of the gods and communal sexual fantasy. It formed the most enduring conventions we use now:

the alliance of the female body to nature in reclining, passive, landscape poses and water images; the male, to activity, verticality and physical extremity.

In the academies that grew up to serve this image-making, these conventions were neutralised, and became part of the investigation of the figure encouraged by the Renaissance to engage with the pursuit of the ideal within the real. But even here, the taboo surrounding the male figure required that it could not be seen by women artists. Even as the drawing of the figure became one of the preliminaries of art training, and the most seemingly neutral of activities, this continued, making it clear that in the depiction of the body there is no neutral territory.

At base, the academy existed to provide symbolic figure constructions for mythical histories, and centred on the male nude. But even as it flourished, it became increasingly removed from the changes in social structure, and the emerging psychology of the eighteenth and nineteenth centuries, as well as the Realist aesthetic that accompanied them. Realist artists

fundamentally opposed the ideal image; we have inherited from them their concern for the specific and the existential. They could not, however, easily find a way to fit the naked body into the narrative of ordinary life without making overt sexual reference.

Often they did. Francisco Goya's *Naked Maja* and Edouard Manet's *Olympia* were as scandalous as they were, not because they were particularly sensuous – much more overtly sensual pictures were shown in the academy regularly – but because they were contemporary and frank. They had to be interpreted in the real terms of the sexual mores and duplicities of the cultures they represented.

As the Realist position became dominant, images of the body moved permanently from a mythical universe to what could be termed 'locations', in the film sense, of the seashore and the bath, which could

place these mythical associations in an ordinary context. The female body appeared increasingly in images of prostitutes and mistresses, or as part of the private lives of artists who felt the need to expose this layer of psychic connection, or whose bohemianism freed them from social constraint.

The male nude largely disappeared from these works principally because no reasonable realist scenario could be developed for them that did not have unwelcome overtones. Those who did depict it, such as the American Realist Thomas Eakins, did so in terms of real but idealised male communal activities, such as bathing or wrestling. Eakins himself was forced

out of the Philadelphia Academy after taking off his clothes for a female student who had never had the opportunity to draw the male body totally naked.

Towards the turn of the century, the limits that Realism imposed on depictions of the body forced artists to look for new ways to represent it freely. They did this first by looking backwards to classicism, and to 'primitive' sexual frankness, or looking inwards, with modern psychology, to the amoral universe of the mind itself. The mental hell of both the first and second World Wars was followed by use of the body as political metaphor, and by a tortured Christian iconography. Later in the century, realism

right **Philip Pearlstein**
FEMALE MODEL LYING ON A BED, FEET ON FLOOR 1975

We seem to come across the figure during a disinterested scan of a room. The odd placement and partly covered face of the model typify Pearlstein's devices for approaching the figure as a 'natural phenomenon'.

opposite above **Alberto Giacometti**
NUDE WITH FLOWERS (LUST 32) 1960

One feels the power of the existence of the model for the artist, who seems to be there to capture it. The attitude is in opposition to that of Pearlstein.

opposite below **Ron Bowen**
COLIN 1991

The cropping suggests that, though the figure is that of an individual, the category 'man' is more important than personality. The focus on sensate awareness is developed by careful observation of surface.

opposite far right **Max Beckmann**
ADAM AND EVE 1917

The moral breakdown following the first World War made the expulsion from Eden the most cogent of subjects. Beckmann depicted it in terms of the greatest despair.

has resurfaced as companion to the casual nudity that has become part of the hedonistic strain in contemporary life, but also to establish individual existence in opposition to the – largely photographic – ideal image of the body, as a symbol of the age.

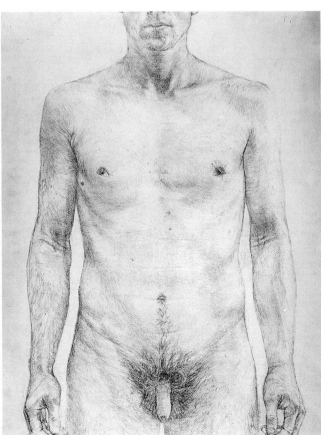

The communal drawing of the nude in art schools has become a highly intellectualised ritual of initiation into the idea of artistic control and restraint. The setting itself implies a social control over the body image. When artists depict the nude in the studio, the conscious appeal to this convention of neutrality is a refuge for the investigation of underlying themes.

Whatever the setting, twentieth-century depictions of the body are rarely ones of ease. The politics of the century mitigate against that. Often the studio has something of the dissection room about it – the image is truncated or displaced. It could hardly be otherwise. The proliferation of images in our century has highlighted the elements of control and exploitation inherent in image making. With an image as potent as that of the body, the possible exploitation of the person represented comes to symbolise the situation of all others like them. Equally, we have become aware of the collusion that exists between model and artist, and the role of the depicted in the depiction.

right **Balthus**
Study for **NUDE WITH CAT**
c. 1949
The combination of heightened
gesture and intimate
circumstance directs us
towards the internal world of
the girl's dreamlike state. The
combination of religious and
sensuous gesture suggests
a subversive fusion of ideas
of ecstasy.

opposite right **William Dobell**
NATIVE SCRATCHING HIS
BACK 1953

This drawing is of a gesture
caught by the artist that
conveys for him some essential
feature of the subject in its
own right, without further
meaning being attached to it.

opposite far right **Jean Auguste**
Dominique Ingres
CHRIST HANDING THE KEYS
TO ST. PETER c. 1820-1841

This study for a larger work
places the figure in a
narrative, and is intended to
convey meaning as part of it.
The general sense of the
gesture is both familiar and
readable, but its particular
meaning is unclear outside of
the larger picture.

GESTURE

Gesture is the language of the body. The automatic
mannerisms we all have – biting our lip, flicking a
lock of hair away – are physical clues to a state of
mind. The way we walk and appear in ordinary
movement says much about how we are – what Leon
Battista Alberti called the soul in the body. Depiction
of the psychological element of our communal life
depends on keen observation of these revealing
physical traits, and artists have always made telling
statements about the way in which ordinary gestures
suggest the psychology of what they see.

But we also use gestures overtly, to suggest attitude,
to convey feeling, to elicit response. From the moment
we wave to a friend or gesticulate in conversation, the
actions become part of what we want to say, and are
rhetor-ical devices. At the personal level, gestures are
perhaps our principal means of communication. The

range of our gestural expression, which starts with
nuance, extends to the overt and extreme gestures of
heightened emotion, and of public rhetorical or
theatrical gesture. The more symbolic the event, the
more we are likely to resort to an obviously symbolic
gesture to affect it. In order to understand the
gestures of others, we must be able to read them, and
to do this we are reliant on a vocabulary of shared
gestures. We have – every one of us – amassed an
array of readings that we apply to the gestures we see.
These, however, must be communally understood and
agreed upon in order to be effective.

Gestures have the possibility of being ambiguous,
and the more spontaneous they are the more
ambiguous they are likely to be. We have all seen
photographs in which people have posed in obviously
symbolic attitudes inherited from history. But we have
also seen others in which extreme emotion is
obviously present, but we cannot tell whether it is

intense joy or grief. The context of the action is important to this reading, since the gesture is directed so inwardly that it cannot communicate on its own.

Rhetorical gesture is not then simply a stopped action, but rather a selected action specifically directed outwards; the relation of gesture to action may be expressed by comparing the gesture that a winning runner makes when crossing the finish line, with the actions that brought him or her to it. To the degree that such gesture is part of a communal language of expression, it is the language of the mime and actor in all of us.

Such languages are derived from the many symbolic possibilities of the gestures around us. From this language of gestures, artists select some which are accorded heightened pictorial meaning. When we look at the art of past centuries we must place the gestures within them into this specific pictorial context in order to understand them.

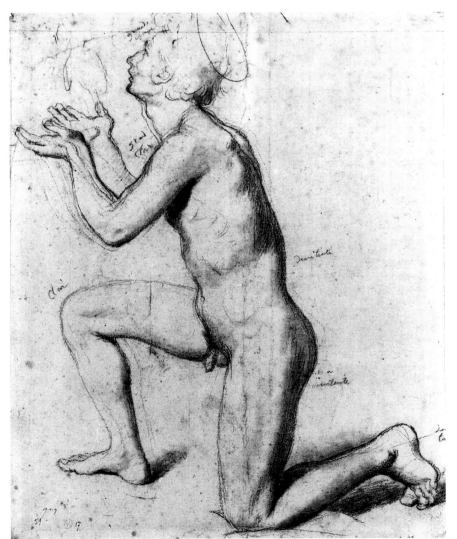

HOLDING REALITY DOWN

Throughout this book, I have described our experience as one of continual movement and change as we move through the space of the world, and it moves around us. If life is essentially a flux of change and motion, in our minds we have a sense of there being a constant reality beneath. Still images have a natural association with this 'arrested' reality. They exist in a continuous unchanging present, confirming our inner belief in the constant images we carry with us through time, and providing us with unchanging images to consider and reconsider as we never can in experience. Nevertheless, they are made over a period of time, and in a specific historical time, and consequently bind our complex ideas of time and timelessness together.

We see the timeless images of the quattrocento as symbols of their time although the century was marked by change and upheaval. We have declared our own century as one of movement, and are perhaps even more attracted to the stillness of these images because the idea is foreign to our lives.

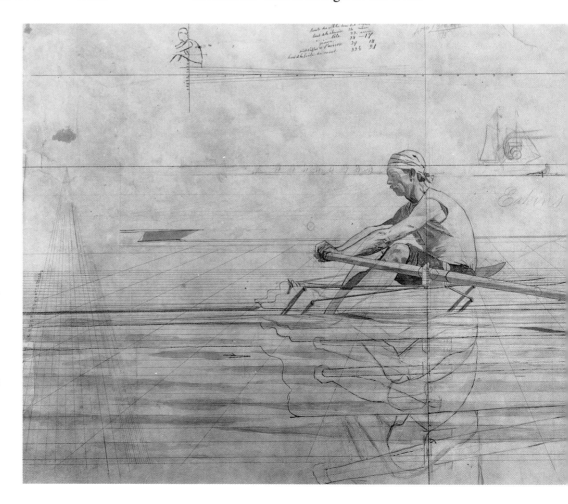

above **Giorgio Morandi**
LARGE STILL LIFE WITH PARAFFIN LAMP 1930

The solitary world of this artist is one that aims at a still state. The ordinary objects Morandi used are arranged in their almost hermetically sealed spaces, to pose symbolically for us, rather like a family group.

right **Thomas Eakins**
Perspective drawing for **JOHN BIGLEN IN A SINGLE SCULL**

Eakins's works were often of athletic events, though the stillness that was inherent in his meticulously realised world led him to depict the pause between actions rather than the action itself. This study contains the celebrated rower in a web of perspective lines that suggests a world in which everything has its place. As viewers, we pause in the still moment just before the rush of movement that we know will follow.

All drawings are static images, but drawings directed towards timelessness do so by articulating this stasis or stillness for the viewer. They encourage us to step out of time, to look carefully in a way we do not in ordinary life. This pause in our ordinary speed of looking stands for far more than its own brief duration. Such images are sometimes quite slowly made, and are arrived at by compiling the image from many minute observations in time. When we make images of stillness, we arrive at the symbolic truth through a fiction, carefully controlling the subject and situation to arrest it in believable fashion, artificially removing any trace of the mosaic of fragments, setting up sometimes extreme procedures to create the enduring image. The sitter for a portrait is not allowed to move, and is constantly re-positioned by the artist to maintain the impossible static pose, to be drawn one feature at a time.

As viewers we are very sensitive to nuances of time in the image. The 'captured' time of drawings is quite unlike the 'stopped' time of photographs. We

right **François Clouet**
PORTRAIT OF A GENTLEMAN

In this classical portrait, the sitter is positioned carefully and held in place for careful inspection. The image was developed in such detail that we must read it over some time, opening up different parts and examining them in the way that the artist has, then returning to place the detail of each part into the context of the whole. Our sense of time is extended by a process that becomes a symbol for timelessness.

sometimes sense time paused in an image, or it can seem to be lightly held, or forcibly held down. This follows from the making of the mark itself. Drawings of stillness have, before anything else, to control the movement of the viewer's eye. The more carefully the image is made, the more the sense that the unhurried image exists outside of time. Anyone who has made such an image knows that one's sense of time is suspended during the making process. The image allows the viewer to forget time, just as it has the artist who constructed it.

GAMES FOR
INTIMATE DESCRIPTION

GAME ONE
• Consider yourself in relation to someone else or to your surroundings. Try to depict this in a careful portrait of either yourself or a close friend.
GAME TWO
• Attempt a nude or semi-nude picture of yourself or a friend incorporating an interior and a reference to the world outside – through a window, or as a second image.

left **Ron Bowen**
NICK 1984

This drawing was made of someone who has often posed for me. He was asked to take up a position that he often assumes ordinarily. 'Relaxed' positions of this kind are actually the most difficult to sustain, and so the drawing was done in more than one session. The total time taken over it was about three hours.

opposite **Sharon Brindle**
SELF-PORTRAIT IN FRONT OF WINDOW 1991

The artist has drawn many images of herself. In this one, she emphasises the relationship of natural forms outside the room to her body, and includes props, such as the cloth with its symbols, and the cat's-head shaped container, that have symbolic overtones. The description of herself is not so much realistic as hieratic – the specifics of features are subsumed under the general form, and the sense of connection to images of goddesses is quite strong.

above left **Cecil Beaton**
SERGE LIFAR 1928

*The action is represented in a
series of superimposed, stopped
positions, placed together in a
somewhat schematic fashion.
The effect is similar to that of
a multiple-exposed
photograph. It might be
compared to the more active
Leonardo on p 137.*

left **Roy Lichtenstein**
SWEET DREAMS, BABY!
(POW!) 1965

*Sense-related symbols and
words are often used in
popular narrative images in
order to describe action. In
this case, lines of force des-
cribe movement, written sound
describes force and contact.*

above **Katsushika Hokusai**
FOOTBALL

*Movement is expressed in the
extreme off-balance positions
of the figures. To these we
add our knowledge that the
suspended slipper must be in
mid-flight, and that the ball
is not a permanent appendage
to the head, but has just
landed there.*

opposite right **Marcel Duchamp**
NUDE DESCENDING A
STAIRCASE, NO. 2 1912

*Duchamp used the familiar
form of the nude as a base for
a movement machine. He
reverses our sense of what is
'real' by making the
movement more solid than the
figure itself.*

TIME AND MOVEMENT

The rush of time we experience in our century has been expressed throughout it in images of motion. We can, after all, engage our senses with change and motion, but we can only 'sense' time. It is a paradoxical sense: of our moving forwards through time, and time moving forwards through us – and at many different speeds, at a stately pace, or in a rush. As we grow older, time seems to pass more quickly than when we were young. It has been suggested that our cultural sense of time is similar, and increasingly expresses time in rushed images as it goes on, just as older people describe the experience of rushed time.

Our experience of the world is inherently one of motion, and artists have always had to find codes for depicting moving forms. We are pressed to our most extreme when we are attempting to depict moving forms with still pictures, and the manner of their depiction is determined by obvious pictorial strategies

to a degree not apparent in drawings of still images.

At their most representational, images of movement are attached to stilled form as we follow it with our eyes. However, there is nothing more static than an image of a moving form that refuses to excite ideas of movement in us. Rhythms and clues to movement have to be placed back onto such forms so that we can somehow move ourselves through the drawing and ally that movement to the image. We have codes for movement based on our visual processes, such as the movements we make with our eyes when we follow a moving object. We also have movement memories based on our own experience of our body's movement through space, and the paths of force we make in the world. We have knowledge of some actions, like the throwing of a ball, that we can visually read. And we recognise the 'wagging tail' sort of marks, that come to us from film history. Any contemporary strategy for

left **Rico LeBrun**
RUNNING WOMAN
WITH CHILD 1948

The extreme position and dramatic handling determine our immediate response, and contribute to heighten the drama of an action that turns to comedy when we recognise it as a picture of a truly heroic attempt to get out of the rain.

right **Georges Seurat**
DANCING SALTIMBANQUES

The formalised frontality of the figures ally the image to the classical figures of vases and wall paintings such as those on pp. 127 and 46. Within the silhouetted positions, the limbs of the performers are emphasised differently, and seem to activate one another, making up a dance of forms against the static geometry of the carefully emphasised horizontal and vertical edges that frame them.

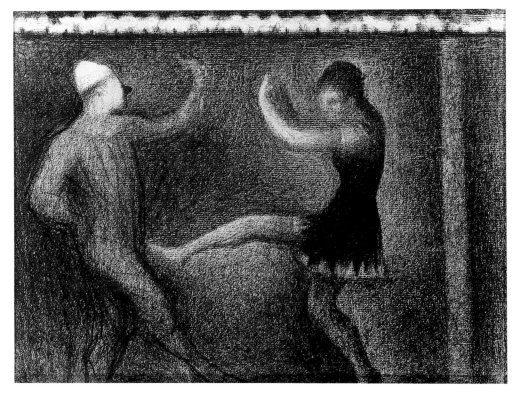

depicting motion owes much to photography and film, and the knowledge gained from them that we can visually stop objects in time, or construct moving images by connecting static ones.

When we draw movement as a subject on its own, we have switched focus away from the object to the abstract patterns we relate to the way in which movement seems to move through them. We establish movement within images through these movement codes. An appeal is being made to our sense of balance in images of an arrested or pregnant action selected out of time, or of an unbalanced action that has to be continued or rebalanced by the viewer. An appeal to our knowledge is made in narratives that place, for instance, a ball in the air. The active or rhythmical connection between forms relies on our kinetic sense; our notion of aggregate or sequential time is necessary to the understanding of any pictures linked in time, whether they are of medieval lives of the saints or strip cartoons.

The appeal to the empathic connection of viewer to the track of the artist underlies all depictions of movement. We make drawings over time, the speed and pace at which they are made establishing the time-scale implicit in them, in which the moving hand of the artist becomes the guide. We follow the graphological movement to recreate the implied one, and construct the kind of 'time' in which it exists.

above **Vladimir Burliuk**
UNTITLED 1913

The artist did not attempt to depict the figure in motion realistically, but used it as a familiar form that could be torn apart and reconstructed easily. The paths of movement that disrupt the form also become part of a larger figure/motion form from which we must recompose the figure in time.

left **Leonardo da Vinci**
HORSE WITH RIDER

The many contours and differing positions superimposed in the drawing are gradually worked towards the most expressive position to be painted. But Leonardo's attaction to the subject of action was directly mirrored in the frenetic attack of his drawings in a way that it never was in painting.

FANTASY

As the symbolic categories in which we place images, subjects are the image clusters around which we weave our imagination. Though they offer us focal points for remembering and considering our existence, in the existential continuum of our lives, they are all connected. There is no single order we could give to them: each has points of connection with the others. Cityscape embodies landscape, man embodies animal, personal life and public life are intertwined, cities and countryside are both related to change and movement, but in different ways.

The making of categories is part of our mental equipment, but so is the crossing over and recombination of categorical knowledge. Subjects are no exception. When we cross-breed images and recombine them in our imagination, we are testing the ways in which one set of symbolic values relates to another.

Over the last century, we have been presented with an ever-increasing number of images to consider in daily life. The more symbolically important of these images persist as we are presented with others and we are almost forced to find some relationship between them. The chance connections that were encouraged by artists in earlier centuries are now a central feature of life. Juxtaposition and imaginative connection are central features of the art of this century.

MAP OF EUROPE 1870

National stereotypes are moulded into a satirical mini-history. Notice the little old lady England with Ireland on a lead, or fat Prussia advancing on France with Holland in one hand, and a knee in Austria's groin.

below **René Magritte**
THE RAPE 1935

The pun is obvious, but the shock of the image comes from the invasion of the convention of portraiture by that of the nude, which becomes much more overtly sexual in the social context.

far left top **ST. GEORGE AND THE DRAGON** from St. Gregory: Moralia in Job
12th century
The invention of monsters is a part of the free play of all imaginations, and in them, we can sense the fertility of imagination shown by previous artists of all cultures. It is interesting, however, to dissect such creatures in terms of the references they contain to animal and cultural behaviour, and to the body.

left below **Max Morise, André Breton, Yves Tanguy, Marcel Duhamel**
THE EXQUISITE CORPSE

Among the many games that exist to encourage visual invention, the most common is the one in which the figure is drawn by a number of people in sections, each participant being able to see only the part they are drawing. It was a favourite Surrealist pastime, and the one shown was made by four leading lights of the movement.

GAMES FOR
DEPICTING MOVEMENT

GAME ONE
• Do a drawing of another person or yourself that suggests stopped action.
GAME TWO
• Divide two A4 sheets into nine sections each.
• In each section draw the relation between two objects from one positon, slightly changing your position between each drawing.
• Make a flip book from them, as described opposite.

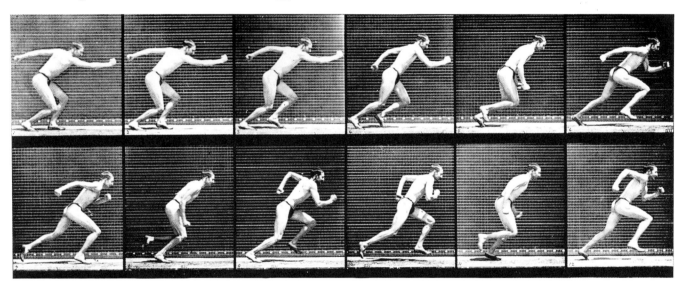

Eadweard Muybridge
THE FIGURE IN MOTION

The serial photographs by Muybridge were made by setting up multiple cameras activated by trip wires. Along with the Zoescope and other visual games of the time that suggested movement, they presaged the modern film. They have had enormous influence on our way of depicting movement.

left **Ron Bowen**
BENDING FIGURE 1988

The image was drawn quickly, but compiled and filled out as the action was repeated a number of times over about ten minutes.

Michael Scott
FLIP-BOOK DRAWINGS 1992

The artist divided a semicircle around the shoes into 18 equal portions, each ten degrees apart, and drew from each one. He was conscious of each image succeeding the previous one, and so the positioning of the shoes on each square of the paper was an important consideration. The drawings have been placed quite close to the right edges of the squares.

TO MAKE A FLIP BOOK

You will need two pieces of A4-sized light card. Divide them into thirds in both directions. With the card held horizontally, choose one end of the sections as the 'holding end' and leave a 2.5-cm (1-inch) space free at this end of each section. Do one drawing in each section. After finishing the drawings, cut apart the sections, put them in order and add two blank pages at each end. With one hand, grasp them firmly at the 'holding end', and flip quickly through them with the other to see the apparent movement. The effect of the drawings as they are flipped over can be seen in the photograph above. The pages can be kept permanently in place if lightly glued along the 'holding end'.

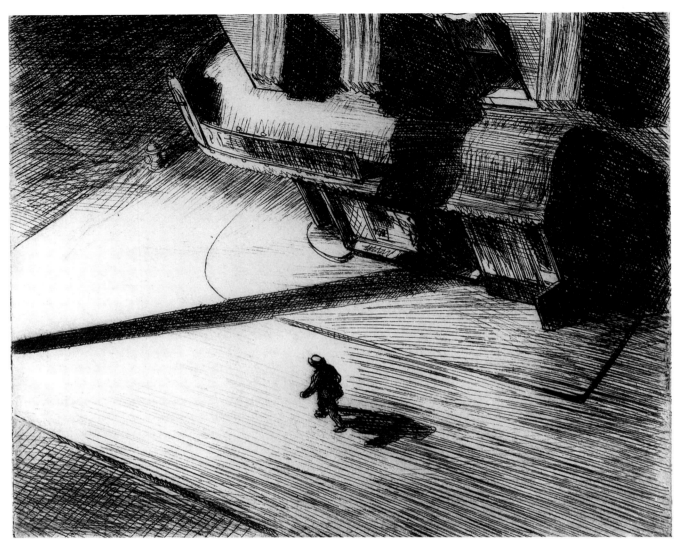

above **Edward Hopper**
NIGHT SHADOWS 1921

In the semi-deserted streets of cities at night, Hopper found an appropriate metaphor for his sense of the transience, dislocation and loneliness of modern day America. This drawing of the single ant-like figure among the enormous and overpowering forms of the street reveals his own distanced and isolated position.

right **Edvard Munch**
OLD MAN AND WOMAN c. 1916

Aging and death were constant themes in Munch's work, which he approached with a Romantic's mixture of alarm and fatalism. In this simple sketch, his approach to the image seems intimate but discreet, as if he does not wish to intrude too much into a rather private world.

opposite **Ron Bowen**
THE FRENCH MODEL 1980

This is one of a series of drawings made to investigate the kind of pictorial decisions we make when we visually assess other people. Each drawing was of someone who 'looked' typically French, English, Italian and so on. Here the pose of the model was carefully chosen to highlight typical features, in this case, a certain angularity, and distinctive profile. She was also positioned so as not to address the viewer directly, but to create a kind of removed, separate world that is 'just there'.

SUMMARY

The communal drawing project I described at the beginning of this chapter is dependent on the differences of approach and emphasis we bring to the images that we make. Our contribution to the larger community rests on these differences. But we also have a responsibility for our images, and must attempt, as a part of the process of making a drawing, to understand where it places us in relation to our subject – what predisposition led us to choose the image from all others possible and what attitude to the subject is implicit in it. From that knowledge we build an idea of clarity, and a more complex approach to the next image. It is in this way, rather than by advanced technique, that drawings get better.

That advancement takes place naturally, as we need to know about depictive schemes in order to do those things we identify as necessary to push our understanding forward when we draw. I said at the beginning of this book that we learn to draw by drawing, but we also learn to draw by looking at all the propositions that other image-makers have used to approach their subjects. This is not as difficult as it may seem. We are surrounded by drawings of all sorts and each one of them tells us something about the situation in which they were made, their purpose, and the artist's relation to the image.

A current theme in the evaluation of all art activities is to consider them in terms of the social conditions in which and for which they were made, and the context or stance in the social structure of which they are a part. It has been a valuable critique for any maker of images, but not the subject of this book, which is essentially about how to use a simple act of depiction in order to understand oneself.

Nevertheless, one of the essential components of self-knowledge is the recognition I have just outlined, of recognising one's position in relation to the image. That position cannot be separated from the criteria of empathy and control I started with. One is led, through drawing what seems to be important, not only to consider what it is like physically, but also where it exists in the mental universe you are constructing when you make it. The point of the exercise is not to over-construct your position so that it is too limiting, but to learn from it to construct others. The idea of position that started with a physical proposition takes on a psychological and ethical dimension when one is led to consider the artist's position, and what the image adds to the stock of personal and cultural imagery.

TECHNICAL DIRECTORY
PERSPECTIVE

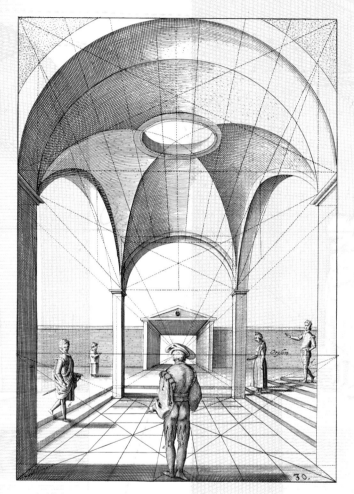

Linear perspective is a system for constructing the orderly recession of space and the objects within it away from the surface picture plane. The apparent convergence of parallel lines as they recede from us is graphed onto a spatial grid into which general geometric shapes can be placed in rational size and distance relationships. Different perspective systems exist to accommodate the complexities of different spatial situations. The one we choose to use depends on our orientation to the space.

One-point perspective approximates what we see when we look 'flat on' into a space. A description of a space constructed using this system is shown left.

Jan Vredeman de Vries
Diagram from **PERSPECTIVE**
1604

This depicts the relationship of the horizon line to the viewer's eye height and to the heights of distant figures. Note that figure heights are determined by the plane of space in which they exist. Though the figure on the right is at the top of a flight of steps, his height has been measured at ground level, and raised to the level of the platform.

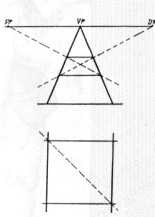

ONE-POINT PERSPECTIVE

1 A horizontal line is drawn that is assumed to be at eye level. It is the horizon line.
2 A vanishing point (VP) is placed on it to which all parallel lines at a 90° angle to the picture plane will converge like railway tracks.
3 Two distance points (DP) are established to which all diagonals of 45° will converge. A line at a 45° angle that crosses parallel lines will establish a depth equal to the distance between them to form a receding square. If the horizontal distances between all receding lines are equal, these squares form a grid of receding spatial boxes.
4 Using these and the VP, we can measure the heights and widths of objects of the same size at different distances, and solid forms can be built.
5 By drawing a rectangle that rises from this grid to 'surround' the VP, and drawing lines from the VP through its corners, we can 'draw ourselves into' a simple rectangular space. Our eye level in the space is at the level of the horizon line. We

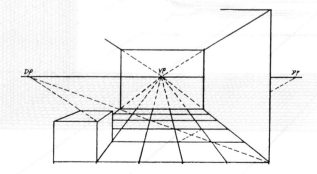

Jan Vredeman de Vries
Diagram from **PERSPECTIVE**
1604

*This diagram demonstrates
the manner in which the*

*diagonal can be used to
determine the shape of simple
solids in different positions,
and circles and ellipses can be
derived from them.*

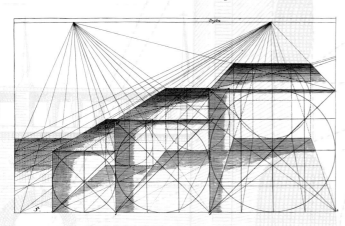

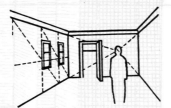

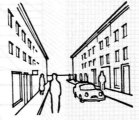

*are also placed right, left
or centre within it by the
placement of the VP (as
shown right).*

*6 Many kinds of spaces can
be constructed this way; a
street or a room would only
differ in which parts of the
spatial box were left open
(see diagrams at right).*

*7 By using the DP diagonals
as edges, we can also establish
solid forms at a 45° angle,
and by plotting positions in
relation to these basic frontal
and diagonal grids, we can
work out many other angles,
and more complex forms.*

*8 The accurate plotting of
forms in this way requires
that they first be drawn in
plan before their positions can
be established on the spatial
grid. Forms such as circles or
ellipses can only be given
outside geometrical figures
within which they can be
drawn.*

*9 If complex forms are to
be placed in relation to each
other, then the entire floor
grid must be planned before
their relative positions can
be established on the
receding plane.*

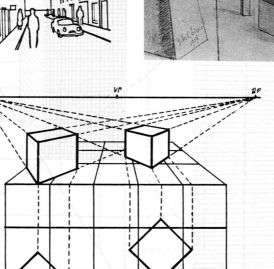

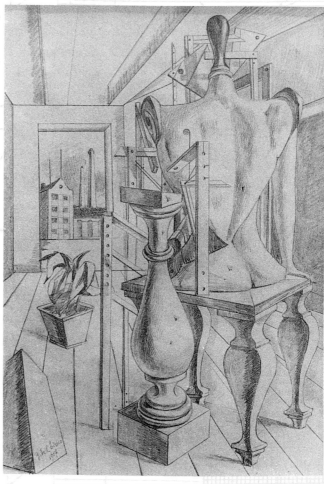

Giorgio de Chirico
THE FAITHFUL SPOUSE 1917

*The use of one-point
perspective contributes a sense
of high drama to the image.
For de Chirico, perspective was
a cultural reference as much
as a pictorial device. He used
it quite loosely here, as can be
seen if the recessional lines
are carried back to their
vanishing points.*

MULTI-POINT PERSPECTIVES

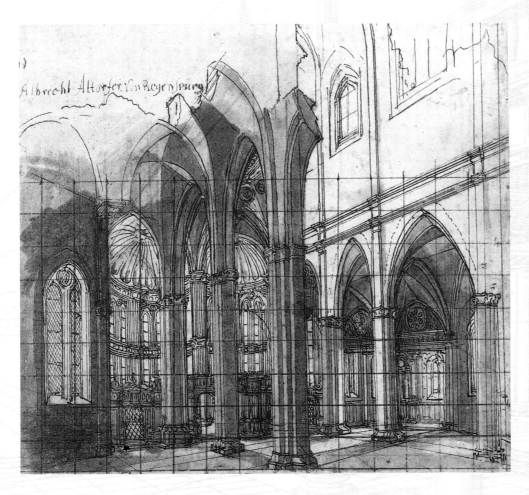

Albrecht Altdorfer
STUDY OF A RUINED
CHURCH c. 1520

*This drawing shows the
complexity of forms that can
be established by determining
squares and rectangles in
space. If we look closely at the
arches and semi-circular
niches, it is easy to see that,
within the general
construction, complex forms
are still being drawn freely.*

Two- and three-point perspective systems were
developed to plot the sizes and shapes of forms in
spaces that are not parallel to the picture plane. In
two-point perspective, the main corridors of space are
at angles to the viewer. The two distance points of
one-point perspective can now better be described as
left and right vanishing points. In three-point
perspective, a third vanishing point is added on a
vertical axis in order to describe the more complex
recession of objects above or below the horizon.
Other projection systems are used as alternatives to
perspective when the need to measure from drawings
is a concern.

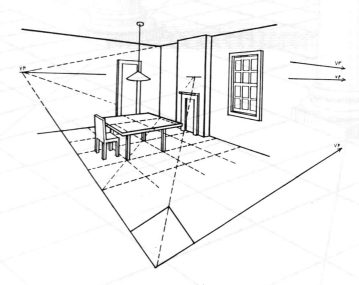

James Stirling
Design for the **UNIVERSITY OF CAMBRIDGE HISTORY FACULTY BUILDING** 1964

The projection system most favoured by contemporary architects is the axonometric projection, which combines the scale plan with a scale elevation of one aspect of a building. Either vertical or horizontal dimensions can be measured directly from such a drawing.

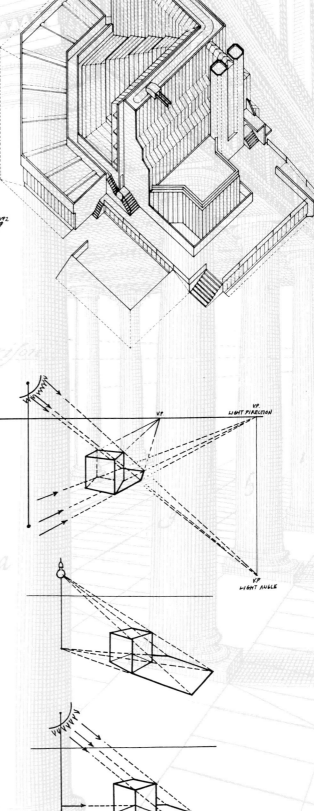

TWO- AND THREE-POINT PERSPECTIVE

1 *The diagonal DPs established in using one-point systems may be used on their own as a two-point perspective system that will establish two spatial corridors at 45° angles to the picture plane.*
2 *At other angles, one of the sides of a cube would recede at a greater angle than the other. This can be seen in the drawing left. Correspondingly, as one of the VPs moves closer to the central axis, the other moves farther away. Their positions can be determined by constructing a plan.*
3 *The height of objects can only accurately be determined by establishing them at the picture plane.*
4 *A third VP can be used to accentuate the fact that we are looking up or down at an object. The farther from the horizon the form is, the more extreme would be this vertical recession, and the closer the VP.*

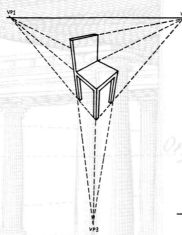

CONSTRUCTING A LIGHT SOURCE

In order to construct shadows as they might fall in any perspective space, we must determine the direction, the position and the nature of the light.
1 *The direction is established at the ground or floor plane, and is indicated by a line drawn on it.*
2 *The angle of the light is established and a line is drawn at that angle near the edge of the drawing.*
3 *The edges of shadowed areas can be plotted by placing an angular line at*

each extreme point of the object, and finding the points at which they intersect with the directional lines, as shown in the diagram.
4 *The rays of the sun are assumed to be parallel, and so the angled rays are constructed as parallel lines.*
5 *The directional and connecting lines that form the edge of the shadow at the ground plane are drawn in perspective, and converge at the horizon.*
6 *Artificial light emanates from a central source outwards, and the rays are not parallel, but are drawn from their convergence at the position of the light. In all other respects, the formula is the same.*

MEASURING AND PLACING IMAGES

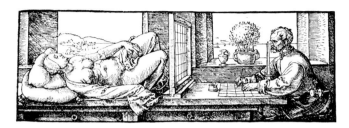

Measurement is used for a variety of reasons in drawing, and different methods are used to aid the assessment and placement of images.

DETERMINING THE IMAGE

VIEWERS allow a rectangular portion of space to be separated out from the larger field of vision. If a similar rectangle is drawn on the page, the image can be transferred onto it. Viewers often have cross-hair vertical, horizontal or diagonal sub-divisions that allow the space to be broken down even farther. GRIDS can be used as simple markers to divide the image vertically, horizontally or diagonally, or they can be more complex. The simplest grids are used as reference points for the placement of the image at the beginning of a drawing. More complex ones can be drawn on mirrors, glass or other transparent surfaces. Used as viewing plates, they can help us to establish the positions of forms much more closely. The image can be drawn directly onto the transparent surface through which it is seen, or onto a similar grid drawn on paper. In order to use them, the eye, grid and drawn form must remain in the same position in

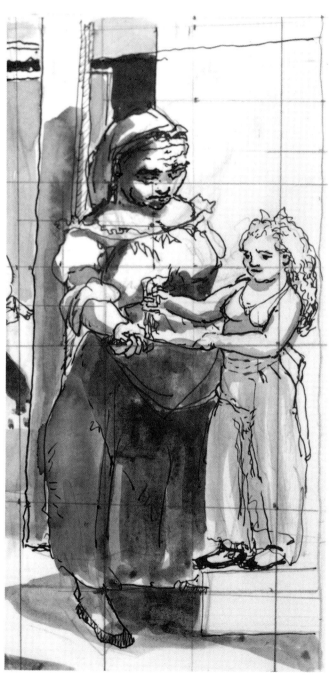

above **Albrecht Dürer**
A DRAUGHTSTMAN USING A NET TO DRAW A NUDE FIGURE IN FORESHORTENING 1538

This print depicts one of the many drawing devices invented by artists of the Renaissance. Notice the obelisk-like form that acts as a sighting mechanism to keep the eye in one place, and the identical grid on which the artist is drawing.

right **Paula Rego**
Detail of a study for
CRIVELLI'S GARDEN 1990

As shown, a grid can be placed on a drawing to allow preliminary sketches to be incorporated into it. Grids are drawn on the sketches and they are transferred square by square.

relation to each other. Drawing devices such as that shown were devised by artists of the Renaissance to keep this relationship constant. Used more loosely, even held up in front of the image, they are fairly easy to use.

MEASURING across the field of vision can be used to establish the proportion and placement of what is drawn. It is possible with a stick, ruler or pencil held in the hand. A method for measuring is demonstrated on the following pages.

PLUMB LINES can be used to establish the true vertical in the space to be drawn. They can be made simply by attaching a small weight to the end of a string, and holding it up to the image. In the making of careful sustained drawings, plumb lines are sometimes hung permanently in the space as an aid to measurement.

TRANSFERRING IMAGES: Grids are valuable in transferring an image from one surface to another of another scale. Artists use them regularly to transfer preparatory sketches and observational studies onto compositions. Often these works are divided into a single overall grid, which can be sub-divided as necessary, and grids are placed on the studies in proportion to it. An example of the use of such a method is shown on the opposite page.

PICTORIAL GEOMETRY: The proportions of the picture surface and the placement of images on it are important to the overriding pictorial statement of a drawing. Artists often use quite formal geometrical arrangements in images, basing them on squares, double squares, or in geometrical constructions, such as the golden section, devised in the Renaissance to relate the pictorial surface to systems of natural growth. An explanation and diagram of this construction are on this page.

THE GOLDEN MEAN

The thirteenth-century mathematician, Leonardo Fibonacci, identified the number series 1.1.2.3.5.8.13. and so on, in which each number is the sum of the two preceding it, as related to growth. The system was turned into a plane geometry by making a square of each number and arranging them in a spiral. The mathematics are quite raw, but on any side of the resulting rectangle, the whole length, and all of its smaller divisions will be in the same proportion to each other.

Jo Volley
UNTITLED

This drawing was arrived at by measurement, using the system explained on p. 150, and developed out of a concern for the geometrical surface relationships in the work.

A METHOD FOR MEASURING

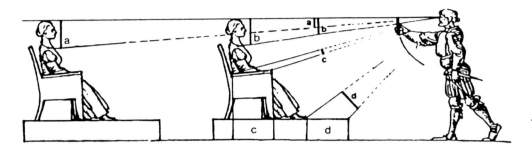

We use measuring to accurately determine the size and shape of things across our field of vision, which can be very different from their actual sizes and shapes.

DIAGRAM 1 (above) illustrates how both distance and position can affect the amount of visual space an object takes up. It also depicts a widely used method of measurement. In this, a ruler or pencil is held at arm's length, and at right angles to the eye. It is sighted at the object to be measured, which is positioned along it to obtain its measured dimensions. If a ruler is used, these dimensions can simply be read. If a pencil is used, the measurement is obtained by aligning one extremity of the object with its tip, and marking the other with the end of the thumb.

DIAGRAM 2 (right) illustrates an easy way to hold a pencil for this purpose.

In PROPORTIONAL MEASUREMENT the lengths obtained are used in relation to each other (a head might be used as a unit to determine how many heads high or wide a body is).

In SIGHT-SIZED MEASUREMENT the lengths measured are placed directly on the page, and all measurements can be used without reference to the others.

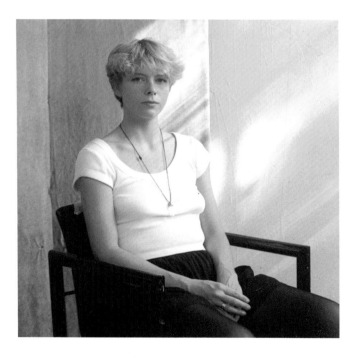

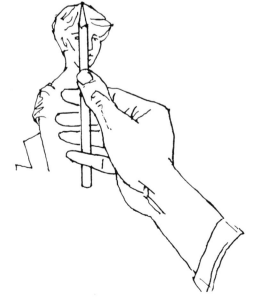

ARTIST'S NOTES

STAGE 1 The drawing was done sight-sized. The vertical edge of the screen behind the model seemed the best reference point to measure from. I drew a vertical line and marked the point at which the model's arm crossed it, then measured up to, and marked, the meeting of edge and sleeve. From my first mark I measured and marked the far edge of the figure at the head, shoulder and arm. I then placed the head, measuring from the screen to its left point, back to the right, and from the crown to the chin. I divided the figure into head measurements vertically, at the breast and the meeting of arm and chair. Then I drew the general shape of the right side of the head and shoulder to the triangle. Switching to the left side, I positioned and drew the shoulder, elbow and arm, then the chair arm and back. The drawing of the right side of the torso completed the major forms.

STAGE 2 These were now a base from which to measure others. With the outer edges in place, the most important inner contour seemed to be the point at which light and shadow met. I drew this, then continued to delineate other edges and inner contours.

STAGE 3 I realised that the head and face were the wrong size and redrew them. I also tackled the hands and clothing in more detail.

STAGE 4 The body proved to be too wide and had to be redefined. Other adjustments were small. At this stage, I emphasised the way the light described the form.

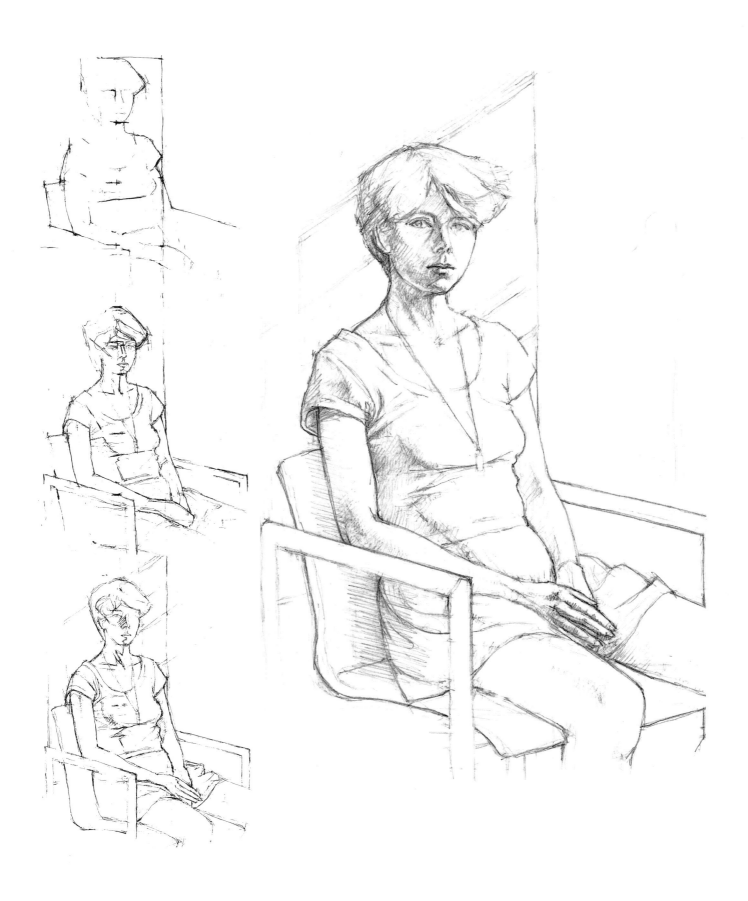

DRAWING MATERIALS

The surfaces that we work on, and the implements we use to draw, fundamentally affect the images we make, and investigation of the properties of materials is an essential part of the activity of drawing. While it is worth trying a range of materials simply to gain experience of them, it is also necessary eventually to determine the material appropriate to each work. This is related both to process – the kind of mark or surface you require – and intent. If your output is huge and the works transitional, you might decide to use the cheapest paper possible, even though it may discolour and disintegrate quickly. In order to make a sustained drawing, you must consider how the marks can be moved or removed, and you would most likely choose a heavier paper that would take a good deal of erasure and reworking, and that would be appropriate to the amount of effort in the work.

WET AND DRY MATERIALS

Artists choose drawing materials depending on their ease of use, speed, the quality of their mark, and how easily they can be erased or changed. The most widely used drawing materials are listed here with these properties in mind.

INK was used as a drawing medium in early Egypt, China and India long before the classical period. The placement of carbon or pigment in solution allows a variety and fluidity of mark not possible with 'dry' media. Applied with a brush, it allows the development of soft tonal area washes. The difference between ink and paint is generally one of 'body', drawing inks having the ability to be used easily with pen as well as brush. The inks we use today are usually thinned with water, though some are solvent based. In both groups, some are open to reworking, while others are waterproof when dry.

BRUSHES of a crude sort were used by the earliest artists. More sophisticated ways of binding fibres or animal hair together to use with ink have developed in all cultures, from Chinese and Japanese brushes, which deliver a soft-edged mark, to the red sables that can make the finest of lines. Brushes deliver widely differing marks in response to changes in pressure. The shape and composition of the brush determine the quality of the mark it makes.

PENS: The use of quills, reeds and bamboo pens dates back to the first writing and drawing systems. Metal nibs came into common use in the nineteenth century. All of these are available today. Pen nibs vary greatly, from the 'cut' nibs that deliver thick and thin marks, to rounds and points. They respond to the pressure and energy of the mark in different ways, depending on the material of the nib. Reed is a relatively stiff material; quill is more flexible. Metal nibs are made at different degrees of stiffness.

TECHNICAL AND MARKER PENS: There is now available a huge variety of easily used self-contained pens, which can produce marks from fine lines to fat brush strokes. Inks are either solvent- or water-based. Some pens are refillable, some waterproof and some have nibs that can be replaced. Fibre or felt tips, roller 'ball' points, and brush pens all give different marks, though none have the response to pressure of traditional pens. It is worth noting that some of the inks used in these pens fade, and the type of ink should be checked if you require permanence.

The removal of ink marks depends on the composition of the ink. Solvent-based inks can be removed by using blenders or thinners to lift marks off the paper. The technical drawing ink used in tubular nib pens can be removed with a kneadable rubber (eraser) provided the surface of the paper is hard and smooth enough.

CHARCOAL: Aside from naturally occurring chalk, charcoal is the oldest drawing material. It can be made by the controlled burning of any wood, although only three types are commonly available today – willow, vine and poplar. Vine is available in fine and medium sticks, willow in thicknesses up to the largest called 'scene painters', and poplar in large triangular sections. The colours of the three differ slightly: willow has a blue undertone; vine and poplar are more brown. These natural charcoals are basically gestural materials. The holding of the stick, its flaking during the process of making the drawing, and the rubbing and smoothing that is usually done with the hand means that the artist is very much 'in' a charcoal drawing. Charcoal is obviously not inherently precise. The sticks cannot be sharpened easily to hold a point, and their natural inconsistencies result in differences

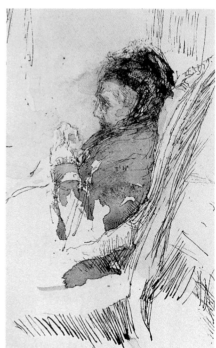

left **Richard Eurich**
MALE FIGURE SEATED 1925

The drawing demonstrates the flexibility of pencil as a medium, and the ease and versatility with which it can be used.

below **James McNeill Whistler**
STUDY OF MRS PHILIP

When ink is used with both pen and brush, the different effects have opposing characteristics. Works done this way gain their interest through these oppositions of hard against soft, linear against atmospheric.

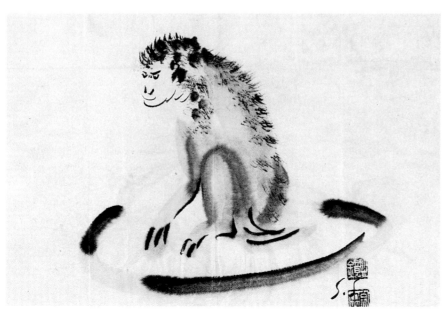

left **Sochu Suzuki**
MONKEY C. 1980

The possibilities of ink used with brush are seen in the variety of marks made to stand for different kinds of surfaces.

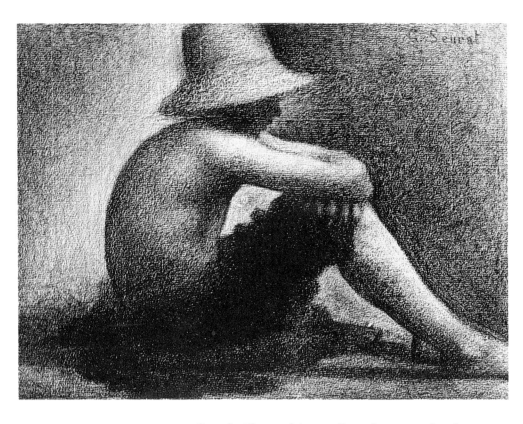

right **Georges Seurat**
SEATED BOY WITH STRAW HAT 1882

Seurat used the texture of the paper as an essential element in building up the tonal values. The effect is one of the image being seen through a tangible atmosphere. The medium is conté.

below **Giovanni Battista Tiepolo**
Study for **THE MADONNA AND CHILD (Ceiling Decoration)**

The tooth of the paper was used to hold the soft chalk of the drawing on the surface. Compare the effect with that of the rather smooth paper used by Eurich on the previous page.

of mark. Charcoal is excellent, however, for the making of a variety of marks, and for developing large tonal areas. It is also erased easily, and allows the building of pictures by positive/negative processes. COMPRESSED CHARCOAL gives a very much denser, less dusty mark than charcoal, and can achieve much deeper blacks. It is, however, much more difficult to erase. It is available in different degrees of hardness, the harder ones becoming less black.

CONTÉ CRAYONS AND DRAWING LEADS: Conté carré is a square section black pastel made from pigment and clay. Drawing leads are also made from pigment and clay and can be used in clutch pencils or on their own. Both come in a few grades of hardness.

GRAPHITE AND PENCILS: Graphite was discovered in the late sixteenth century, encased in wood shortly thereafter and, in 1790, combined with clay by Nicolas-Jacques Conté to permit varying degrees of hardness or softness. The pencil quickly became the principal informal writing and drawing instrument, and today is the most universal of writing and drawing tools. It is the most flexible of materials, has the advantages of ease of use and erasure, and in its many degrees of softness/hardness can be used with great precision or loose expressiveness.

The more graphite there is in the graphite/clay mixture, the softer the pencil. Pencils are graded as H (hardness) or B (blacker), with a number to

indicate the degree of hardness or softness. A 6B pencil is much softer than a 2B. There are about 20 grades normally sold. Graphite is also available in large sectioned sticks for the making of large marks, or for working on large areas.

CHARCOAL PENCILS are made up of a bound charcoal medium in a pencil casing. They can be sharpened and used with precision, and come in various grades of hardness, making marks of differing degrees of blackness. The marks made are less loose or dusty than those made with charcoal itself.

MATERIALS FOR ERASING or moving marks are essential to the process of selection that is integral to drawing. Erasure is a necessary part of virtually all sustained works. Rubbers (erasers) are used either to remove marks completely or to move and change them. Plastic rubbers are the best tools for the total removal of marks; putty ones are best for moving and changing them. Paper stumps are good for smudging and smoothing out marks while working. Dusty materials like charcoal or pastel are the easiest to remove; the denser ones, like compressed charcoal, are more difficult to erase. But even some pen lines can be erased with a vinyl eraser. The nature of the paper surface affects erasure (see *Paper* below). Marks on smooth-surfaced papers are more easily erased than those on Not or rough surfaces. Heavyweight paper can be carefully scraped with a blade to remove heavy charcoal or pen marks, though not if the surface is too rough. Surface-sized paper is more easily erased than others.

FIXATIVES are glues that stick pigment particles to the paper and make the drawing resistant to smudging. They can, however, change the look of the drawing, flattening tonal areas and contrasts. You can avoid the need for fixative somewhat by using a rough-surfaced or flocked paper, and by careful handling. Fixatives can be useful during the working of a drawing, to fix layers of underdrawing so that they can continue to be worked on, but erasure back from the fixed image is difficult.

PAPER

Paper is available in large and small sheets, in pads and blocks, and increasingly in rolls of all sizes and qualities. It comes in different thicknesses, described in terms of weight by a GSM (grams per square metre) number. Medium-weight paper is about 150 GSM, the lightest are below 100, the heaviest 300 or more. Different types of paper lend themselves to particular drawing methods and materials. Descriptions of their general properties follow.

The surface has an obvious effect on the mark placed on it. Artists' paper is available in three different surfaces: Rough, Not (cold pressed) and HP (or hot pressed). Rough is a heavily textured paper that mirrors the rough undulating surface of the blankets the paper was pressed between when it was made. Not is a medium-rough paper that has had a further pressing without blankets. HP has been pressed under heat to make an extremely smooth, flat surface. Rough and Not paper are conducive to heavy drawing because the drawing materials are held in the texture of the surface. A material such as charcoal will simply fall off a smooth-surfaced paper. Rough and Not sheets generally give an obvious textured surface to the drawing, while the smooth surface of HP facilitates fluid pen marks, and is also good for careful sustained pencil drawings, since marks can be erased more easily.

WOVE AND LAID: The surface of the paper is either wove or laid, depending on which type of mesh it was formed on. A wove mesh has no effect on the paper surface, while a laid sheet has a network of lines within it, and these can give the paper a ridged surface texture.

SIZING is used to reduce the absorbency of the paper, but it also hardens the paper surface. Gelatine surface sizing, or 'tub' sizing, deposits a layer of gelatine on the surface of the paper which allows for heavier work on the paper without wearing holes in it. It also makes the erasing of marks easier. Internally sized paper has a softer, more fibrous surface, which is easier to work into but also disintegrates more easily under sustained working. The hardness or softness of the surface can be distinguished easily by touch.

Paper is either machine-made, mould-made or handmade. Machine-made paper has a regular surface, while handmade paper has irregularities and 'character', and mould-made is somewhere in between the two. All cartridge paper is machine-made; watercolour paper is hand or mould-made.

Surfaced or flocked paper has a layer of pigment or powdered cotton on its surface, which grips chalk or charcoal particles and is excellent for heavily worked drawings, but cannot be erased easily.

There are many papers with special characteristics that are useful for drawing. Very absorbent rice paper, tracing and graph paper are commonly used, but there are any number that might be tried.

A word of caution: paper that is not acid free, typically newsprint or cartridge, will turn brittle and decompose quickly. If you wish to keep drawings, then the paper you work on must be acid free.

INDEX

Page numbers in *italics* refer to the illustrations.

ACKNOWLEDGMENTS

Every effort has been made to obtain the necessary permissions with reference to copyright material; we apologise if there are any omissions in this respect.

I would like to thank all those who have contributed to this book: the fellow artists who have read and commented on the text and those who have contributed works, the students and artists who have made works specially for the games sections, and especially to Madeleine Nicklin, the editor, for her valuable help in turning disparate notes and lectures into a coherent text, and to Karen Bowen, who not only designed it beautifully, but who was involved in virtually every aspect of its evolution.

p. 1: Giorgio Morandi (1890-1964): Morat-Institut für Kunst und Kunstwissenschaft, Freiburg im Breisgau, © DACS 1992

pp. 2-3: Pablo Picasso (1881-1973): Four Dancers (detail), 1925, pen and ink, 35.2 x 25.4 cm (13⅞ x 10 in), Collection, The Museum of Modern Art, New York, Gift of Abby Aldrich Rockefeller, © DACS 1992;

Contents: Leonardo da Vinci (1452-1519): from Codex Atlanticus, Biblioteca Abrosiana, Milan, photo: The Mansell Collection, London

p. 6: Ron Bowen (b. 1939): collection of the artist; Sergei Eisenstein (1898-1948): British Film Institute Stills, Posters and Designs, London

p. 8-9: Richard Dadd (1817-1886): courtesy of the Board of Trustees of the V & A, London; Fernand Léger (1881-1955): © DACS 1992, photo: Galerie Louise Leiris, Paris

INTRODUCTION: WHAT IS DRAWING?

pp. 10-11: Georges Seurat (1859-1891): The Metropolitan Museum of Art, New York, Bequest of Stephen C. Clark, 1960 (61.101.16); Hendrick Hondius (1597-1651): reproduced by permission of the Reference Library Department, Birmingham Public Libraries, England; Raoul-Auger Feuillet (c. 1675-1710): Tattooed Woman/Cheryl: tattoos by Jim Watson, photo: Chris Wroblewski; Andreas Vesalius (1514-1564)

pp. 12-13: Stencilled hand: cave art recently discovered by Henri Cosquer, photo: © Henri Cosquer-Fanny Broadcast/GAMMA; Furrows at Byfield Hill, Northants, photo: Aerofilms Library; The Opening of the Mouth Ceremony: reproduced by Courtesy of the Trustees of the British Museum

pp. 14-15: Fay McCaul (b. 1985): courtesy of the artist; Nadia's drawing of a horse and rider from Nadia by Lorna Selfe, Academic Press, 1977; Horse's head: cave art recently discovered by Henri Cosquer, photo: © Henri Cosquer-Fanny Broadcast/GAMMA

pp. 16-17: Ellsworth Kelly (b. 1923): collection of Whitney Museum of American Art, New York, Purchase, with funds from the Neysa McMein Purchase Award; Sochu Suzuki: collection of Mr. and Mrs. Tom Chetwynd; Philip Guston (1913-1980): photo: David McKee Inc., New York

pp. 18-19: Jacques Louis David (1748-1825): Musée National du Château de Versailles et des Trianons, photo: R.M.N.; Frank Lloyd Wright (1869-1959): Design for the Yahara Boat Club, Madison, Wisconsin, 1905, © 1992 The Frank Lloyd Wright Foundation, photo: The British Architectural Library, RIBA, London; Karen Bowen (b. 1941): courtesy of the artist; Pablo Picasso: Musée Picasso, © DACS 1992, photo: R.M.N.

pp. 20-21: Sadie Tomlinson (b. 1968): courtesy of the artist

Chapter 1: ACTIVE SEEING

pp. 22-23: Hiroshige (1797-1858): The Brooklyn Museum, New York; Pablo Picasso: Four Dancers (detail), 1925, pen and ink, 35.2 x 25.4 cm (13⅞ x 10 in), Collection, The Museum of Modern Art, New York, Gift of Abby Aldrich Rockefeller, © DACS 1992; André Hermond: collection of Tonie and Valmai Holt

pp. 24-25: Diagram of the optical system of the eye, from Rene Descartes's Discours de la méthode plus la dioptrique, les météores et la géometrie, Leiden, 1637; Robert Delaunay (1885-1941): Eiffel Tower, 1910, pen and ink on brown cardboard, 56 x 48.9 cm (21¼ x 19¼ in), Collection, The Museum of Modern Art, New York, Abby Aldrich Rockefeller Fund, © ADAGP, Paris and DACS, London 1992

pp. 26-27: Photograph of a dancer, Bibliothèque Nationale, Paris; Edgar Degas (1834-1917): Philadelphia Museum of Art: The John G. Johnson Collection; Charles Sheeler (1883-1965): courtesy of The Fogg Art Museum, Cambridge, Massachusetts, Louise E. Bettens Fund

pp. 28-29: Drawing from Peter Schmid's Das Naturzeichnen: collection of Professor Clive Ashwin; Patrick Caulfield (b. 1936): from book of 32 drawings, courtesy of the artist, photo: Waddington Galleries, London; Joseph Piccillo (b. 1941): Glenn C. Janss Collection

pp. 30-31: Attributed to Rogier van der Weyden (1399-1464): The Metropolitan Museum of Art, New York, Robert Lehman Collection, 1975 (1975.1.848); M.C. Escher (1898-1972): © M.C. Escher/Cordon Art, Baarn, Holland; Albrecht Dürer (1471-1528): reproduced by Courtesy of the Trustees of the British Museum

pp. 32-33: Rackstraw Downes (b.1939): Glenn C. Janss Collection; Vincent van Gogh (1853-1890): Vincent van Gogh Museum/Van Gough Foundation, Amsterdam; Charles Sheeler: collection of The Corcoran Gallery of Art, Washington, D.C., Museum Purchase, Mary E Maxwell Fund

pp. 34-35: Spider-Man from The Complete Spider-Man, 26 February, 1992; Avalokitesvara as Guide of Souls: reproduced by Courtesy of the Trustees of the British Museum; Luca Signorelli (c. 1441/50-1523): Windsor Castle, Royal Library, © 1992 Her Majesty The Queen

pp. 36-37: Brendan Kelly (b. 1970): courtesy of the artist

pp. 38-39: Goyo Hashiguchi (1880-1921): reproduced by Courtesy of the Trustees of the British Museum; Photograph and a computer image produced electronically using Aldus ® PhotoStyler™; Henri Matisse (1869-1954): © Succession H Matisse/DACS 1992

pp. 40-41: Salvador Dali (1904-1989): © DEMART PRO ARTE BV/DACS 1992, photo: Sotheby's, London; Chuck Close (b. 1940): collection of Whitney Museum of American Art, New York, Purchase, with funds from Peggy and Richard Danziger, photo: Geoffrey Clements

pp. 42-43: Paul Klee (1879-1940): © DACS 1992; Raphael Santi (1483-1520): Ashmolean Museum, Oxford; Zandra Rhodes (b. 1939): courtesy of the artist; Allen Jones (b. 1937): courtesy of the artist, photo: Waddington Galleries, London

pp. 44-45: Hans Meyer (1655-1712) after Arcimboldo: ('Me into mountain didst form and onto paper didst impart/nature by accident Arcimboldo by art'), Ashmolean Museum, Oxford; Salvador Dali: © DEMART PRO ARTE BV/DACS 1992, photo: Galerie André-François Petit, Paris; Albrecht Dürer: reproduced by Courtesy of the Trustees of the British Museum

pp. 46-47: Flight of the Masked Man: photo: Scala; Pablo Picasso: Musée Picasso, © DACS 1992, photo: R.M.N.

pp. 48-49: Daniel Preece (b. 1970)

Chapter 2: DRAWING STRATEGIES

pp. 50-51: Christo (b. 1935): private collection, © Christo 1992, photo: Wolfgang Volz; Gerald Atkinson (1893-1971): from Curtis's Botanical Magazine, vol. 151, 1925, source: Royal Botanic Gardens, Kew; Juan Gris (1887-1927): photo: Christie's, London; Ivon Hitchens (1893-1979): courtesy the Hitchens estate, photo: Waddington Galleries, London

pp. 52-53: Vincent Westbrook (b. 1960): courtesy of the artist

pp. 54-55: Victor Newsome (b. 1935): reproduced by Courtesy of the Trustees of the British Museum; Henry Moore (1898-1986): © The Henry Moore Foundation; Pablo Picasso: The Baltimore Museum of Art, The Cone Collection, formed by Dr. Claribel Cone and Miss Etta Cone of Baltimore, Maryland BMA 1950.270, © DACS 1992

pp. 56-57: Jacques Villon (1875-1963): private collection, © ADAGP, Paris and DACS, London 1992, photo: Galerie Louis Carré, Paris; Euan Uglow (b. 1932): photo: Browse & Darby, London

pp. 58-59: Fay McCaul: courtesy of the artist; Keith Haring (1958-1990): © 1992 The Estate of Keith Haring; Virgin Atlantic emergency instructions: courtesy Virgin Airlines; Claes Oldenburg (b. 1929): Systems of Iconography – Plug, Mouse, Good Humor, Lipstick, Switches (1970), 1971, Offset lithograph, 71.1 x 59.2 cm (28 x 23⁵⁄₁₆ in), edition of 250, printed by Imprimeries Réunies, Lausanne, published by Margo Leavin Gallery, Los Angeles, © Claes Oldenburg, 1992, photo: Tate Gallery, London

pp. 60-61: Justin Mortimer (b. 1970): courtesy of the artist

pp. 62-63: Dancing Figure, 16th-century Italian drawing: The Metropolitan Museum of Art, New York, Gift of Cornelius Vanderbilt, 1880 (80.3.72); The Fisherman: Athens National Museum, photo: Tap Service

pp. 64-65: Paula Rego (b. 1935): Marlborough Fine Art Ltd., London; Attributed to Rosa Bonheur (1822-99): National Gallery of Canada, Ottawa; Piet Mondrian (1872-1944): The Solomon R. Guggenheim Museum, New York, © DACS 1992, photo: David Heald; Ron Bowen: collection of the artist

pp. 66-67: Piet Mondrian: Peggy Guggenheim Collection, Venice, © DACS 1992; Leonardo da Vinci (1485-90): Galleria dell'Accademia, Venice, photo: The Mansell Collection, London; Liubov Popova (1889-1924): private collection, photo: Sotheby's, London; Tess Jaray (b. 1937): courtesy of the artist

pp. 68-69: Alfred Kubin (1877-1959): Albertina, Vienna; Marc Chagall: (1887-1985), Study for Birthday, 1915, Pencil, 22.9 x 29.2 cm (9 x 11½ in), Collection, The Museum of Modern Art, New York, Gift of the artist, © ADAGP, Paris and DACS, London 1992; Pavel Tchelitchew (1898-1957): photo: Christie's, London

pp. 70-71: René Bouët-Willaumez (1900-1979): © The Condé Nast Publications; Natalia Gontcharova (1881-1962), © ADAGP, Paris and DACS, London 1992; John Salt (b. 1937): photo: O.K. Harris Works of Art, New York; Citroën 2CV engine: courtesy Citroën, Neuilly-sur-Seine

pp. 72-73: Marcus Grey (b. 1960): courtesy of the artist; Sarah Weatherall (b. 1968): courtesy of the artist

Chapter 3: DRAWING ELEMENTS

pp. 74-75: Henry Fuseli (1741-1825): reproduced by Courtesy of the Trustees of the British Museum; Vasily Kandinsky (1866-1944): The Solomon R. Guggenheim Museum, New York, © ADAGP, Paris and DACS, London 1992; Jan van Eyck: Staatliche Kunstsammlungen, Dresden; Amedeo Modigliani, Italian (1884-1920): Seated Nude, graphite, 1918, 42.5 x 25 cm, The Art Institute of Chicago, Given in Memory of Tiffany Blake by Claire Swift-Marwitz, 1951.22, photo: © 1992 The Art Institute of Chicago. All rights reserved.

pp. 76-77: Georgia O'Keeffe (1887-1986): Eagle Claw and Bean Necklace, 1934, charcoal, 48.3 x 63.8 cm (19 x 25⅛ in), Collection, The Museum of Modern Art, New York, Given anonymously (by exchange), © 1992 The Georgia O'Keeffe Foundation/ARS, N.Y.; Jennifer Bartlett (b. 1941): The Saatchi Collection, London;

Diego Rivera (1886-1957): Leeds City Art Galleries

pp. 78-79: David Hockney (b. 1937), My Father, 1972, © David Hockney; Ben Nicholson (1894-1982): courtesy the Nicholson estate, photo: Waddington Galleries, London; Paul Cézanne (1839-1906): reproduced by Courtesy of the Trustees of the British Museum

pp. 80-81: Pablo Picasso: c DACS 1992, photo: Galerie Louise Leiris, Paris; Susan Rothenberg (b. 1945): private collection, photo: Sotheby's, New York; Jean Dubuffet (1901-1985): The Saint Louis Art Museum, Gift of Mrs. Katharine Kuh, © ADAGP, Paris and DACS, London 1992

pp. 82-83: Vincent van Gogh: Vincent van Gogh Foundation/Van Gogh Museum, Amsterdam; João Penalva (b. 1949): courtesy of the artist; Tom Norris (b. 1960): courtesy of the artist

pp. 84-85: Marie Laurencin (1885-1956): Musée Marie Laurencin, Japan, © ADAGP, Paris and DACS, London 1992, photo: Sotheby's, London; Leonardo da Vinci: cartoon of The Virgin and Child with SS. Anne and John the Baptist, reproduced by Courtesy of the Trustees, The National Gallery, London; Arshile Gorky, American, born Armenia (1904-1948): The Artist's Mother, charcoal on ivory laid paper, 1926 or 1936, 63 x 48.5 cm, The Art Institute of Chicago, Worcester Sketch Fund, 1965.510, © 1992 Agnes Fielding-Gorky/ADAGP, Paris and DACS, London 1992, photo: © 1992 The Art Institute of Chicago. All rights reserved.

pp. 86-87: El Greco (Domenikos Theotocopoulos Greco) (1541-1614): Staatliche Graphische Sammlung, Munich; Jean François Millet (1814-1875): collection of The Corcoran Gallery of Art, Washington, D.C., William A. Clark Collection 26.119; Ron Bowen: collection Mr. and Mrs. Michael Newton

pp. 88-89: Paula Modersohn-Becker (1876-1907): Hamburger Kunsthalle, Hamburg; Camille Claudel (1864-1943): © DACS 1992; Chuck Close (b. 1940): printed at Crown Point Press, published by Pace Editions, New York

pp. 90-91: Paula Rego: reproduced by courtesy of the Trustees, The National Gallery, London; Edouard Manet (1832-1883): The Burrell Collection, Glasgow Museums; Otto Dix (1891-1969): Galerie der Stadt, Stuttgart, © Otto Dix Stiftung, Vaduz, Switzerland

pp. 92-93: K.D. Bahashtion (b. 1971): courtesy of the artist; Andrew Pankhurst (b. 1968): courtesy of the artist

Chapter 4: DRAWING TO RECORD

pp. 94-95: Photograph of Toulouse-Lautrec (1864-1901) from Toulouse Lautrec vu par les photographes by George Beaute, Edita SA, Lausanne, 1988, courtesy of the author; Henri de Toulouse Lautrec: Fondation Pierre Gianadda, Martigny, Switzerland; Drawing of The Execution of Mary Queen of Scots at Fotheringhay Castle: © The British Library; Anonymous 18-century drawing: c. 1770-71, collection of David Bindman; Rembrandt van Rijn (16061669): Staatliche Museen Preussischer Kulturbesitz, Berlin Kupferstichkabinett, photo: Jörg P. Anders

pp. 96-97: Honoré Daumier (1808-1879): The Metropolitan Museum of Art, Rogers Fund, 1927. (27.152.2); Vincent van Gogh: Vincent van Gogh Foundation/Van Gogh Museum, Amsterdam; Thomas Gainsborough (1727-1788): Staatliche Museen Preussischer Kulturbesitz, Berlin Kupferstichkabinett, photo: Jörg P. Anders

pp. 98-99: Jean Cocteau (1889-1963): © DACS 1992 photo: Sotheby's London; Hans Holbein (1497/8-1543): reproduced by courtesy of the Trustees, National Portrait Gallery, London; Ron Bowen: private collection

pp. 100-101: John Marin (1870-1953): Brooklyn Bridge, 1913, etching, printed in black, plate: 28.6 x 22.5 cm, Collection, The Museum of Modern Art, New York Gift of Abby Aldrich Rockefeller; The Pedestrian Walkway of the Brooklyn Bridge, Museum of the City of New York, The Byron Collection; photograph of Tamara Karsavina in Le Spectre de la Rose, 24 June, 1911, Covent Garden, Mander & Mitchenson Theatre Collection, London; Jean Cocteau: courtesy of the Board of Trustees of the V & A , London © DACS 1992

pp. 102-103: Jacques Louis David, The Oath of the

Tennis Court at Versailles on 20 June 1789, Musée National du Château de Versailles et des Trianons, photo: R.M.N.; Francisco Goya (17461828): Prado, Madrid, photo: Witt Library, London; Reginald Marsh (1898-1954): The William Benton Museum of Art, University of Connecticut, Storrs

pp. 104-105: Henri de Toulouse-Lautrec: Musée Toulouse-Lautrec, Albi; Etienne Dominique Esquirol (1772-1840): from Des maladies mentales considerées sous in rapport médical, hygiénique et médico-légal, Paris: J.B. Bailliere, 1838, Wellcome Institute Library, London; Jock McFadyen (b. 1950): photo: William Jackson Gallery, London; William Hogarth (1697-1764); The Pierpont Morgan Library, New York

pp. 106-107: Rembrandt van Rijn: Rijksmuseum, Amsterdam; Sergei Eisenstein: photo: British Film Institute Stills, Posters and Designs, London; Merce Cunningham (b. 1919): © Marion Boyars; Antonio Sant'Elia (1888-1916); Ron Bowen: collection of the artist

pp. 108-09: Hannah Moody (b. 1970): courtesy of the artist; Yolanda Chetwynd (b. 1960): courtesy of the artist

Chapter 5: DRAWING SUBJECTS

pp. 110-111: J.M.W. Turner (1775-1851): Fitzwilliam Museum, University of Cambridge; Francesco Clemente (b. 1952): Staatliche Museen Preussischer Kulturbesitz, Berlin Kupferstichkabinett, photo: Jörg P. Anders; Christopher Wood (1901-1930): reproduced by Courtesy of the Trustees of the British Museum; Michelangelo Buonarroti (1475-1564): Windsor Castle, Royal Library, © 1992 Her Majesty The Queen

pp. 112-113: Eugène Delacroix (1798-1863): courtesy of The Fogg Art Museum, Harvard University, Cambridge, Massachusetts, Bequest – Meta and Paul J. Sachs; Charles Lebrun (1619-1690): Bibliothèque des Arts Décoratifs, photo: Jean-Loup Charmet; George Herriman (1880-1944) collection of Mr. and Mrs. S.I. Newhouse, Jr.; George Stubbs (1724-1806): reproduced by Courtesy of the Trustees of the British Museum

pp. 114-115: Paul Cézanne, La Montagne Sainte-Victoire, National Gallery of Ireland, Dublin; Harry Tonks (b. 1862-1937): Strang Print Room, University College London; Hans Hofmann (1880-1966): Glenn C. Janss Collection

pp. 116-117: Karen Bowen: collection of the artist; George Grosz (1893-1959): © DACS 1992, photo: Christie's, London; William Glackens (1870-1938), Glenn C. Janss Collection

pp. 118-119: Paul Cézanne: Musée du Louvre, photo: R.M.N.; Vincent van Gogh: Vincent van Gogh Foundation/Van Gogh Museum, Amsterdam; Edvard Munch (1863-1944): Munch-Museet, Oslo; Mary Cassatt (18441926): National Gallery of Art, Washington, D.C., Rosenwald Collection

pp. 120-121: Käthe Kollwitz (1867-1945): Allen Memorial Art Museum, Oberlin College, Oberlin, Ohio, R.T. Miller, Jr. Fund, 1944, © DACS 1992; James Gillray (1775-1815): reproduced by Courtesy of the Trustees of the British Museum; Otto Dix: The Museum of Modern Art, Braunschweig, Germany, © Otto Dix Stiftung, Vaduz, Switzerland, photo: Witt Library, London; Rembrandt van Rijn: Albertina, Vienna

pp. 122-123: Four Athletes, detail from a Panathenaic amphora: reproduced by Courtesy of the Trustees of the British Museum; Pablo Picasso: Fitzwilliam Museum, University of Cambridge, © DACS 1992; Paul Gauguin (1848-1903): photo: R.M.N.

pp. 124-124: Attributed to Jean August Dominique Ingres (1780-1867): private collection; Pierre Auguste Renoir, French (1841-1919): Study for The Bathers, red and white and black chalk, with brush and red and white chalk wash, on tan wove paper, c. 1884-85, 98.5 x 64 cm, The Art Institute of Chicago, Bequest of Kate L. Brewster, 1949.514, photo: © 1992 The Art Institute of Chicago. All rights reserved; Dora Carrington (1893-1932): Strang Print Room, University College London

pp. 126-127: Philip Pearlstein (b. 1924): The Baltimore Museum of Art: Purchase, Women's Committee Fund, BMA 1975.23, © Philip Pearlstein; Alberto Giacommeti (1901-1966): © ADAGP, Paris and DACS, London

1992, photo: Christie's, London; Max Beckmann (1884-1950): courtesy of the Board of Trustees of the V & A, London, © DACS 1992; Ron Bowen: artist's collection

pp. 128-129: Balthus (b. 1908): Study for Nude with Cat, c. 1949, Pencil, pen and ink, 30.2 x 45.1 cm (11⅞ x 17¾ in), Collection, The Museum of Modern Art, New York, Gift of John S. Newberry, © DACS 1992; William Dobell (1897-1970): courtesy Sir William Dobell Art Foundation, photo: Sotheby's, Australia; Jean Auguste Dominique Ingres: Musée Ingres de Montauban

pp. 130-131: Giorgio Morandi: Morat-Institut für Kunst und Kunstwissenschaft, Freiburg im Breisgau, © DACS 1992; Thomas Eakins (1844-1916): Museum of Fine Arts, Boston; François Clouet (c. 1515-1572): Albertina, Vienna

pp. 132-133: Ron Bowen: collection of the artist; Sharon Brindle (b. 1960): courtesy of the artist

pp. 134-135: Cecil Beaton (1904-1980): Serge Lifar Exercising on the Lido, from British Vogue, September 1928 © The Condé Nast Publications; Katsushika Hokusai (1760-1849): Museum für Ostasiatische Kunst, Staatliche Museen, Berlin, photo: Postel; Roy Lichtenstein (b. 1923): Sweet Dreams, Baby! (Pow!), 1965, from the portfolio 11 Pop Artists, Volume II. New York, Original Editions, 1965, serigraph, printed in colour, composition: 90.8 x 64.9 cm (35¾ x 25⁹/₁₆) Collection, The Museum of Modern Art, New York, Gift of original Editions © Roy Lichtenstein/DACS 1992; Marcel Duchamp (1887-1968): Nude Descending a Staircase, No. 2, 1912 Philadelphia Museum of Art: The Louise and Walter Arensberg Collection, © ADAGP, Paris and DACS, London 1992

pp. 136-137: Rico LeBrun (1900-1964): 1948, UNL-F.M. Hall Collection, Sheldon Memorial Art Gallery, University of Nebraska, Lincoln, 1963-H-778; Georges Seurat: Nichido Museum, Tokyo; Vladimir Burliuk (1888-1917): untitled lithograph inserted into The Bung (1913) by V. Khlebnikov, and D., V. and N. Burliuk, © The British Library; Leonardo da Vinci: Windsor Castle, Royal Library, © 1992 Her Majesty The Queen

pp. 138-139: Page with initial and St. George and the Dragon from St Gregory: Moralia in Job: Bibliothèque Publique, Dijon, photo: Andre Held; Map of Europe: Bibliothèque National, photo: Bulloz; Max Morise, André Breton (1896-1966), Yves Tanguy (1900-1955) © DACS 1992, Marcel Duhamel: Collection Robert Lebel, Paris, photo: Witt Library, London; René Magritte (1898-1967): The Menil Foundation, Houston, © ADAGP, Paris and DACs, London 1992

pp. 140-141: Eadweard Muybridge (1830-1904): photo: Mary Evans Picture Library, London; Ron Bowen: collection of the artist; Michael Scott (b.1954): courtesy of the artist

pp. 142-143: Edward Hopper (1882-1967): Whitney Museum of American Art, New York, Bequest of Josephine N. Hopper 70.1048; Edvard Munch, Munch-Museet, Oslo; Ron Bowen: collection of the artist

TECHNICAL DIRECTORY

pp. 144-145: Jan Vredeman de Vries (1527-1605); Giorgio de Chirico (1888-1989): Galleria Nazionale d'Arte Moderna, Rome, © DACS 1992 photo: Witt Library

pp. 146-147: Albrecht Altdorfer (1480-1538): Staatliche Museen Preussischer Kulturbesitz, Berlin Kupferstichkabinett, photo: Jörg P. Anders; James Stirling (1926-1992): courtesy of the artist, photo: Geremy Butler

pp. 148-149: Albrecht Dürer: from Dürer's Underweyssung der Messung, 2nd edn. Nuremberg, 1538; Paula Rego: Marlborough Fine Art Ltd., London; Jo Volley (b. 1953): courtesy of the artist

pp. 152-153: Richard Eurich (1903-1992): Strang Print Room, University College London; James McNeill Whistler (1834-1903): Helen and Alice Colburn Fund, Courtesy, Museum of Fine Arts, Boston

pp. 154-155: Georges Seurat: Yale University Art Gallery, New Haven, Connecticut, Everett V. Meeks, BA 1901 Fund; Giovanni Battista Tiepolo (1696-1770): The Fogg Museum, Harvard University, Cambridge, Massachusetts, Gift of Jacob M. Heimann

hans hofmann 42